MW00836808

EXPOSÉ 8™

Finest digital art in the known universe

Edited by

Daniel Wade

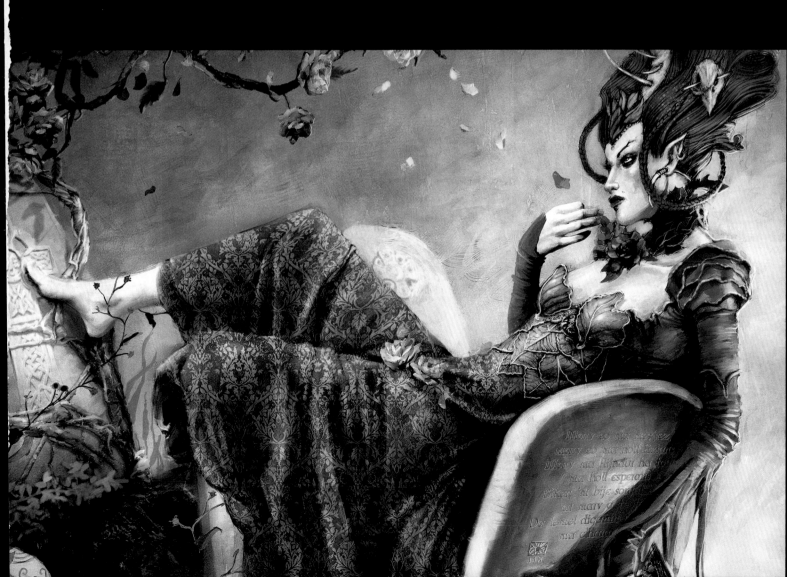

EXPOSÉ 8 ™

Published
by

Ballistic Publishing

Finest digital art books in the known universe

134 Gilbert St
Adelaide, SA 5000
Australia

www.BallisticPublishing.com

Correspondence:
info@BallisticPublishing.com

First Edition published in Australia 2010 by Ballistic Publishing

Softcover Edition	ISBN 978-1-921002-84-7
Hardcover Edition	ISBN 978-1-921002-82-3
Limited Collector's Edition	ISBN 978-1-921002-83-0

Editor/Publisher
Daniel Wade

Assistant Editor
Paul Hellard

Junior Editor
Gemma White

Art Director
Lauren Stevens

Design & Image Processing
Lauren Stevens, Daniel Cox

Advisory board
Brom, Max Dennison, Lorne Lanning, Stephan Martiniere,
Chris Sloan, Chris Stoski, Phil Straub

Printing and binding
Everbest Printing, China (www.everbest.com)

Partners
The CGSociety (Computer Graphics Society) www.CGSociety.org

Also available from Ballistic Publishing
EXPOSÉ 7 Softcover	ISBN 978-1-921002-64-9
The Art of UNCHARTED 2	ISBN 978-1-921002-71-7
d'artiste Character Modeling 3	ISBN 978-1-921002-67-0
EXOTIQUE 5 Softcover	ISBN 978-1-921002-69-4

Visit www.BallisticPublishing.com
for our complete range of titles.

Cover image credits

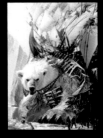

Warhammer 40000: Enforcer
Photoshop
Client: Games Workshop
Marek Okon, POLAND
*[Front cover: EXPOSÉ 8
Softcover & Hardcover editions]*, 42

'Warhammer 40000' © Games Workshop

Guild Wars 2: Polar Menace
Photoshop
Daniel Dociu, ArenaNet, USA
*[Back cover: EXPOSÉ 8
Softcover & Hardcover editions]*, 41

'Guild Wars 2' © ArenaNet

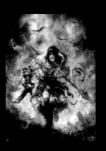

Merciless
Photoshop
Michal Ivan, SLOVAKIA
[Cover: EXPOSÉ 8 Limited Edition], 139

/ BALLISTIC /

Daniel Wade | Editor &
Publisher of Ballistic Publishing

/ B A L L I S T I C /

W W W . B A L L I S T I C P U B L I S H I N G . C O M

After eight years of collecting awe-inspiring art for EXPOSÉ and several other Ballistic Publishing series, it's hard not to get a little philosophical about how we all fit into the art continuum. The communities that have grown around CGSociety.org and Ballistic Publishing have submitted many times more artwork for consideration than are stored in some of the largest museums in the world. In fact, just the images that have been submitted for Ballistic Publishing books are three times the number of pieces in the Louvre Museum's collection—and they've had a 210-year head-start! Though quantity is an impressive measurement of how far we've come, the true indicator of success for Ballistic Publishing, and the EXPOSÉ series in particular, is the quality of entries submitted. The proof of this quality is reflected in the closeness of the judging results by the EXPOSÉ 8 Advisory Board. Very few votes separate the top 20-30 images in each category which we think best demonstrates how any artist featured in EXPOSÉ can consider themselves an award-winner.

From the first EXPOSÉ we knew that the number of award-winners would increase as more artists joined the community and the already high level of artistry was challenged each year. In total there have now been 151 Master Award winners featured in EXPOSÉ across eight editions, and having just looked through all eight editions I'm happy to say that the artwork still sets the standard for what the Advisory Board considers exceptional. In addition to the Master Award which is awarded once per category, the Excellence Award is awarded to the next 2-3 artists in the voting order. Looking back at all of the previous Excellence Award winners, the pieces all stand up as great emotional and technical triumphs, and many names that we know as leaders in their craft have had their works recognized with these awards. Fittingly, the EXPOSÉ 8 award winners stand proudly among this great collection of work, and set the standard for years to come.

Another indicator of the vibrance of the EXPOSÉ series is the way the entries evolve each year, with new styles and subject matter growing to the stage where they demand attention. Two categories of art which we've seen steadily grow in size and quality have been the areas of Game Art, and comic/manga-inspired art. As in previous EXPOSÉ books, we tweaked the balance to make room for the new exciting categories, and feel that we have a great balance across the 21 categories featured in EXPOSÉ 8.

A record number of entries were received for EXPOSÉ 8 (close to 6,300) which gave the judging panel the enormous task of selecting and voting on the best entries. The Advisory Board boasted a who's who of renowned artists including: Stephan Martiniere (concept artist and Grand Master), Lorne Lanning (Co-founder of Oddworld Inhabitants), Chris Sloane (Art Director of National Geographic), Max Dennison (matte painter and founder of Matte Painting UK), Chris Stoski (matte painter and concept artist), Brom (fantasy artist), and Philip Straub (art director and concept artist). Of the almost 6,300 images entered, 393 were featured in EXPOSÉ 8. These came from 283 artists in 52 countries (over one third of these artists were featured for the first time). With so many award winners, it was virtually impossible to squeeze any more entries in than we'd featured for EXPOSÉ 7, so we bit the bullet and added another 16 pages to all editions so we could sneak just a few more large images in.

Congratulations to all the artists who have submitted work for the EXPOSÉ series and our other titles. We hope you enjoy EXPOSÉ 8 as much as we enjoyed producing it. We're also very excited with our Grand Master artist for EXPOSÉ 8. As always, let us know what you think on our Facebook group: www.facebook.com/ballisticpublishing

Finally, it's with sadness that we mark the passing of the great Frank Frazetta whose work continues to inspire. R.I.P.

EXPOSE 8 CATEGORIES

CHOOSING CATEGORIES

Each year we look at every image entered for EXPOSÉ and choose the categories that best represent the balance of those entries. Several categories will regularly receive most of entries like Portrait (Painted), Fantasy, Concept Art, Science Fiction, and Architecture and these continue to be the strongest categories for EXPOSÉ 8. Increasingly, the number of entries created for game properties, comics and Manga art have grown, so to reflect these exciting mediums we've created new categories for them. Overall, the quality of entries significantly increased again with EXPOSÉ 8 to the point where few votes separated the award-winning entries. EXPOSÉ 8 entries received close to 6,300 entries which is an amazing number for a series entering its eighth year, and we couldn't be more proud of the community built around EXPOSÉ and its inspiring artwork.

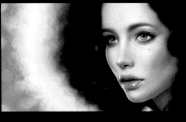

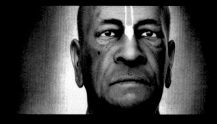

Portrait (Painted)

This category awarded the greatest talent in bringing a character to life, independent of style, or nature of the character. The judging criterion was the ability of the artist to breathe life into the subject. This encompassed technical skill, believability, composition, and importantly, emotion.

Portrait (Rendered)

This category recognized the greatest talent in bringing a 3D character to life. The defining criterion for the category was the ability to bring the subject to life, particularly with texturing and lighting. Successful entries encompassed technical skill, believability, composition, and emotion.

Game Art

This category recognized the concept and finished art created for video and role-playing games. The judging criterion for this category was the artist's ability to create inspired characters and environments that add to the interactive storytelling medium via technical skill, composition, and vision.

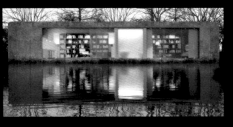

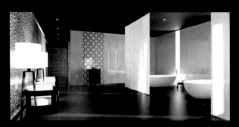

Architecture (Exterior)

This category awarded the best exterior architectural visualization, independent of style, or setting. The category tested the artist's ability to create a commercial or residential space that was believable (lighting, scale and perspective), and evoked the desire to visit the location/building/space.

Architecture (Interior)

This category awarded the best interior architectural visualization of a commercial, or residential space, independent of style, or setting. The judging criterion for the category was the artist's ability to create an interior setting that was not just functional, but also believable (lighting, scale and perspective).

Fantasy

This category honored the highest achievement in the mythic fantasy style from traditional fantasy creatures to heroic characters and dragons. The artist's talent in evoking an emotional response as well as the ability to place their characters in an unfolding story was also crucial.

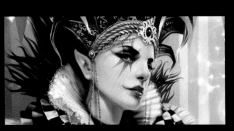

Fantasy Femmes

This category recognized the most outstanding examples of character creation in the fantasy style from elves and nymphs to heroic femmes. The artist's ability to breathe life into fantastic characters was paramount along with technical skill, composition, and emotional resonance.

Concept Art

This category recognized the highest achievement in bringing a concept into being, whether for a movie, TV, or game environment. The judging criterion for this category was to convey a sense of place or personality along with technical skill, composition, color palette, and mood.

Matte Painting

This category honored the artist's ability to create a compelling stage upon which an epic story could be told. The judging criterion was to create a landscape or space where depth, scale, and atmosphere were all well-executed. Technical skill, composition, and mood were also crucial elements.

Environment

This category honored the best landscape or location (indoors, outdoors, underwater, or in space). The artist's ability to evoke a sense of wonder was paramount, along with a combination of artistic interpretation, detail, and lighting to create a believable and evocative environment.

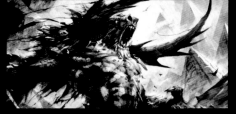

Warriors & Conflict

This category recognized the best examples of heroic characters and epic battles. The judging criterion for this category was the artist's ability to create heroic characters and epic confrontations. Technical skill and composition were crucial to an entry's success.

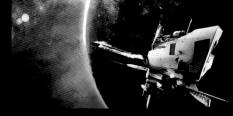

Science Fiction

This category awarded the greatest talent in creating a believable environment or character of the future. The defining criterion was the artist's ability to create an environment or character which though familiar, appeared otherworldly, and technologically advanced.

Robotic/Cyborg

This category recognized the greatest talent in bringing a mechanical or cyborg character into existence. The defining criterion was the artist's ability to create a believable mechanical or composite being. Successful entries encompassed technical skill, believability, composition, and emotion

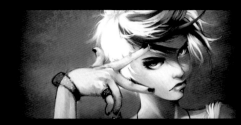

Comic/Manga

This category celebrated the combined genres of comic art, and Japanese-inspired Manga. The judging criterion for the category was the artist's ability to create characters and environments that fit into the comic narrative or Manga style, and also show skill in detail and composition.

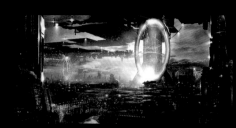

Futurescapes

This category recognized the greatest talent in realizing a cityscape or civilization. The judging criterion was the artist's ability to create a city which enticed the viewer, and demanded a combination of artistic interpretation, detail, lighting, composition, and mood were also crucial factors.

Product Design & Still Life

This category awarded the best examples of still life and product designs that demonstrated excellence in technical design and execution. The judging criterion for this category was a combination of the intricacy of the design and the technical excellence of the modeling, texturing, and lighting.

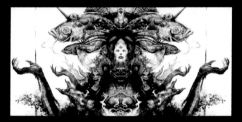

Abstract & Design

This category recognized the most outstanding image that was abstract or predominantly abstract (fractal-generated, 3D or 2D). Here, the artist's design and artistic expression were paramount in creating a piece of artwork that defied categorization and excelled in its pure design and visual appeal.

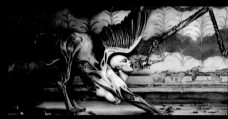

Surreal

This category recognized the best examples of the surreal genre. The judging criterion was to create a feeling of being squeamish about the subject matter, or to create a dreamlike or nightmarish scene which invoked an emotional response ranging from wonder to disturbance.

Storytelling

This category honored the best examples of visual narrative. The judging criterion was the artist's ability to entice the viewer into an unfolding story. Successful entries encompassed technical skill, mood, composition, and, most of all, a compelling narrative.

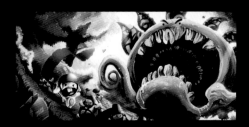

Whimsical

This category awarded the best examples of artwork with a lighthearted feel or in a style that conveys childlike themes. The judging criterion was technical mastery of character or creature design in service of a story. Most Whimsical entries would be ideally suited as illustrations for children's books.

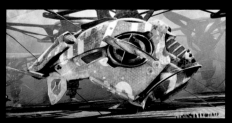

Transport

This category recognized the best examples in transport design, whether exotic vehicle, vintage aircraft, or futuristic ocean-going vessel. The defining quality was the artist's ability to capture and evoke the desire to travel to a place, or by a mode of transport.

Each year we appoint an advisory board to assist in nominating and judging images for the EXPOSÉ awards. All of these people are either leading artists in their own right or are experienced and respected editors and reviewers of digital content and artists.

 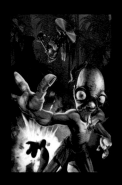 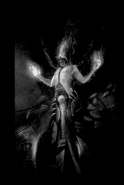 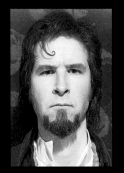 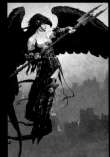

Lorne Lanning is Co-Founder, President, and Creative Director of Oddworld Inhabitants. He serves on the advisory boards of organizations such as Academy of Interactive Arts and Sciences and the CGSociety. Lorne is now in active development on two major projects—his first CG feature film and a CG television series.

Phil Straub is an Art Director and Concept Artist for a wide range of clients including, Electronics Arts, NCSoft, Mattel, Vivendi Universal, and Disney. In addition to overseeing three major Concept/Visual development groups in the games industry, he is also author of the award-winning 'Utherworlds' book.

Brom is a painter of anything that is nasty and bites. For 20 years his work has featured in books, games, and film. His paintings are collected in two art books 'Darkwerks' and 'Offerings'. Recently, he turned his hand to writing a series of illustrated novels. His first novel 'The Plucker' received a Chesley Award.

 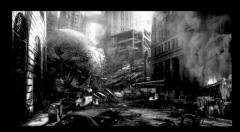 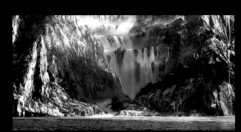

Stephan Martiniere is an internationally-renowned science fiction and fantasy artist and EXPOSÉ 4 Grand Master. An accomplished concept artist, he has worked on movies such as 'Knowing', 'I Robot', 'Star Wars' (Episode II & III), 'Virus', and 'Red Planet'. He is currently Art Director at ID software for the upcoming game 'Rage'.

Max Dennison is the founder of Matte Painting UK Ltd. His work includes: 'The Da Vinci Code', 'Harry Potter and the Goblet of Fire', 'XMen III', 'Superman Returns', 'The Lord of the Rings' trilogy, 'Star Wars: Episode III', 'Black Adder: Back and Forth', 'Wanted', and 'Hitchhikers Guide to the Galaxy'.

 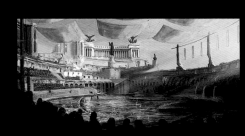

Christopher Sloan is a Senior Editor for National Geographic Magazine, and the magazine's Director of Mission Projects. As a science communicator, Sloan lectures on visual information and science illustration and has contributed to National Geographic books on art, information design, and science

Chris Stoski is a renowned Matte Artist with a list of high-profile projects to his name including: 'Jurassic Park III', 'Star Wars Episode III', 'Indiana Jones and the Crystal Skull', and 'Pirates of the Caribbean: Dead Man's Chest'. He supervised Matte Paintings at ILM on 'Iron Man', 'Lions for Lambs', 'Pirates of the Caribbean: At World's End', and 'Star Trek'

Mark Snoswell | President of the CGSociety

CGSociety.org

Whoosh—that's the sound of another year flashing by. The release of EXPOSÉ is a major annual milestone for us. It's time to pause and reflect on the creative outpouring that gets distilled into these pages. As always I am humbled and in awe of the great artists whose work wins them a place in EXPOSÉ. And as always my heart truly weeps for the many thousands of artists whose work just won't fit.

This past year has been a turning point for the world in many ways—much of which is not good. Almost two years ago we had a global economic collapse. Now the growing effects of the global downturn are taking its toll on whole countries. Oil pollution is a permanent fixture on all the news sites with oil spewing without end into the Mexican Gulf. And yet the creative spirit that fills these pages is stronger than ever!

This is also the year that James Cameron's 'Avatar' brought to life a whole world and people. The vibrancy and enchantment of this film propelled it far beyond any other film ever made. For digital art it has been a milestone—never before have we been able to bring so much fantasy to life. More than ever the technology is getting out of the way and freeing us to realize such a vast scope and depth of the fantasy's and stories locked within our minds. There are a great number of artists in our community that contributed to this landmark film—and we salute you all. Please—I encourage you all to seek out the artists whose work appears on these pages. You will find most of them have portfolios on the CGSociety web site. The stories these images reveal are well worth following up on.

If I could I would offer praise for every image and artist individually. But, life is short, and I feel another year accelerating towards me at alarming speed. I can't finish without reaching out and selecting just a few personal favorites. I was moved by Lukase Pazera's image 'Dog of Zone II' (page 193). This image was a Master award winner, but more than that it's a hauntingly powerful image that pulls you into a world beyond the image. The second image I want to mention is Bobby Chiu's 'Beam me up Scottie' (page 219). This image graces the computer desktop of my daughter Ariana—much to the amusement of everyone who sees it. Thank you Bobby, Lukase and all of the artists here. You and your work enrich our lives.

Ballistic Media divisions

Ballistic Publishing
www.BallisticPublishing.com

View All Entries
www.BallisticPublishing.com/bsw/

The CGSociety (The Society of Digital Artists)
www.CGSociety.org

Artist Portfolios
http://portfolio.CGSociety.org

CGSociety Events
http://events.cgsociety.org

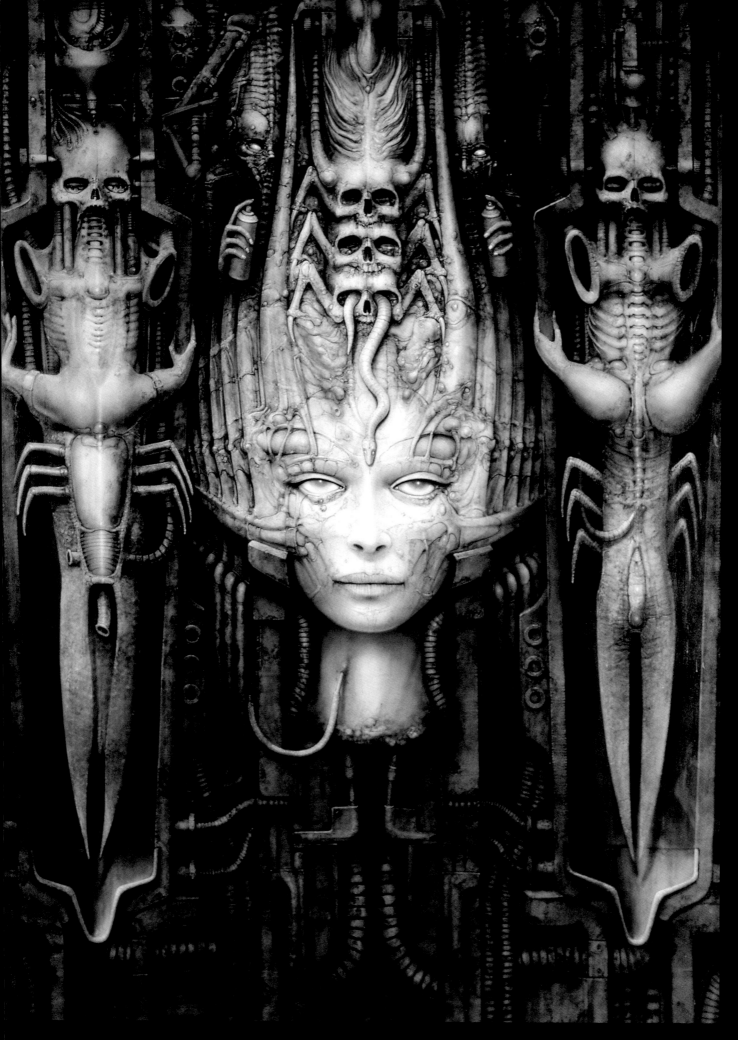

GRAND MASTER
H. R. Giger

Li II, 1973-74
Acrylic and indian ink on paper on wood, 200 x 140cm

GRAND MASTER

H. R. Giger © 2010 DanaFrank.com

Each year EXPOSÉ awards the title of Grand Master to an artist who has had a major influence through their craft. By that measure, the EXPOSÉ 8 Grand Master has had an overwhelming influence on not just the art world, but also on movie-going audiences of any science-fiction movie made since 'Alien' in 1979. H. R. Giger's most memorable works fall into the category of "biomechanoid" art, describing the merging of human anatomy with mechanical elements in dark, sexual, nightmarish worlds inspired by the night terrors that haunted him from childhood. Giger continues to create, and in 1998 he opened the doors to the Giger Museum in the Swiss town of Gruyères in a 400-year-old castle.

Background

H. R. Giger is recognized as one of the world's foremost artists of Fantastic Realism. Born in 1940 to a chemist's family in Chur, Switzerland, he moved in 1962 to Zurich, where he studied architecture and industrial design at the School of Applied Arts. By 1964 he was producing his first artworks, mostly ink drawings and oil paintings, resulting in his first solo exhibition in 1966, followed by the publication and world-wide distribution of his first poster edition in 1969. Shortly after, he discovered the airbrush and, along with it, his own unique freehand painting style, leading to the creation of many of his most well-known works—the surrealistic Biomechanical dreamscapes, which formed the cornerstone of his fame. From the onset of his career, Giger also worked in sculpture and had an abiding desire to extend the core elements of his artistic vision beyond the confines of paper into the 3D reality of his surroundings. To date, more than 20 books have been published about Giger's art and in recent years he has also been honored in a series of major museum retrospectives.

Dark visions

Giger found inspiration for his art in the night terrors he experienced beginning in his childhood. Painting his dark and disturbing visions provided a kind of self-therapy: "I don't have these dreams anymore. Well, maybe I do but I don't make sketches of them. I draw some of the things I have dreamt. For example, there's a rather unpleasant dream where I am stuck in a tomb and the only way out is a very narrow passage. There are huge stones and I am totally stuck. I cannot move at all. So terrifying, claustrophobic nightmares. I made some drawings of them, and every time I look at them, it puts me back into that terrible situation. Looking at these pictures bothers me so much, that I don't look at them anymore."

Giger's first step into film

By the mid-1970s, Giger's work was being exhibited internationally, and came to the attention of Chilean filmmaker Alejandro Jodorowsky, thanks to writer Dan O'Bannon who brought him to an exhibition. Jodorowsky was working on a film adaptation of Frank Herbert's 'Dune', and enlisted Giger to produce concepts for the production: "Jodorowsky said that he would like me to try some designs— I could create a whole planet, and I would have a completely free hand." Despite completing numerous paintings for the project between 1975 and 1976, the film didn't go into production. In 1979, when Dino de Laurentiis acquired the rights to 'Dune', he sought Giger out as the production designer for the movie, and set his sights on Ridley Scott as Director. Giger's work focused on Harkonnen furniture pieces (which now reside in the Giger Museum). 'Dune' was shelved again, only to be revived in 1984 by Director David Lynch. Despite Giger's work on the previous productions, Lynch opted for a new creative team to deliver his vision. Dan O'Bannon was not so easily diverted: "His paintings had a profound effect on me. I had never seen anything that was quite as horrible and at the same time as beautiful as his work. And so I ended up writing a script about a Giger monster."

Giger's Alien

In 1977, Dan O'Bannon was preparing to pitch his script titled 'Alien' to Brandywine Productions. Having already worked with Giger previously, he commissioned him to create two paintings (the Face Hugger and the Alien Eggs) for the sum of $1,000. "The idea that came to me looking at Giger's paintings," explained O'Bannon, "was if somebody could get this guy to design a monster movie, you'd have something completely original, that no one had seen before."

Dan O'Bannon showed a copy of Giger's first book, 'Necronomicon', to Director Ridley Scott, who was fascinated by Giger's artwork: "Initially, Giger wanted to design the creature from scratch. However, I was so impressed with his 'Necronom IV' and 'V' paintings from the 'Necronomicon' book that I insisted he follow their form. I had never been so sure of anything in my life. They were quite specific to what I envisioned for the film, particularly in the unique manner in which they conveyed both horror and beauty." Giger adds: "I only had a short time to draw the monster which I did in Zurich, then Ridley said: 'Please come over [to England] for three or four weeks'. I was there for seven months." While there, Giger worked in a custom-built workspace on Stage "B" at Shepperton Studios where he created the full-size Alien sculpture. Giger also created countless designs, besides the Alien itself, including the Face Hugger, the Chestburster, the Derelict, the Space Jockey (Giger also airbrushed the entire set and "space jockey" by hand), the Egg Chamber, and planet environments. Giger's work earned him the 1980 Oscar for the Best Achievement in Visual Effects for his designs of the film's title character, including all the stages of its lifecycle, and the extraterrestrial environments. In Ridley Scott's introduction to H.R. Giger's Film Design book, he said: "I found the experience of working with Giger to be a very positive one. He threw himself into the project with great intensity, and he was always very ready to listen and come up with useful solutions to the daily challenges which we face on such a complex film. I have come close to working with Giger on a couple of projects since we did ALIEN and it is my strong hope that we can work together again in bringing something special to the screen."

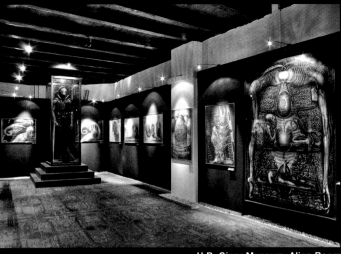

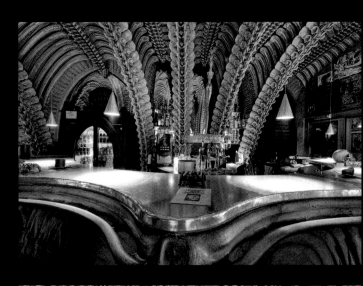

H.R. Giger Museum, Alien Room

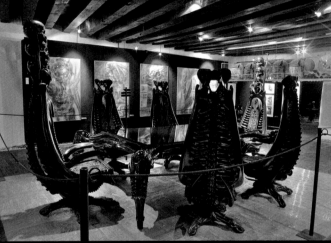

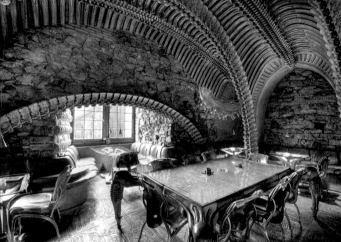

H.R. Giger Museum, Harkonnen Room

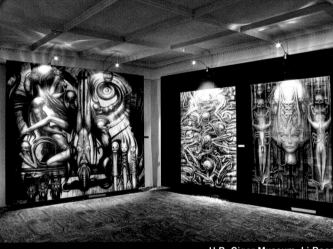

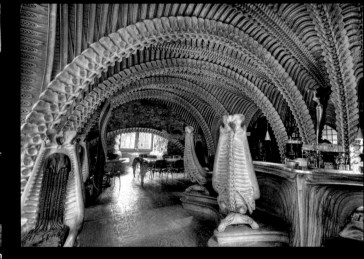

H.R. Giger Museum, Li Room

Photo © 2010 Matthias Belz

Giger Museum

Giger ventured into permanent exhibition in 1998 with the creation of his own museum, renovated from a 400 year old, medieval chateau high atop a hill in the picturesque Swiss town of Gruyères. It houses the most comprehensive permanent display of his paintings, sculptures, furniture and film designs, spanning his entire career: "I am aware it is unusual for an artist to open his own museum," admits Giger. "My reasons for that decision were practical. First of all, there is a continuous demand by collectors and admirers of my art to see the original creations on display. Galleries and museums could only exhibit some of

my art for a couple of months a year. Most of the time the majority of my paintings sat all in storage all year around. And now that my art is on permanent display, I can control their environment and ensure that the rooms and surroundings are suitable."

Giger Bar

The Giger Museum also houses the Giger Bar which opened in 2003 incorporating a womb-like interior with giant skeletal arches covering the vaulted ceiling. Together with the bar's fantastic furniture and the stone floor with its engraved hieroglyphs, it evokes the building's

original medieval character and gives the bar a cathedral-like feeling. It took Giger and his team four years to complete the bar. "I built much more on this bar with my own hands than any of the other ones I had designed", Giger explains. "I was fascinated with concrete, because I felt that an antique building such as this needed stone, aged stone, so I used a mixture of cement and fiberglass to achieve a rock gray color for most of the interior elements. The bar is like the 'dot on the i' of the museum. It illustrates that art is something you can use in everyday life. 'Art in use' or 'Useful art'."

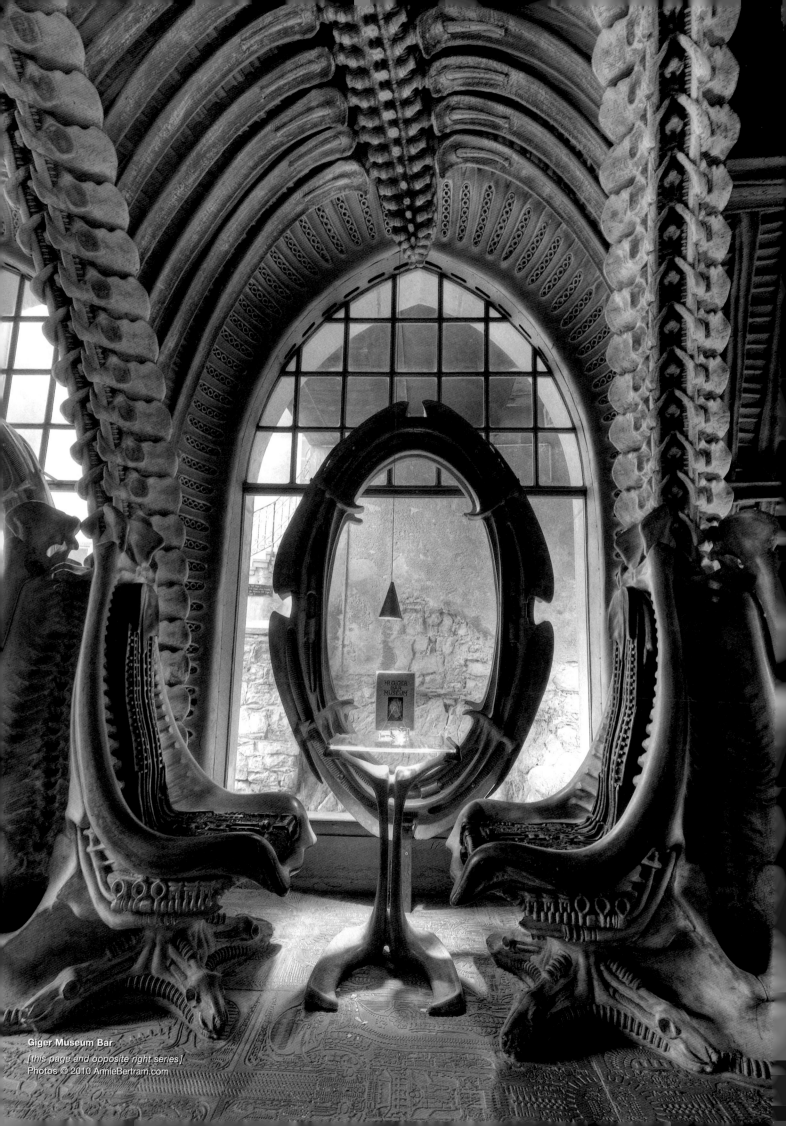

Giger Museum Bar
[this page and opposite right series]
Photos © 2010 AnnieBertram.com

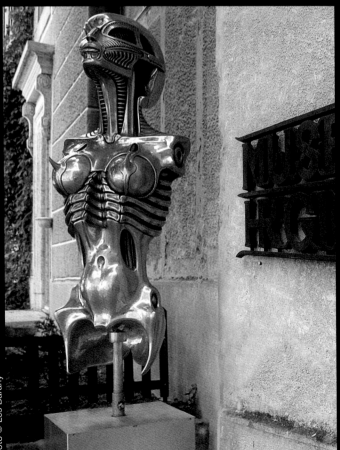

Photo © Matthias Belz

Birthmachine, 1999 Aluminum, 200 x 140 x 25cm, Edition of 7

NYC XXVII, 1981 Acrylic and indian ink on paper, 100 x 70cm

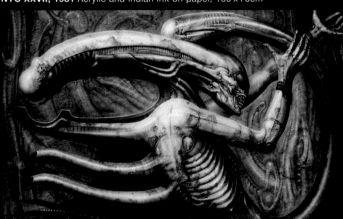

Necronom IV, 1976 Acrylic on paper on wood, 100 x 150cm

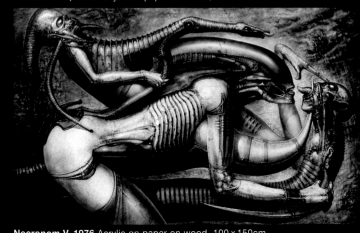

Necronom V, 1976 Acrylic on paper on wood, 100 x 150cm

Photo © Les Barany

Biomechanoid, 2002 Aluminum, 180 x 50 x 50cm, Edition of 6

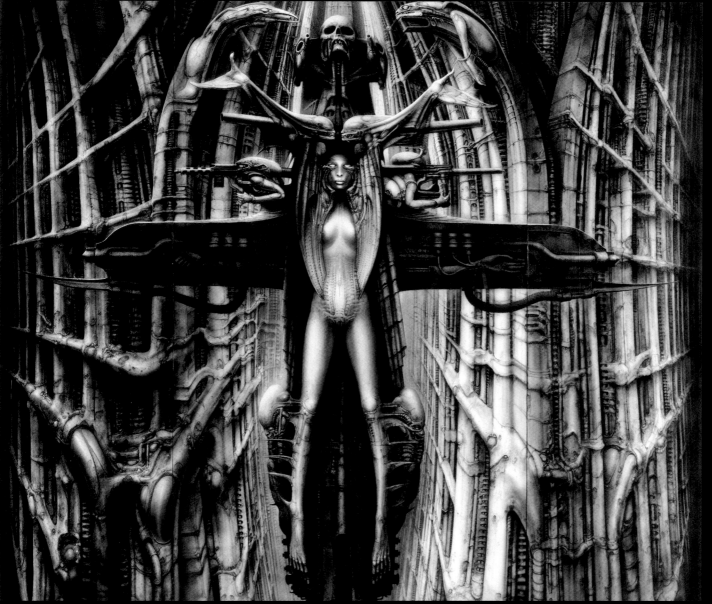

The Spell I, 1973-74 Acrylic and indian ink on paper on wood, 240 x 280cm

Giger's art

"In the beginning I worked on these [large] paintings on a roll of paper, which I fixed with two nails on the wall and I spread out just the top so I could work on it. I had to sit to work with the airbrush so I set my elbows on my knees, so they wouldn't move. Then, I worked on a 70cm area, the upper part of the painting, and when I finished that part I would roll it up some more and fix the nails higher, moving the painting up to work on the next part. I would repeat this until I was through with the painting from top to bottom. And so, I never really had an overview of the whole painting till the end when the paper was rolled out completely. That's when I finally saw what it looked like. While I was painting, I had only the surface I was working on in my view, I couldn't see the rest of the painting surface, which was rolled up. This process of working makes the painting have less of a fixed perspective. If you work on something and you can see the whole image in front of you all the time, then you have to stand on a chair to work on the top area of a large painting, then to work on the middle area, on the figures, while standing up, and the lower portion of the the image sitting down. The result is more of a perspective happening in the painting. But the way I worked, that didn't happen. In my paintings where there is a perspective, it is because

the painting has been changed later, after I finished it. I built a kind of lift in my home, so I could move the paintings up and down on a hydraulic lift through a slit I cut in the floor. That way, I was able to work in my usual way, sitting down with my elbows on my knees, one section at a time, after the whole work was completed, and be able to overwork the painting."

"My paintings express all kinds of themes. Most of the time there is no 'message' attached to them. However, some paintings I made because they strongly express my feelings. For example, The 'Birthmachine' is a slice through of a Walther P38 pistol. You see the barrel, and instead of bullets there are little men with large glasses. They sit there with a weapon in their hands. A weapon with a magazine, and in that magazine are more pistols with magazines. This means that you can go deeper and deeper. With this, I wanted to illustrate the enormous population explosion which is happening. All unpleasant things come from the fact that there are too many people on this planet."

Though Giger's reputation began with the confronting and explicit images springing from his subconscious, it was never his intention: "It was never in my mind to try

to shock people with that sort of imagery," explains Giger, "I like my work very much, and I'm free to realise my dreams. Everyone has the freedom to think what they want about them. I have a different feeling for things than most people. To me, skulls are something pleasant—skulls and bones. As a child, I liked to play with skulls, or with ribs and spines. But I paint these things because I see beauty in them. For me, skulls or bones are something aesthetic. Through the act of painting I transform the ugly into something beautiful or acceptable."

The H.R. Giger Museum
www.HRGigerMuseum.com
Château St. Germain
1663 Gruyères
Tel.: +41 26 921 22 00
email: info@hrgigermuseum.com

The Official Homepage & Webstore
www.HRGiger.com
www.hrgiger-webstore.com

The Giger Archive & Work Catalog
www.littlegiger.com
www.gigerworkcatalog.com

U.S.A. Publisher
www.giger.com

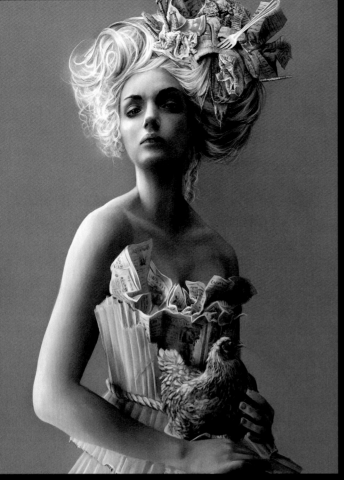

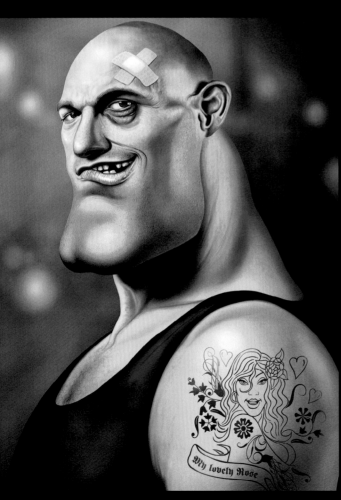

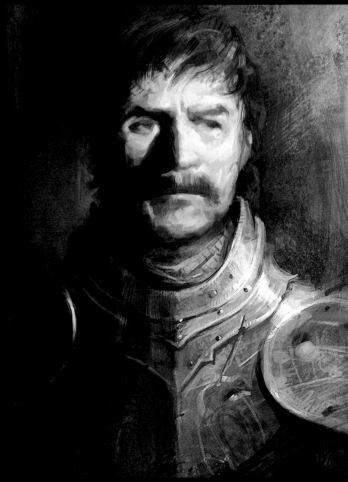

Glamour
Painter, Photoshop
Marta Dahlig-Orłowska,
POLAND
[top]

Tim Jawbone's Tattoo
Photoshop
Fernando Ferreiro,
SPAIN
[above]

Sweet Whispers
Photoshop
Cris de Lara,
ArtePixel Illustration, CANADA
[top]

Night Knight
Photoshop
Daniel Clarke
SOUTH AFRICA
[above]

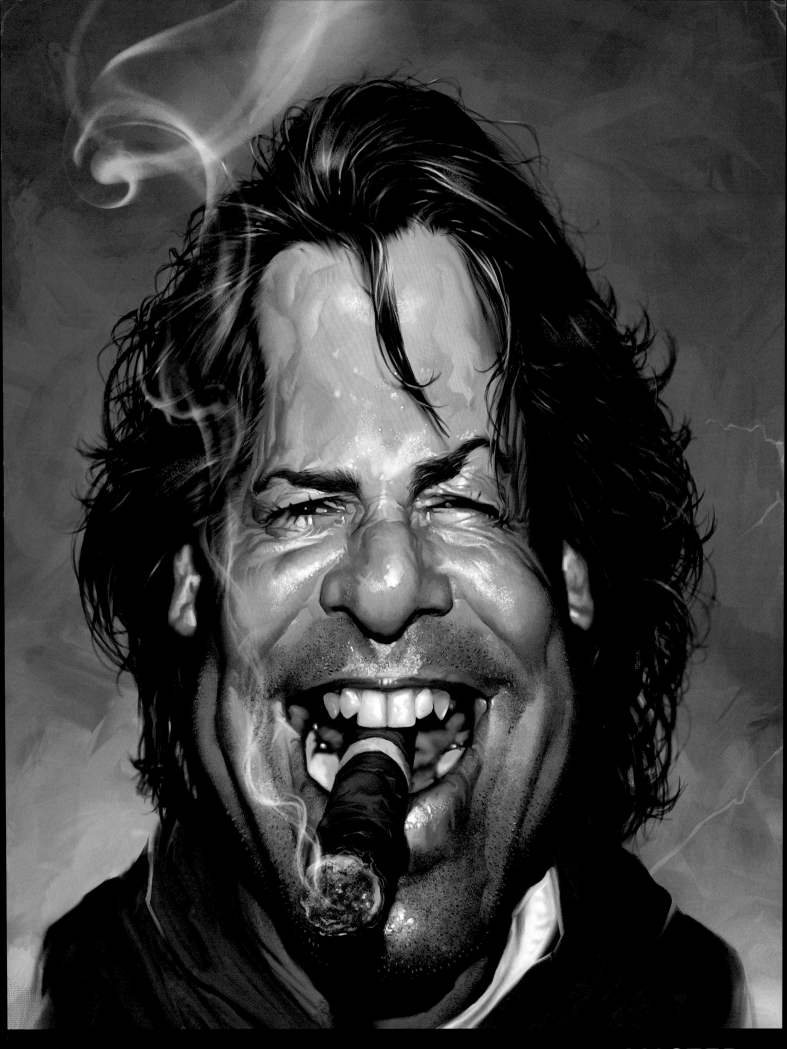

MASTER
Portrait (Painted)

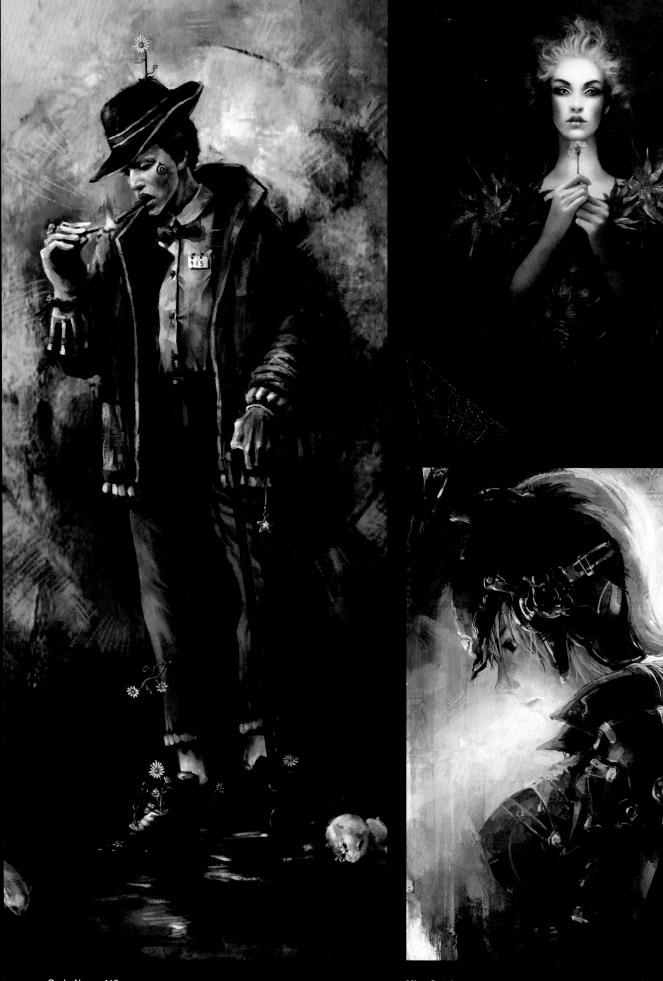

Code Name 415
Photoshop
Chuan Zhong, CHINA
[above]

Miss October
Photoshop
Lea Løvberg, DENMARK
[top]

Chevaleresse
Photoshop
Chang-kyu Jin, BlueSide
SOUTH KOREA *[above]*

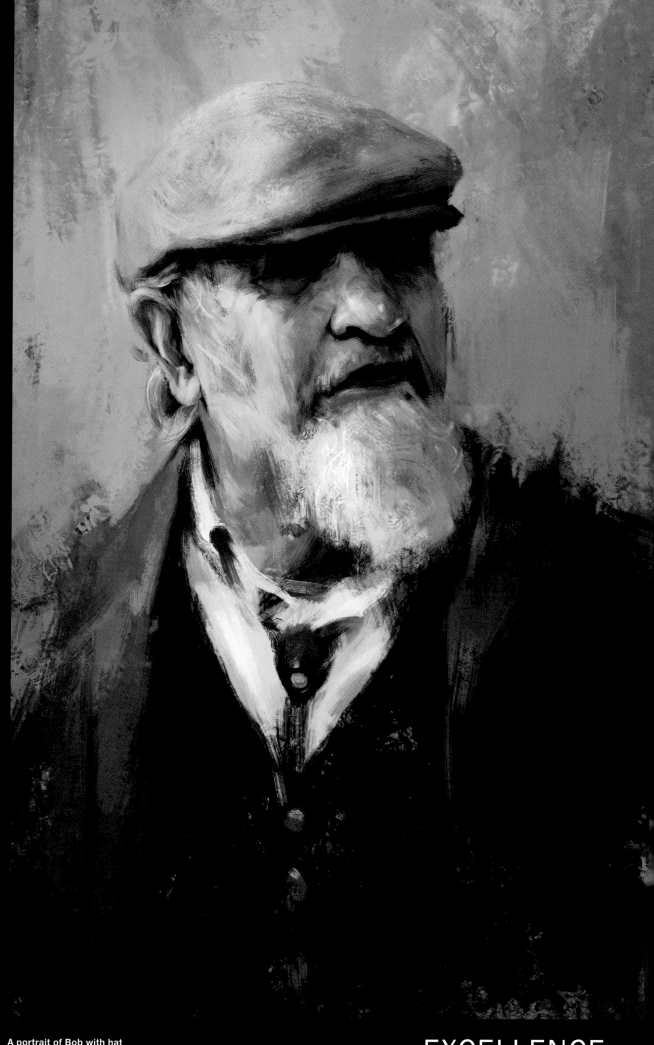

A portrait of Bob with hat
Photoshop
Wei-Che Juan, USA

EXCELLENCE
Portrait (Painted)

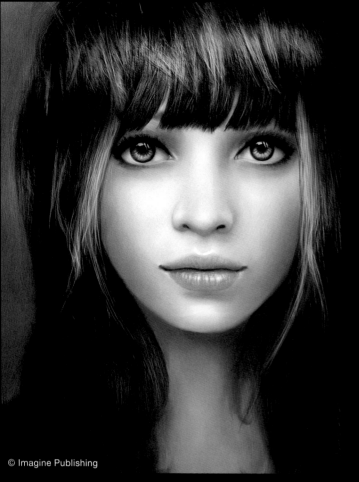

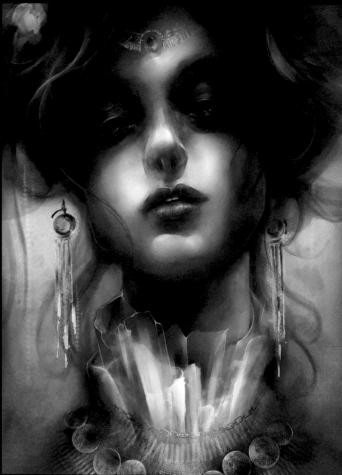

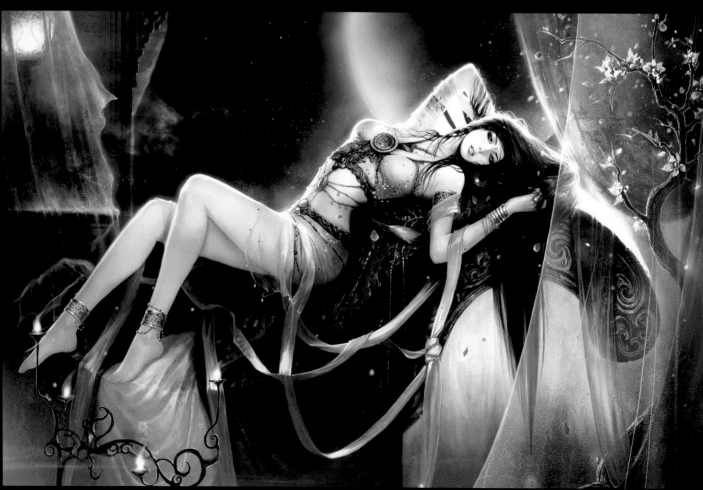

Portrait
Painter, Photoshop
Client: Imagine Publishing
Anne Pogoda, GERMANY [top]

Honey trap
Photoshop
Wenjun Lin, CHINA
[above]

Lust
Photoshop
Inspired by: Gustav Klimt's 'Judith
Te Hu, USA [top]

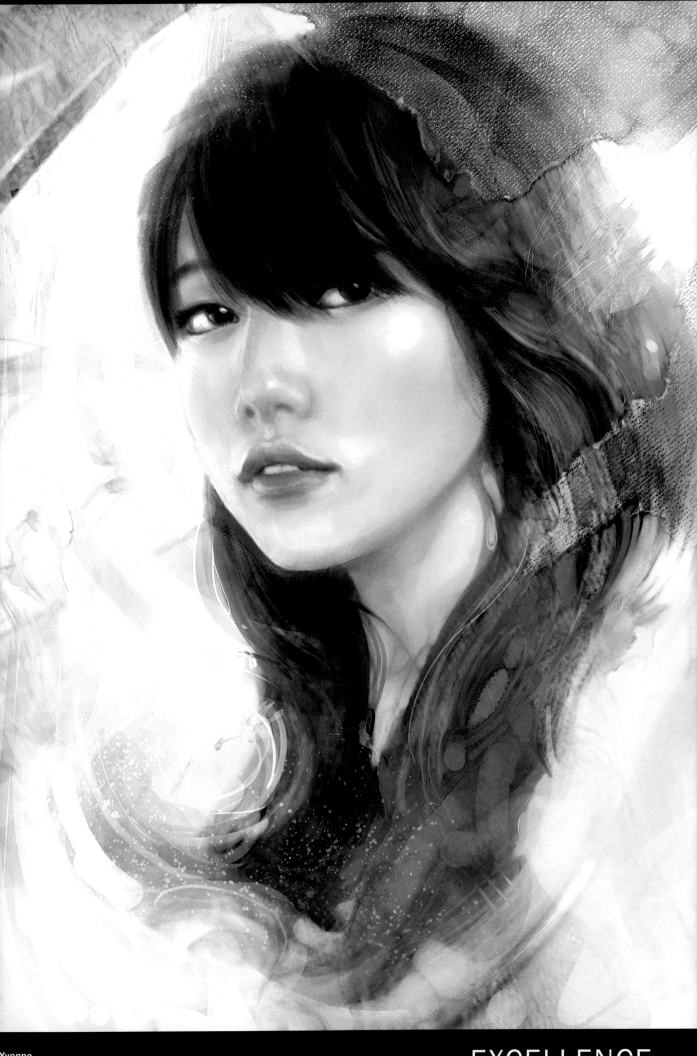

Yvonne
Photoshop
Ivan Tao, The One Academy,
MALAYSIA

EXCELLENCE
Portrait (Painted)

Portrait (Painted)

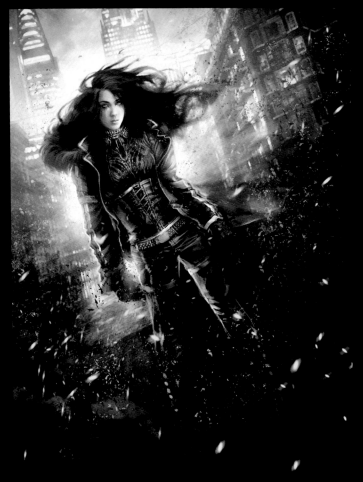

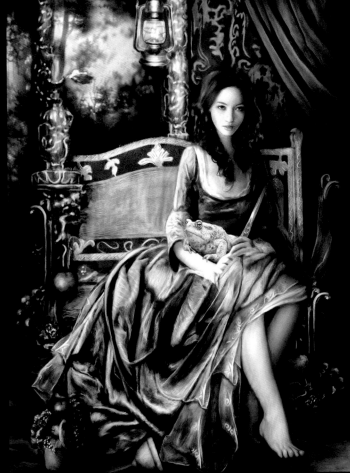

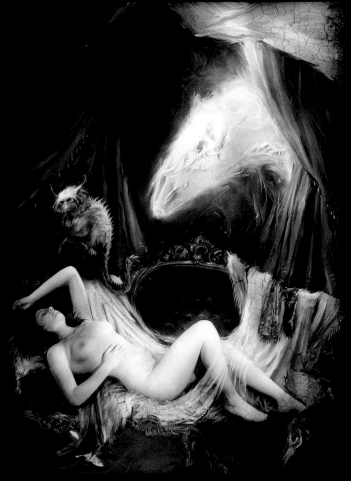

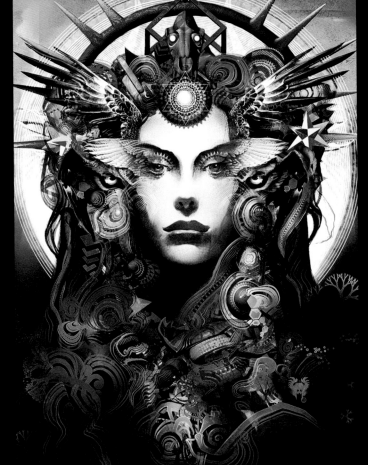

Kira Dust Crow
Photoshop
Helen Rusovich,
UKRAINE
[top]

Nightmare
Photoshop, ArtRage
Bruno Wagner,
FRANCE
[above]

Ruined
Photoshop, Painter
Anne Pogoda,
GERMANY
[top]

Goddess of Dust
Painter
Client: ImagineFX magazine
Andrew 'Android' Jones, USA
[above]

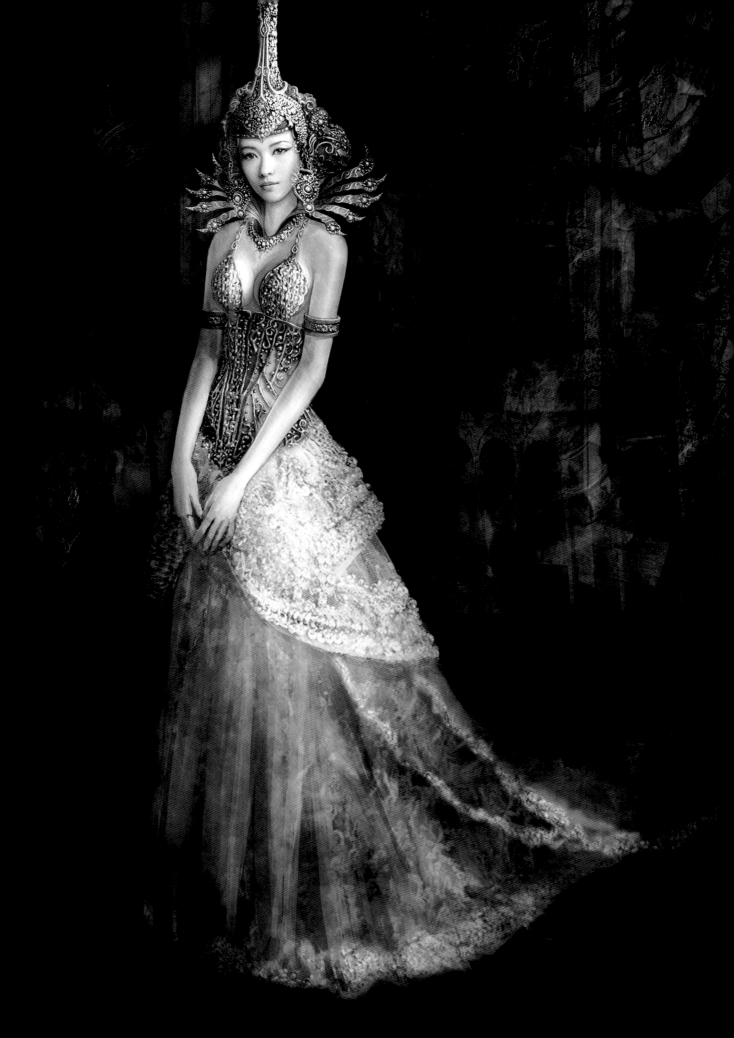

Turandot
Photoshop, Painter
Chen Ziyi, CHINA

EXCELLENCE
Portrait (Painted)

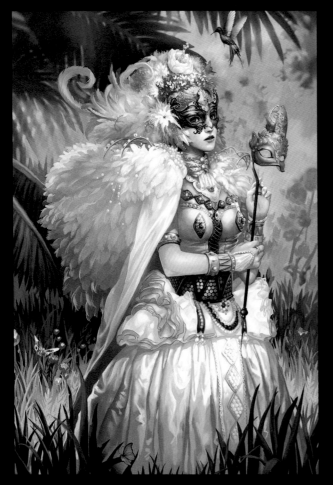

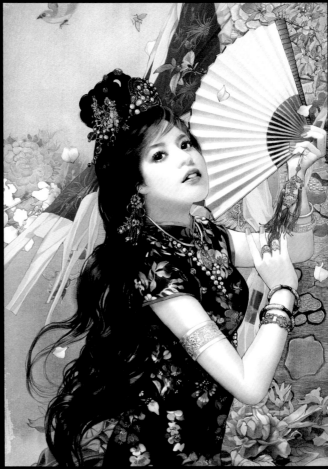

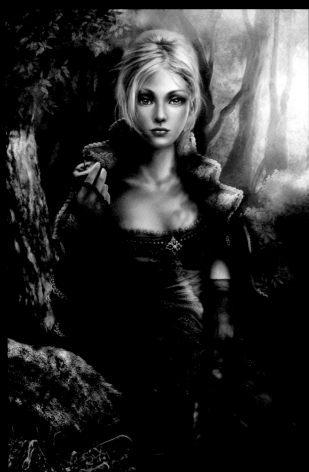

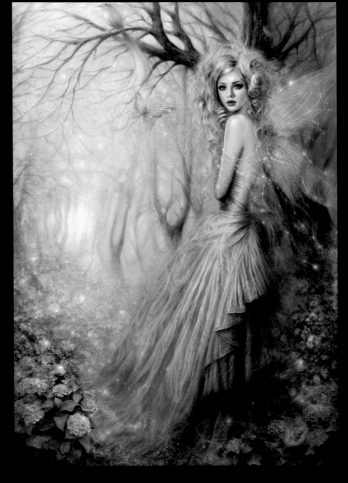

Venetian gala suit
Photoshop
Lei Sheng, Shanghai Popcap
Software Co .,Ltd , CHINA *[top]*

Purple Gaze
Photoshop
Donglu Yu, CANADA
[above]

Beauty with fan
Painter, Photoshop
Der Jen, TAIWAN
[top]

Lost Girl
Photoshop
Ruoxing Zhang, CHINA
[above]

Yi ethnic minority group
Painter, Photoshop

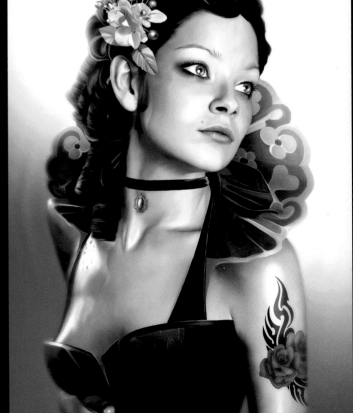

Haruna
PaintTool SAI, Photoshop
Viet-My Bui, AUSTRALIA
[top]

Pink
Photoshop
Ruoxing Zhang, CHINA
[above]

Be my Valentine
Photoshop, Painter
Omar Diaz, SPAIN
[top]

Romantique
Photoshop
Camilla Drakenborg,
SWEDEN *[above]*

Cheree Furiosa: 8 pool
Painter, Photoshop
Art director: Pascal HV
J.S Rossbach, FRANCE *[right]*

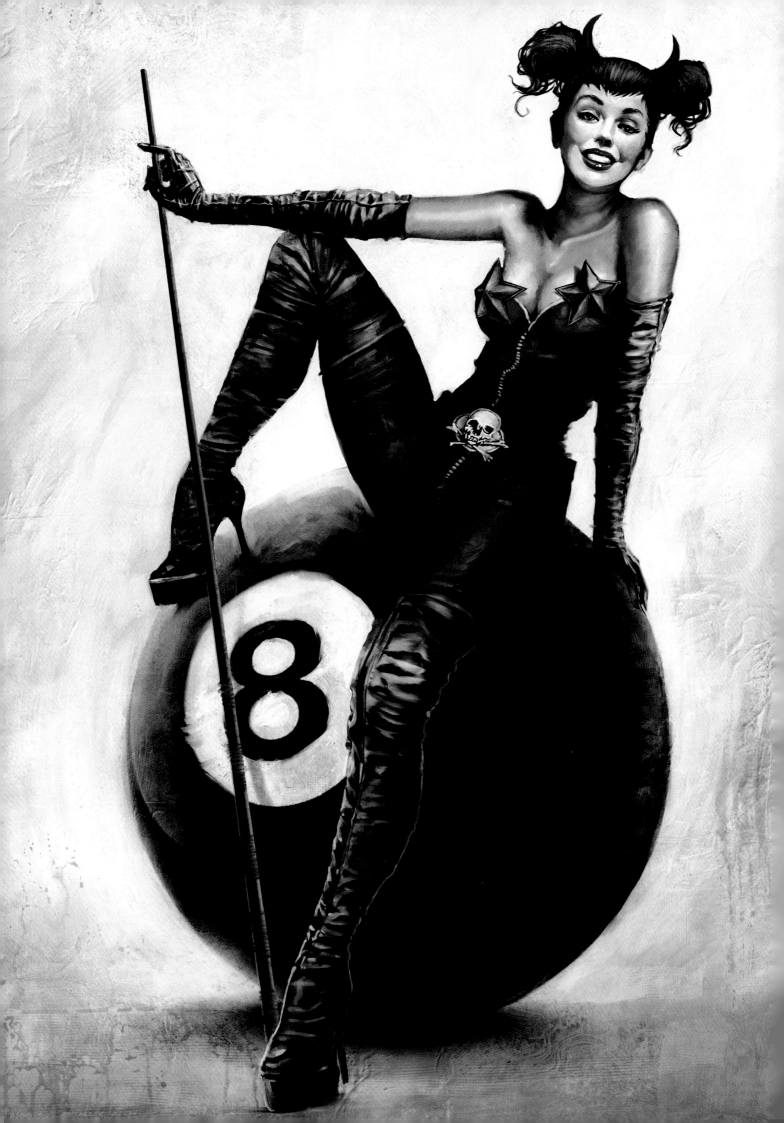

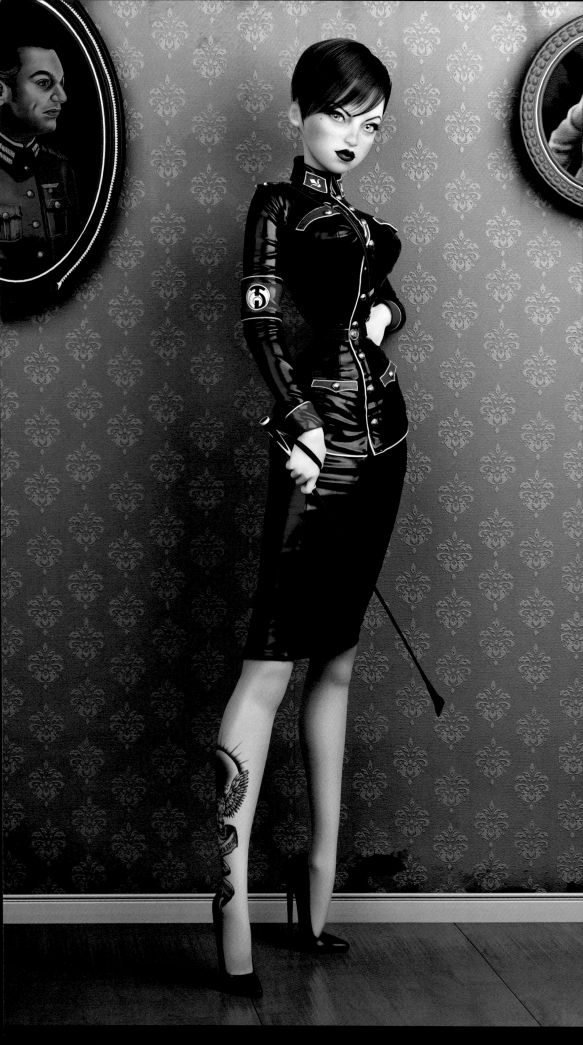

MASTER
Portrait (Rendered)

Twisted Dolls: Mistress Lili
3ds Max, ZBrush, Photoshop
Rebeca Puebla, SPAIN

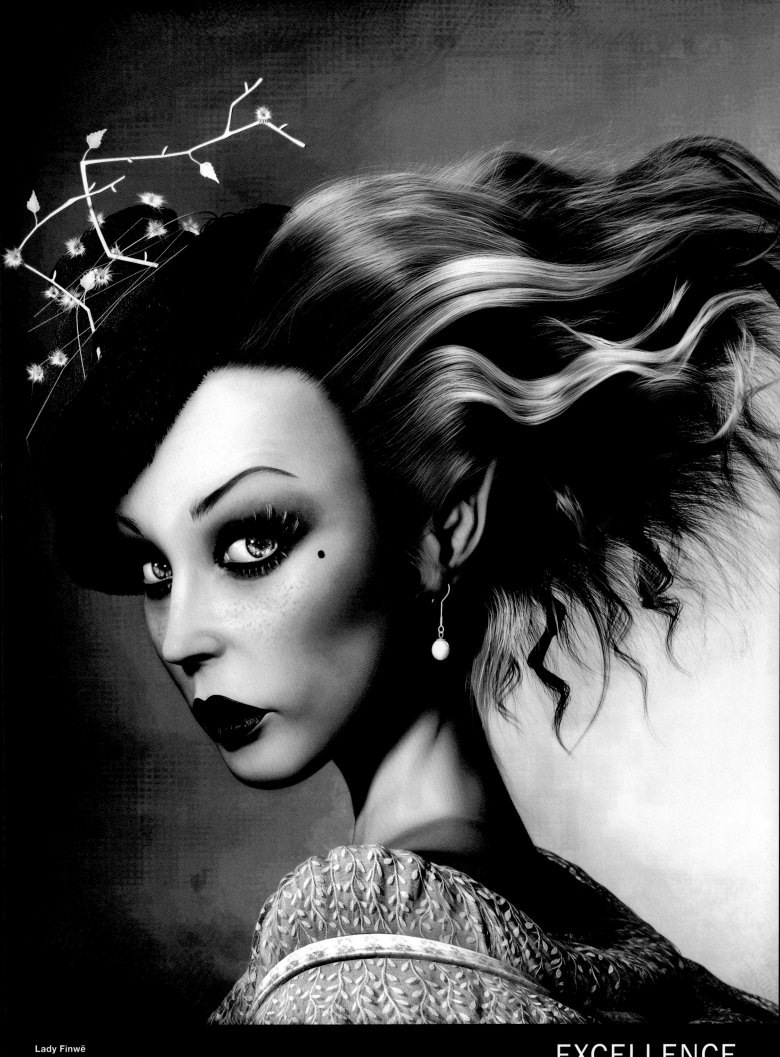

Lady Finwë
3ds Max, ZBrush, After Effects
Inspired by: Eugenio Recuenco
Pascal Ackermann, FRANCE

EXCELLENCE
Portrait (Rendered)

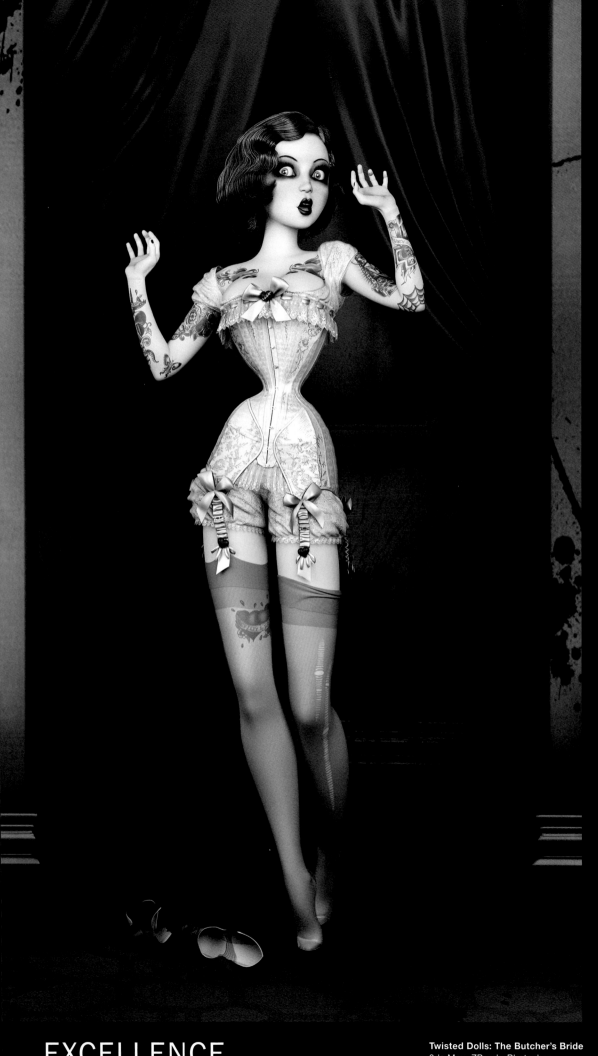

EXCELLENCE
Portrait (Rendered)

Twisted Dolls: The Butcher's Bride
3ds Max, ZBrush, Photoshop
Rebeca Puebla, SPAIN

Guan Guan
3ds Max, Photoshop, ZBrush, mental ray
Jian Xu, Ubisoft Shanghai, CHINA

EXCELLENCE
Portrait (Rendered)

Portrait (Rendered)

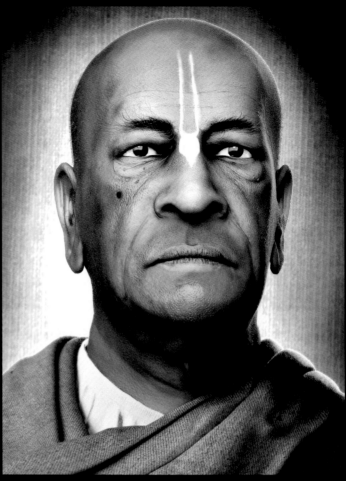

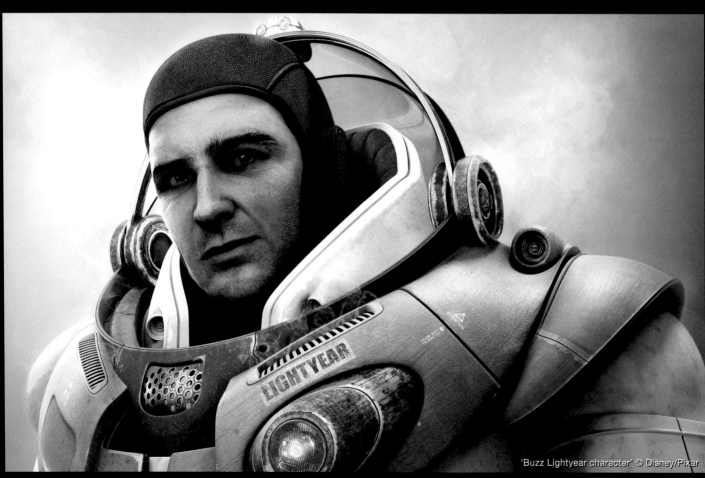

'Buzz Lightyear character' © Disney/Pixar

Blue
ZBrush, Photoshop
Jack Zhang, CANADA
[top]

Buzz
3ds Max, mental ray, ZBrush, Photoshop
Inspired by: Disney/Pixar's Buzz Lightyear character
Raoni Nery, BRAZIL *[above]*

Bhaktivedanta Swami
Mudbox, LightWave 3D, modo, Photoshop
Milivoj Popovic, Lemonade3d, CROATIA
[top]

Vlad
3ds Max, mental ray
Olivier Ponsonnet,
FRANCE *[right]*

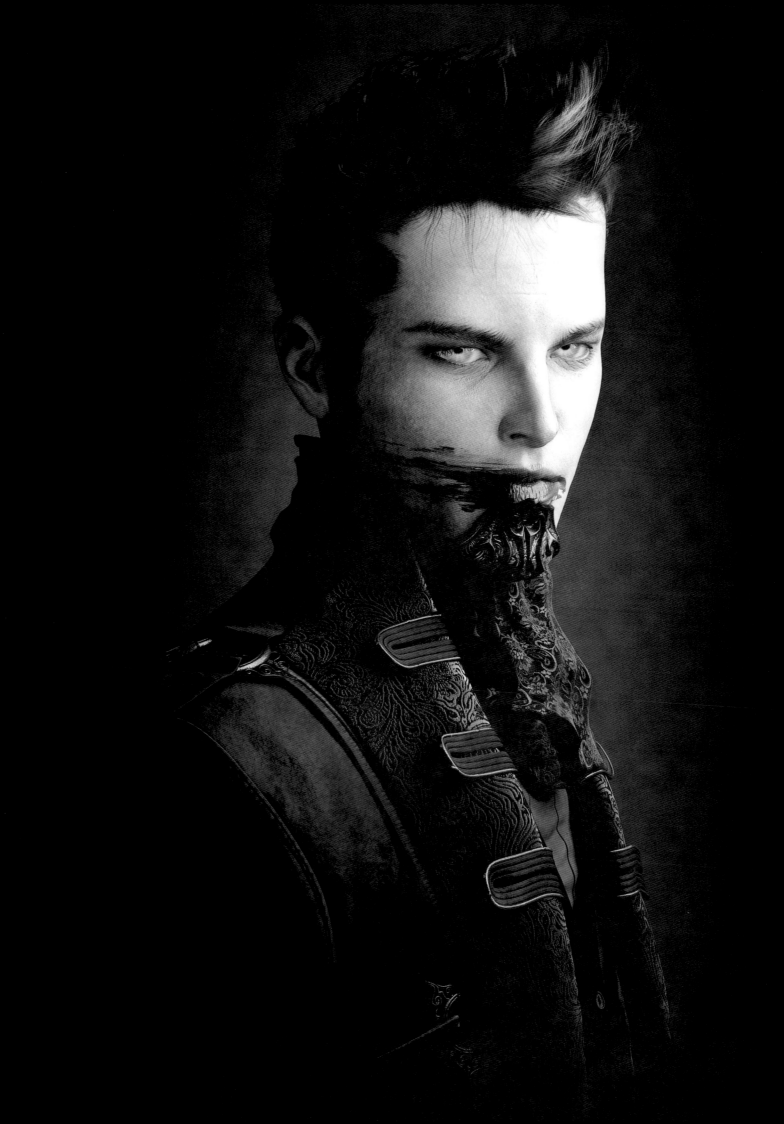

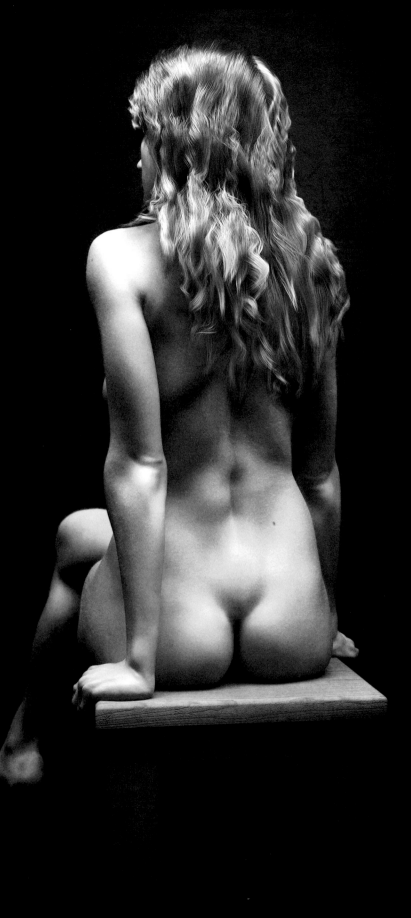

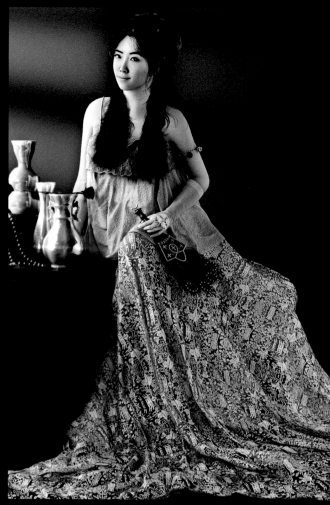

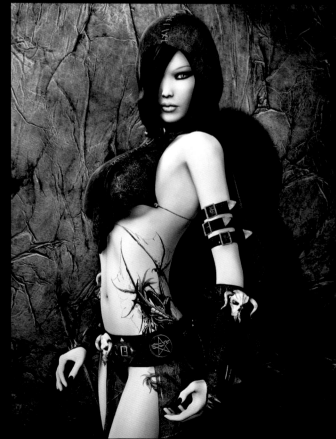

Girl on a chair
3ds Max, ZBrush, mental ray, Photoshop
Alexander Tomchuk, UKRAINE
[above]

A portrait
3ds Max, BodyPaint 3D,
Photoshop, mental ray
Rui Shen, CHINA *[top]*

Geneveve
DAZ Studio, Photoshop
Angela Newman, USA
[above]

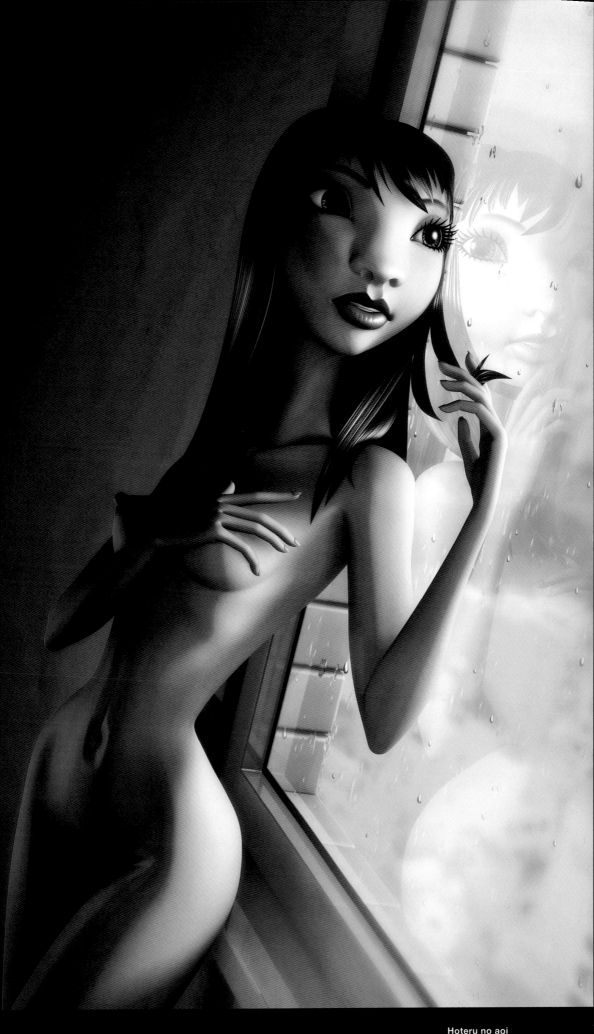

Hoteru no aoi
3ds Max, Photoshop
Andrew Hickinbottom,
GREAT BRITAIN

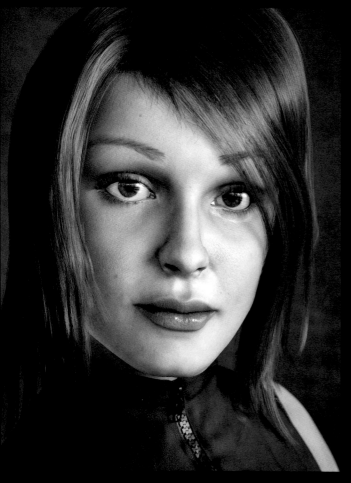

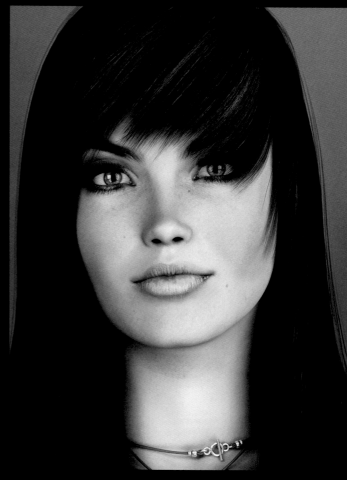

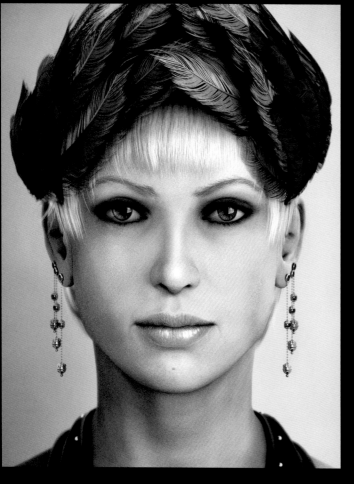

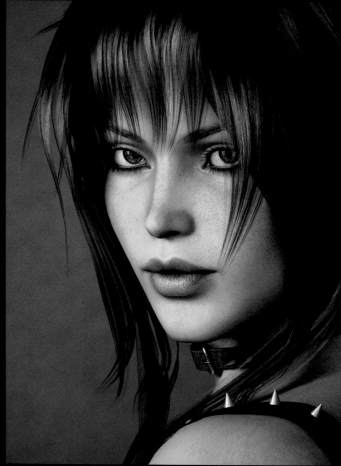

Pink Assassin
ZBrush, CINEMA 4D, fryrender
John Strieder, GERMANY
[top]

Birdieblond
Maya, mental ray, ZBrush, Photoshop
Ilhan Yılmaz, TURKEY
[above]

Laura
3ds Max, V-Ray, Poser
Adam Potter, AUSTRALIA
[top]

Red
3ds Max, V-Ray, Poser
Adam Potter, AUSTRALIA
[above]

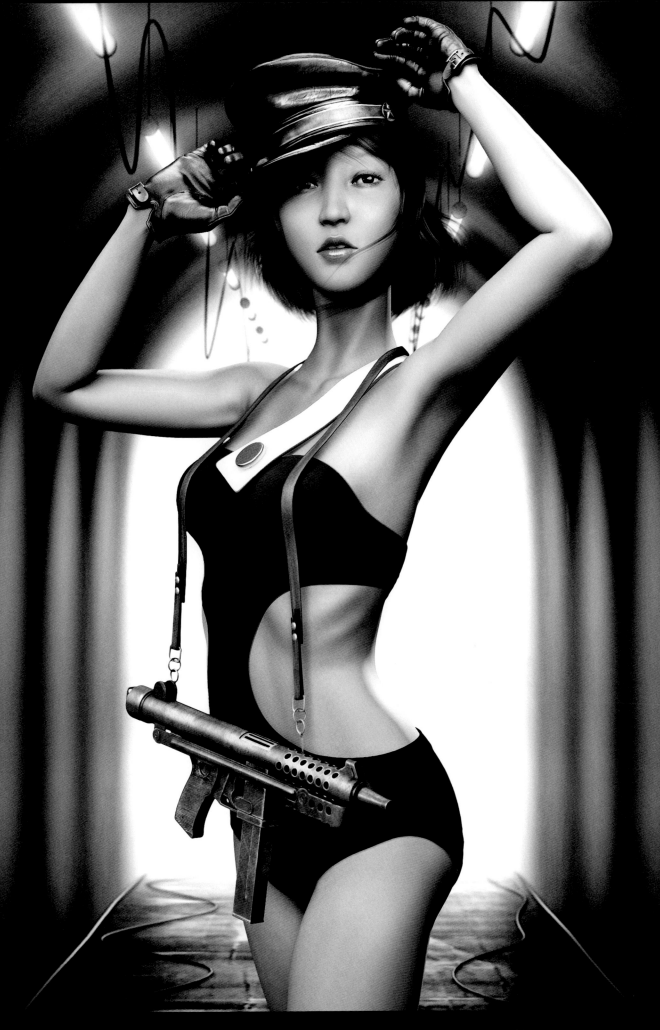

S-Force

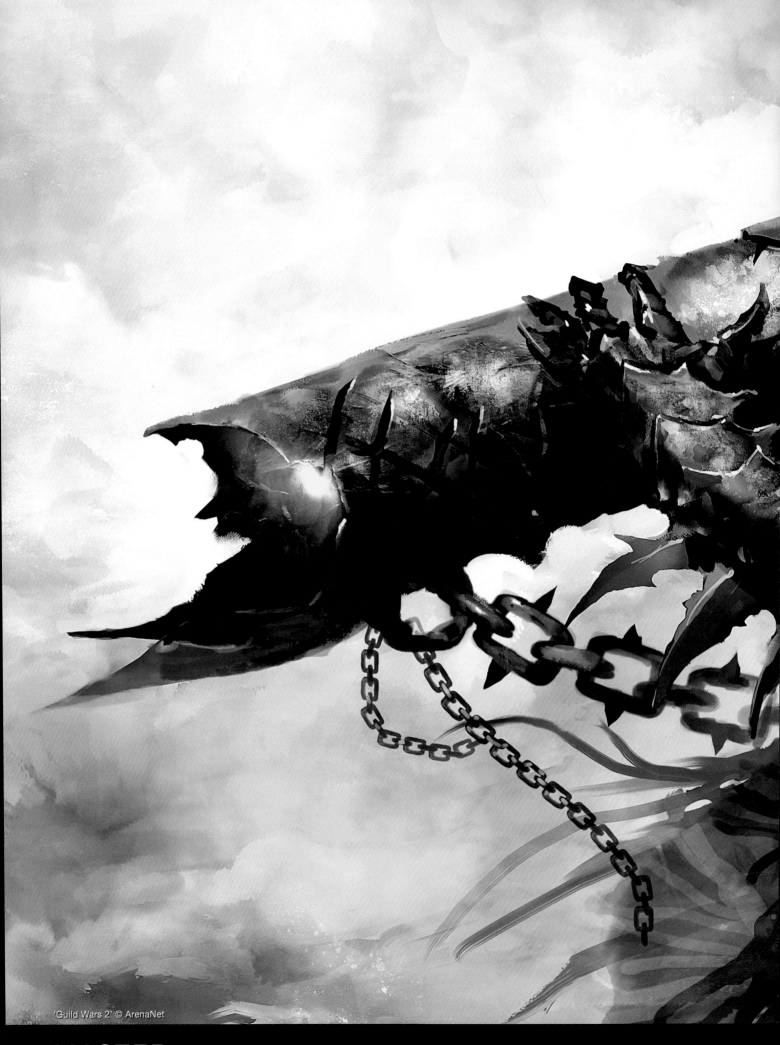

MASTER
Game Art

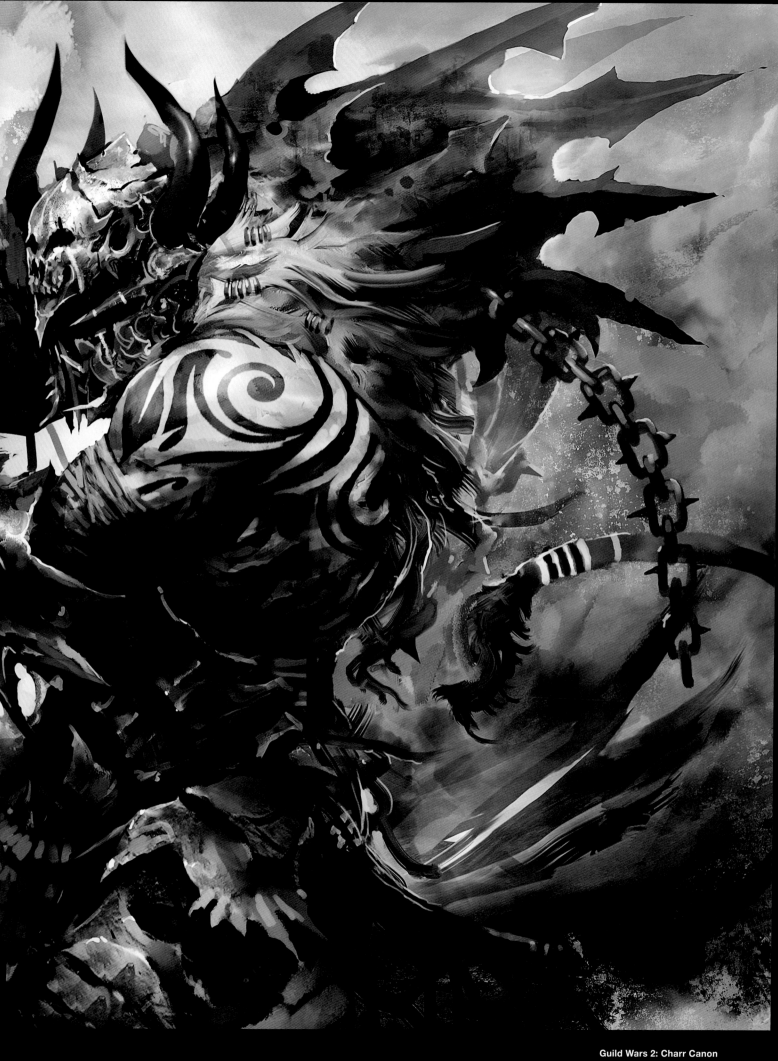

Guild Wars 2: Charr Canon
Photoshop
Kekai Kotaki, ArenaNet, USA

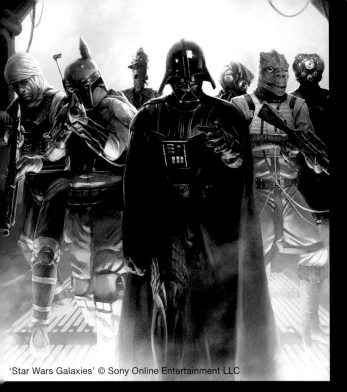

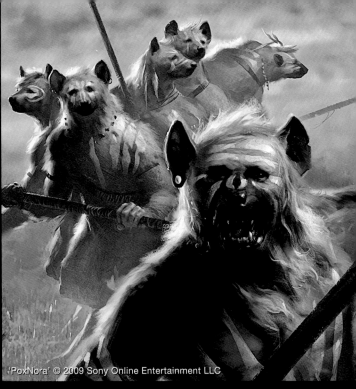

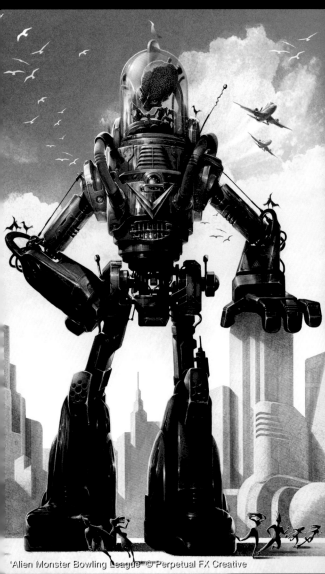

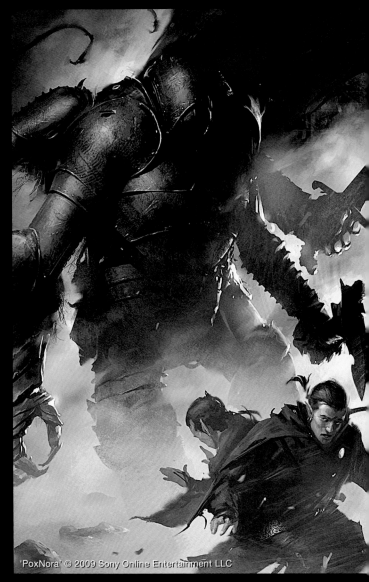

Star Wars Galaxies: Sith Death Mark
Photoshop
Art Director: Roger Chamberlain
Client: Sony Online Entertainment LLC
Darren Tan, SINGAPORE *[top]*

Alien Monster Bowling League:
Alien-Robot
Photoshop
Client: Perpetual FX Creative
Haitao Su, Suhaitao Studio, CHINA *[above]*

PoxNora: Hzeanid Pack
Photoshop
Art Director: Bryan Rypkowski
Client: Sony Online Entertainment LLC
Slawomir Maniak, POLAND *[top]*

PoxNora: Aspect of Violence
Photoshop
Art Director: Bryan Rypkowski
Client: Sony Online Entertainment LLC
Slawomir Maniak, POLAND *[above]*

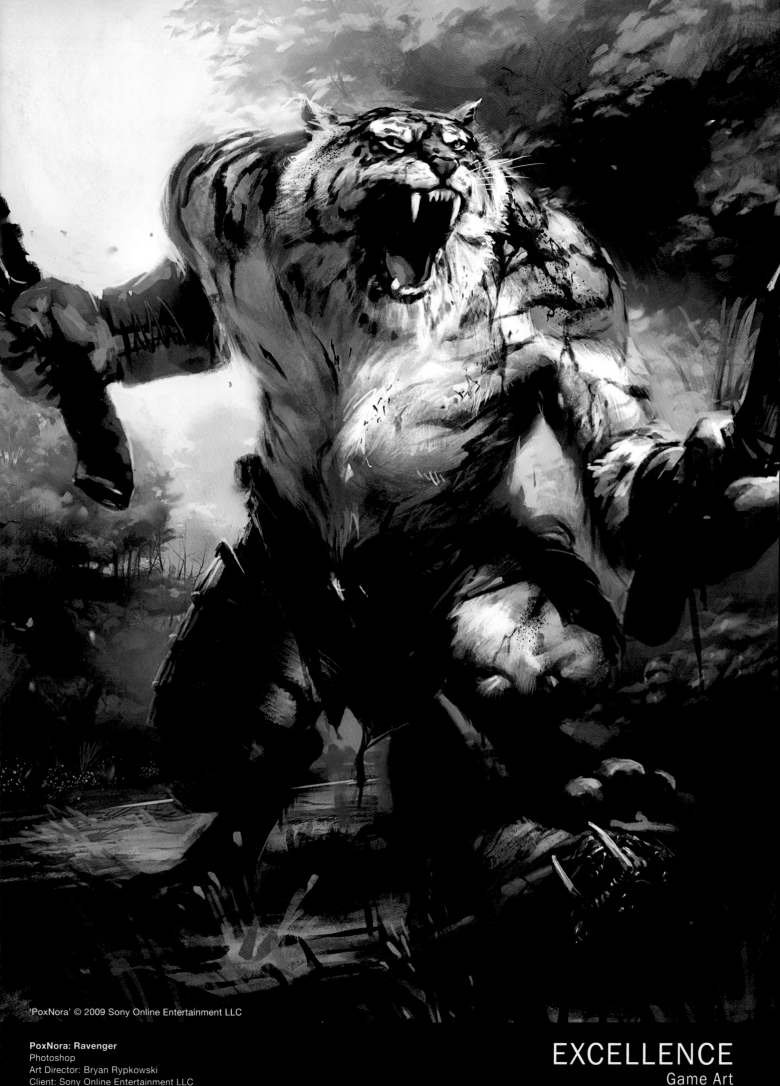

PoxNora: Ravenger
Photoshop
Art Director: Bryan Rypkowski
Client: Sony Online Entertainment LLC

EXCELLENCE
Game Art

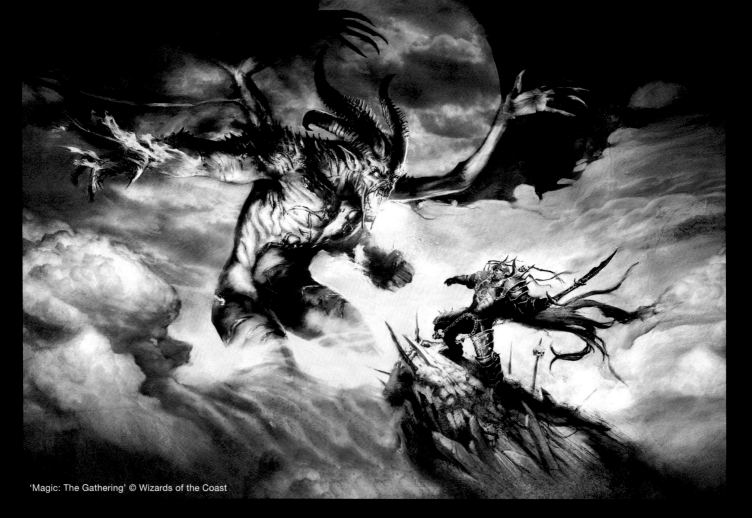

'Magic: The Gathering' © Wizards of the Coast

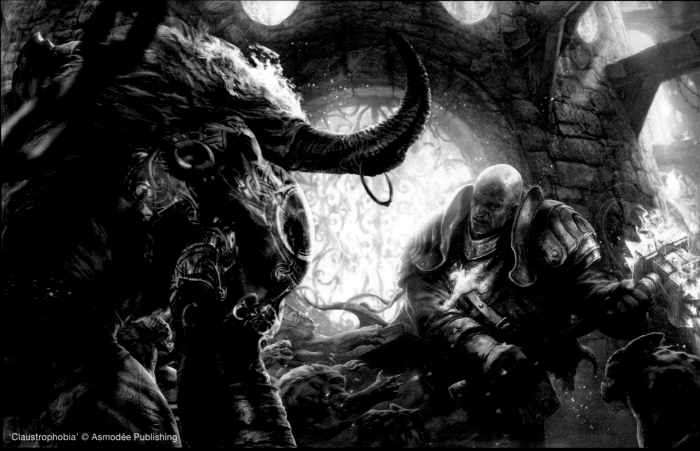

'Claustrophobia' © Asmodée Publishing

Magic: The Gathering: Korlash Vs Tombstalker
Painter, Photoshop
Client: Wizards of the Coast
J.S Rossbach, FRANCE
[top]

Claustrophobia: box cover
Photoshop
Art Directors: CROC & Geoffrey Picard
Client: Asmodée Publishing
Aleksi Briclot, FRANCE *[above]*

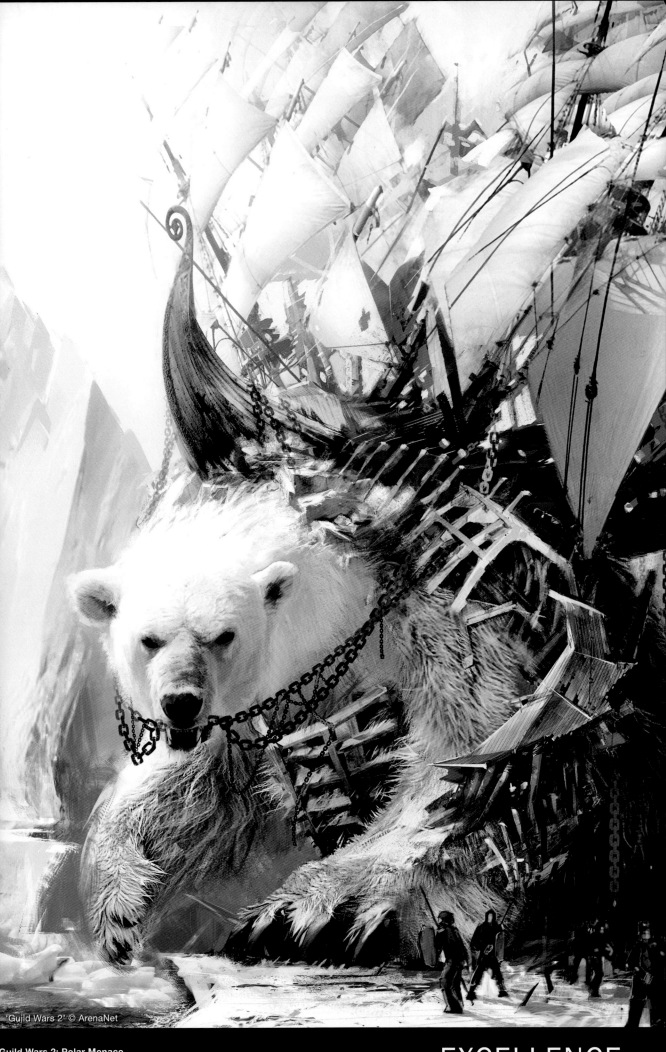

'Guild Wars 2' © ArenaNet

Guild Wars 2: Polar Menace
Photoshop
Daniel Dociu, ArenaNet,
USA

EXCELLENCE
Game Art

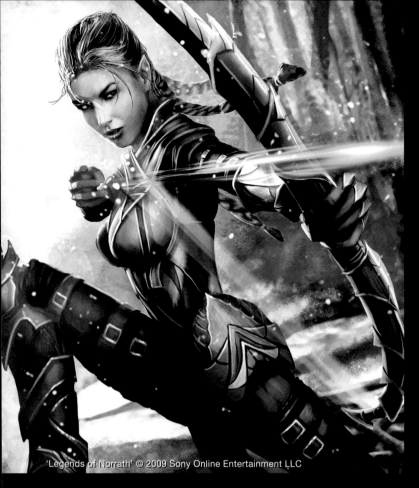

'Legends of Norrath' © 2009 Sony Online Entertainment LLC

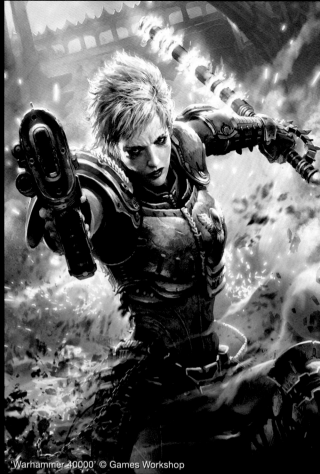

'Warhammer 40000' © Games Workshop

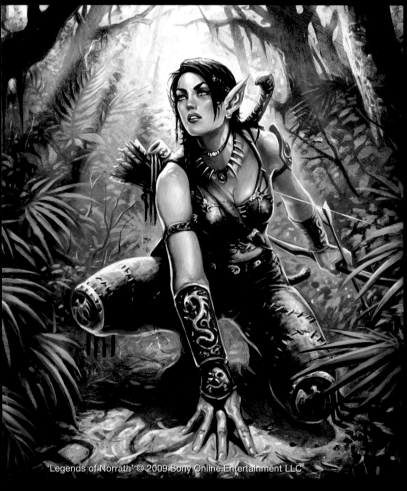

'Legends of Norrath' © 2009 Sony Online Entertainment LLC

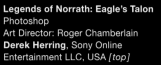

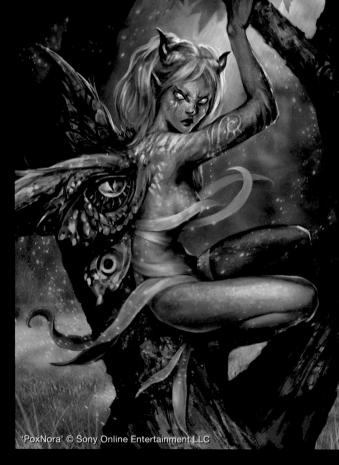

'PoxNora' © Sony Online Entertainment LLC

Legends of Norrath: Eagle's Talon
Photoshop
Art Director: Roger Chamberlain
Derek Herring, Sony Online
Entertainment LLC, USA *[top]*

Legends of Norrath: Overland Ranger
Photoshop
Art Director: Roger Chamberlain
Client: Sony Online Entertainment LLC
Efrem Palacios, USA *[above]*

Warhammer 40000: Enforcer
Photoshop
Client: Games Workshop
Marek Okon, POLAND
[top]

PoxNora: Fairy Trickster
Photoshop
Art Director: Bryan Rypkowski
Client: Sony Online Entertainment LLC
Michele Chang, MALAYSIA *[above]*

'Guild Wars 2' © ArenaNet

Guild Wars 2: Wrekka'
Photoshop
Daniel Dociu, ArenaNet,
USA

EXCELLENCE
Game Art

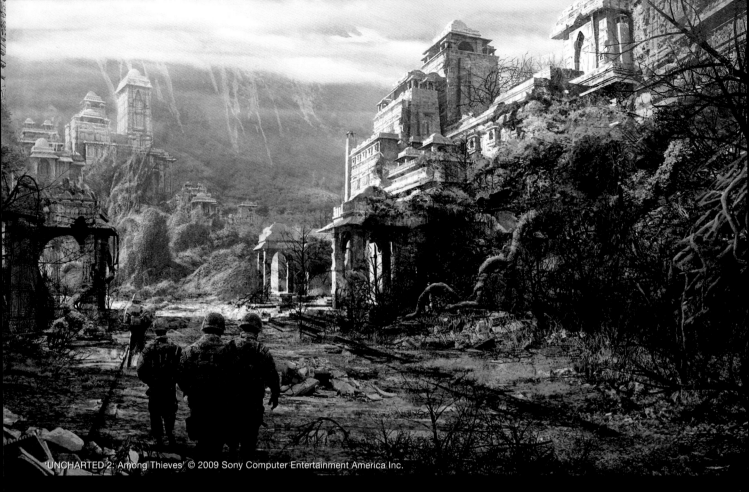

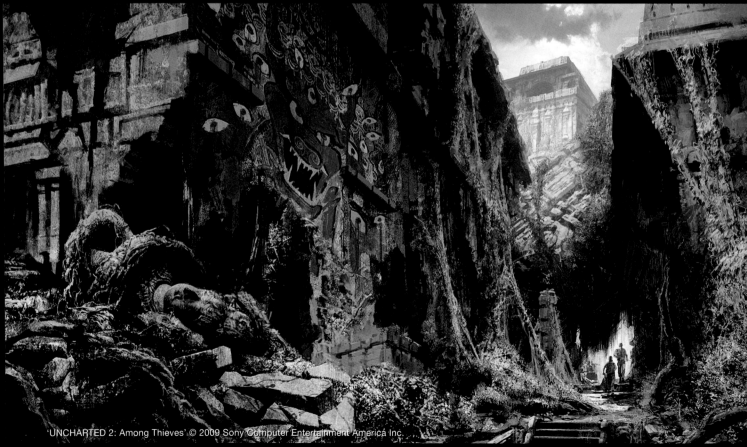

UNCHARTED 2: Among Thieves
(Shambhala ground view)
Photoshop
Robh Ruppel, Naughty Dog, USA

UNCHARTED 2: Among Thieves
(Shambhala alley)
Photoshop
Robh Ruppel, Naughty Dog, USA

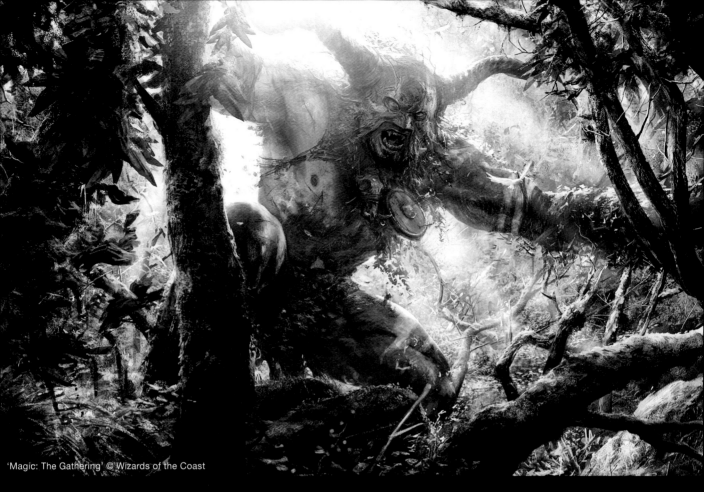

'Magic: The Gathering' © Wizards of the Coast

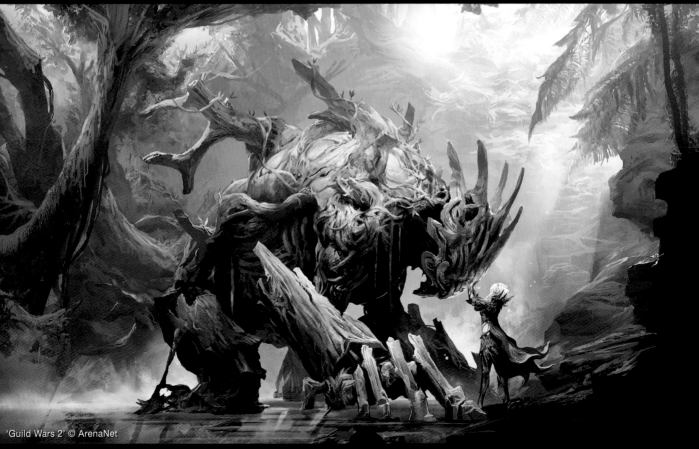

'Guild Wars 2' © ArenaNet

Magic: The Gathering (WildWood Titan)
Photoshop
Art Director: Jeremy Jarvis
Client: Wizards of the Coast
Aleksi Briclot, FRANCE *[top]*

Guild Wars 2: Caithe
Photoshop
Kekai Kotaki, ArenaNet,
USA
[above]

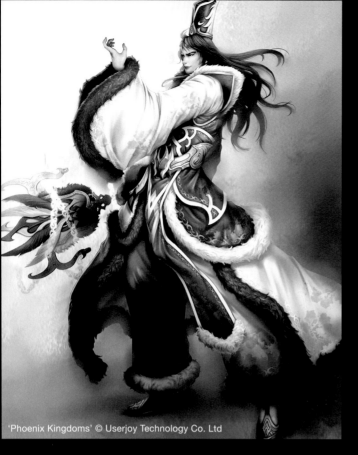

'Phoenix Kingdoms' © Userjoy Technology Co. Ltd

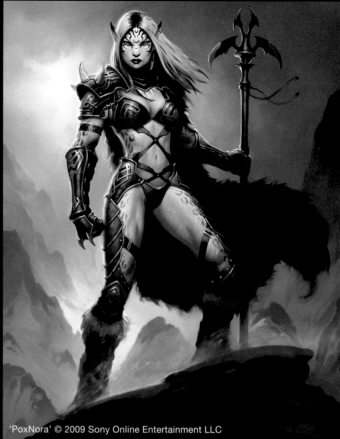

'PoxNora' © 2009 Sony Online Entertainment LLC

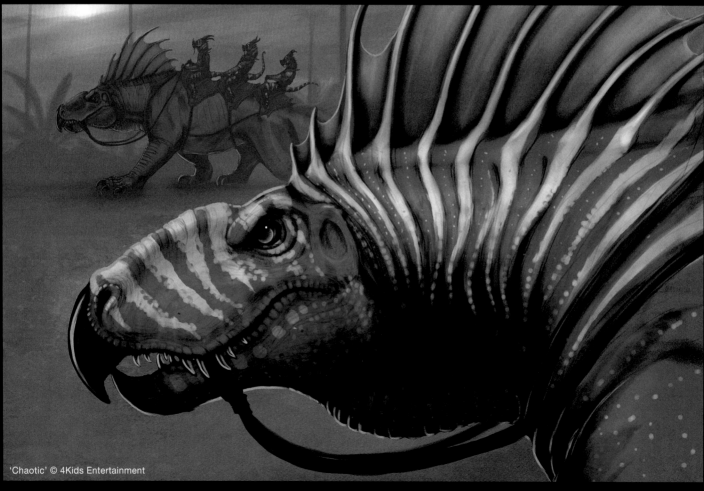

'Chaotic' © 4Kids Entertainment

Phoenix Kingdoms: Online Sima Yi
Painter, Photoshop
Wan Hsienwei, Userjoy Technology Co. Ltd.,

Chaotic Trading Card Game: Fooshbah
Photoshop
Stone Perales, 4Kids Entertainment,

PoxNora: Lonx Hunt Leader
Photoshop
Art Director: Bryan Rypkowski

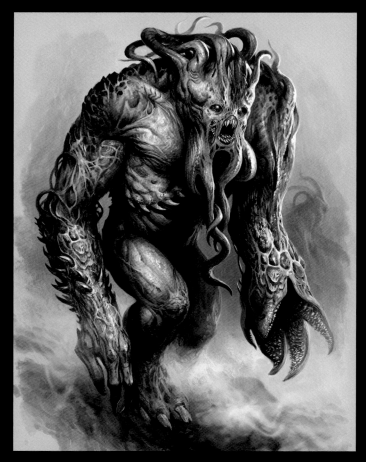

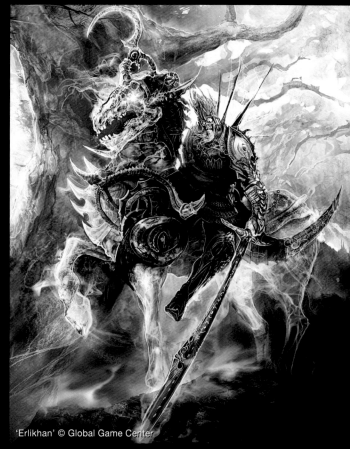

'Erlikhan' © Global Game Center

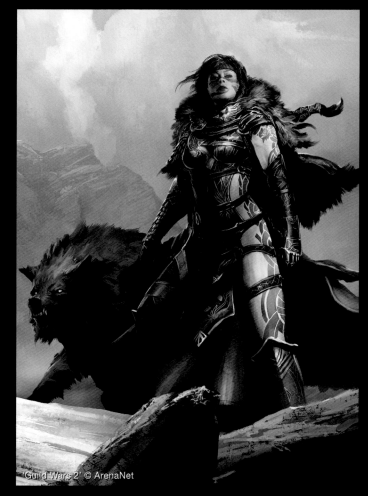

'Guild Wars 2' © ArenaNet

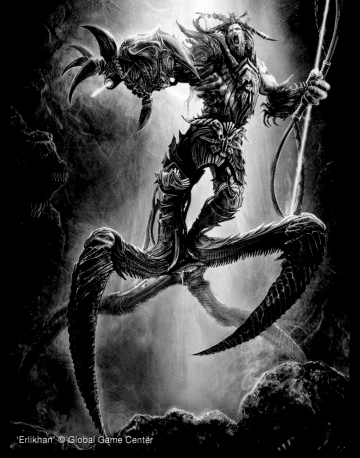

'Erlikhan' © Global Game Center

Amfisbena: Monster
Photoshop
Jakub Kasper,
POLAND
[top]

Guild Wars 2: Eir
Photoshop
Kekai Kotaki,
ArenaNet, USA
[above]

Erlikhan: Melam Lugal
Photoshop
Client: Global Game Center
Ertaç Altınöz, TURKEY
[top]

Erlikhan: Habakku
Photoshop
Client: Global Game Center
Ertaç Altınöz, TURKEY
[above]

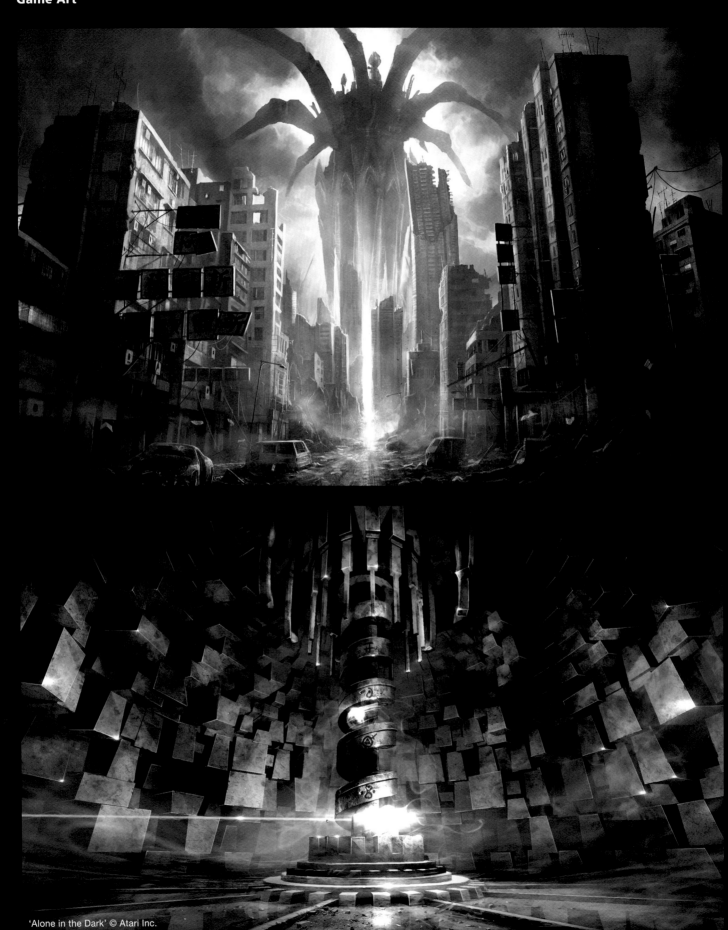

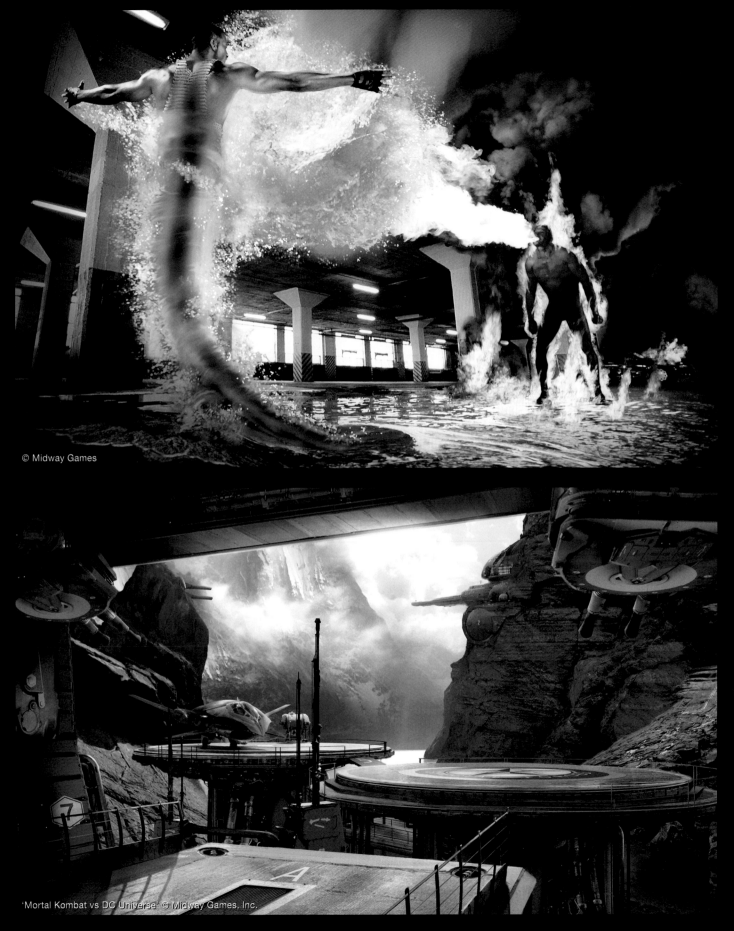

© Midway Games

'Mortal Kombat vs DC Universe' © Midway Games, Inc.

Fire vs Water
Photoshop
Art Director: Stephan Martiniere
Client: Midway Games Inc.
Dave Seeley, USA [top]

**Mortal Kombat vs DC Universe:
Special Forces**
Photoshop, Painter
Stephan Martiniere, Midway Games, Inc.,
USA [above]

MASTER
Architecture (Exterior)

Rijkskantoor, Leeuwarden
CINEMA 4D, V-Ray, Photoshop
Client: Claus & Kaan Architecten
Peter Hoste and **Kyra Frankort**
bmd, BELGIUM

Royal Pines
3ds Max, Photoshop, V-Ray
Samantha Slicer and **Ben Martin**,
FloodSlicer, AUSTRALIA

EXCELLENCE
Architecture (Exterior)

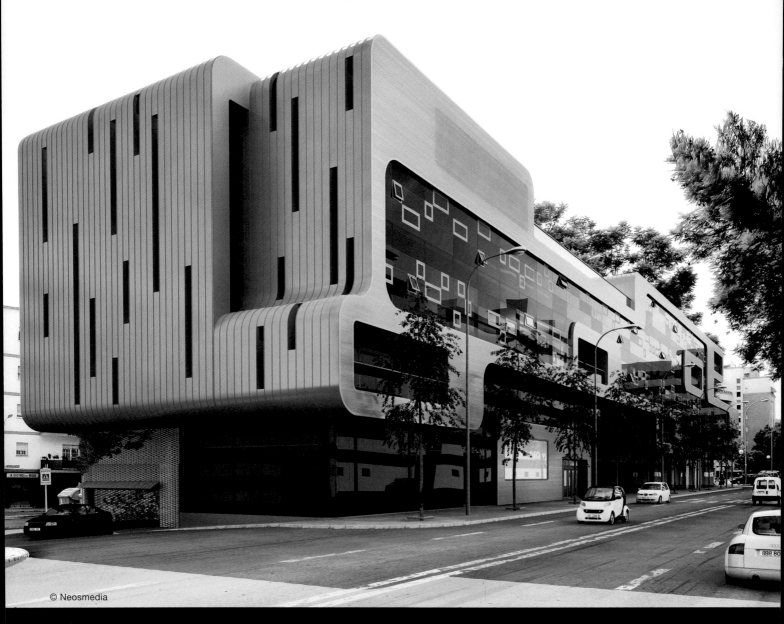

© Neosmedia

EXCELLENCE
Architecture (Exterior)

Ramon y Cajal
3ds Max, V-Ray
Client: Neosmedia
Victor Loba, SPAIN

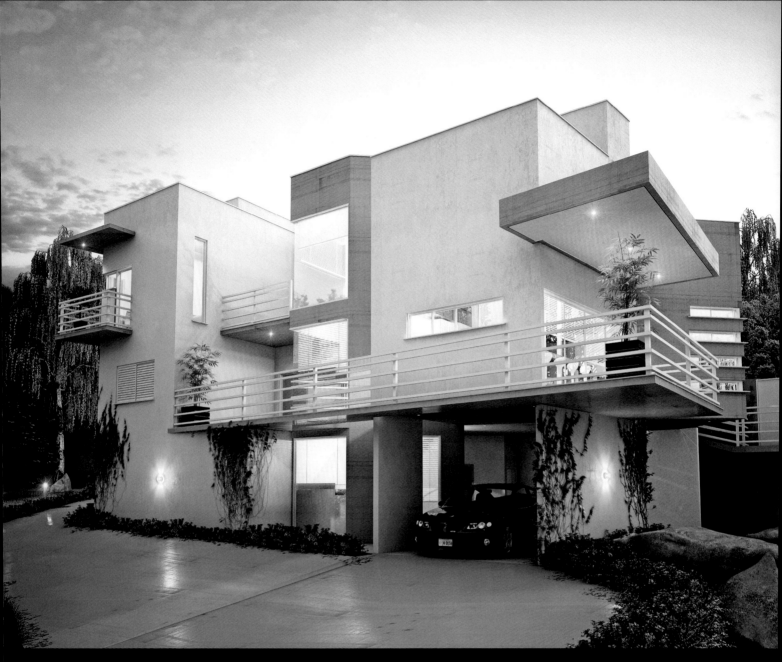

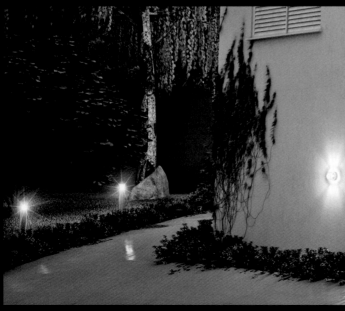

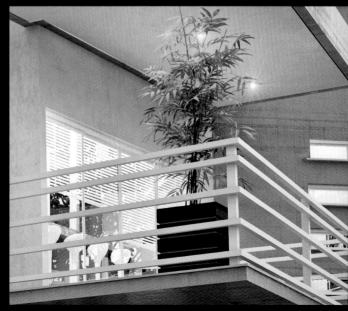

Modern House
3ds Max, V-Ray, Photoshop
Client: Inovarte
Marcelo Eder, BRAZIL

EXCELLENCE
Architecture (Exterior)

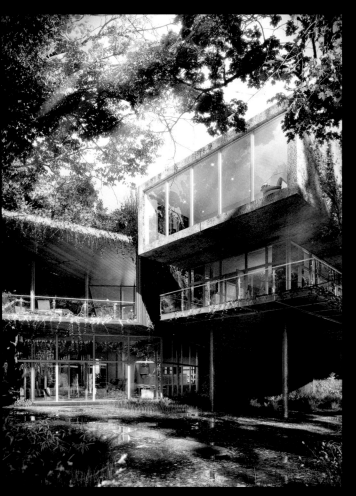

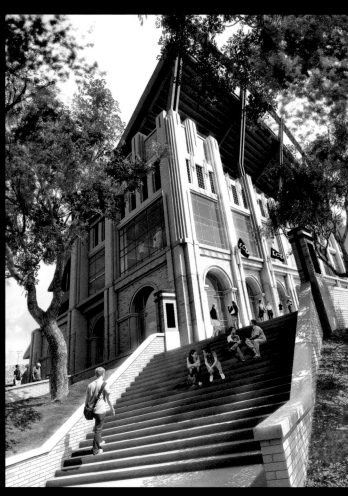

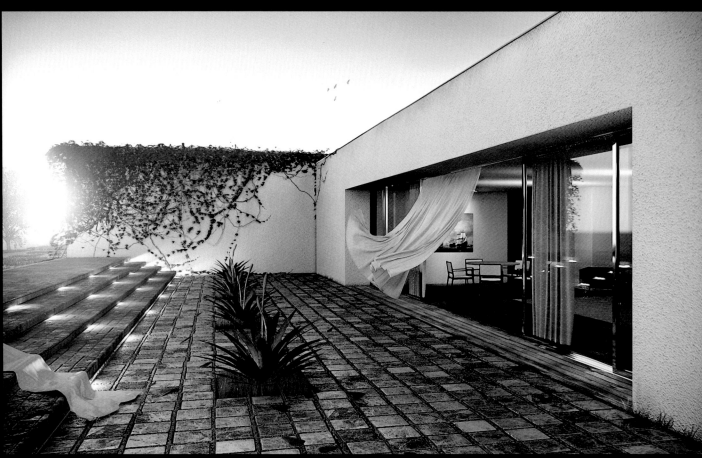

Forest Clearing
3ds Max, V-Ray, Photoshop
David Hyde,
GREAT BRITAIN
[top]

Quinta House
3ds Max, mental ray, Photoshop
Architect: Marcio Kogan
Client: 3DAllusions
Gurmukh Singh Panesar, KENYA *[above]*

Stadium stairs
3ds Max, Photoshop
Judson Rogers,
USA
[top]

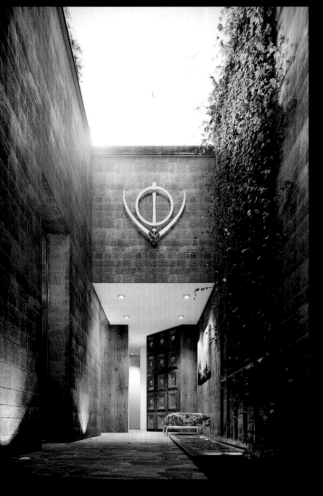

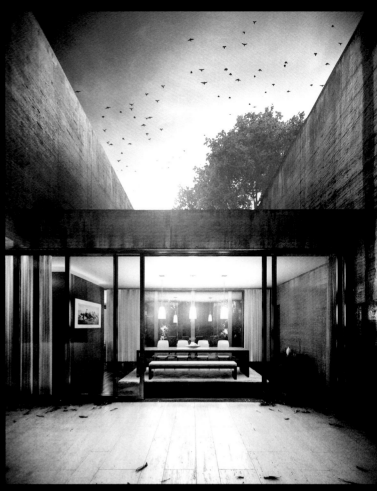

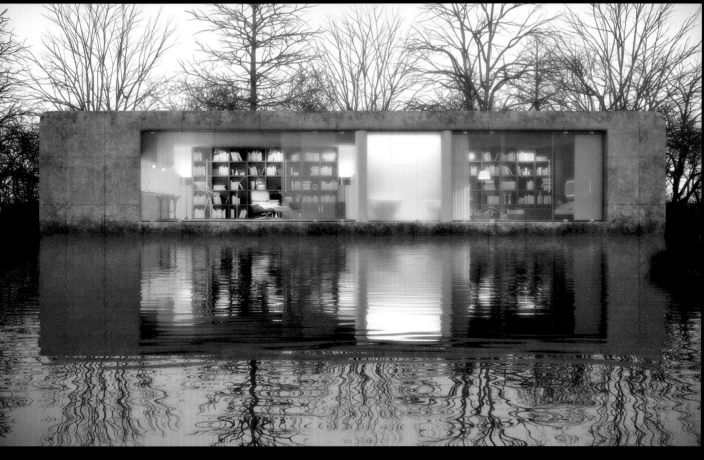

Quinta House: Rear Lobby Interior
3ds Max, mental ray, Photoshop
Architect: Marcio Kogan
Client: 3DAllusions
Gurmukh Singh Panesar, KENYA *[top]*

The Lake House
3ds Max, V-Ray, Photoshop
Daniel Fonseca de Moura,
Domus CG, BRAZIL
[above]

Normafa House
3ds Max
Architect: Satoshi Okada
Viktor Fretyán, HUNGARY
[top]

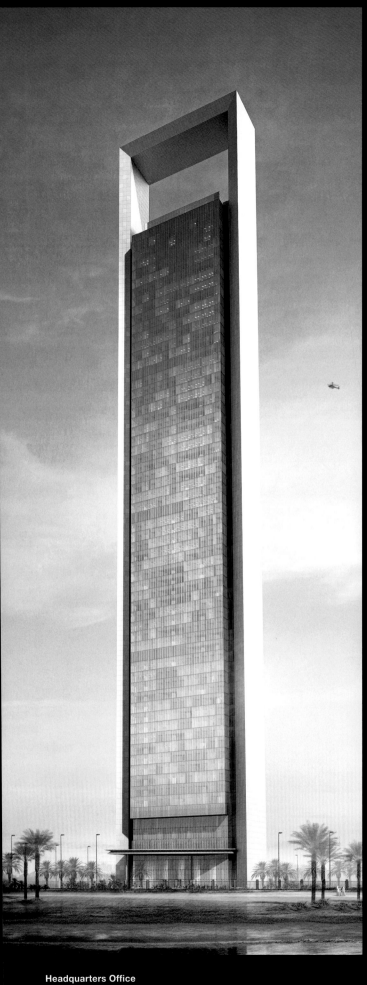

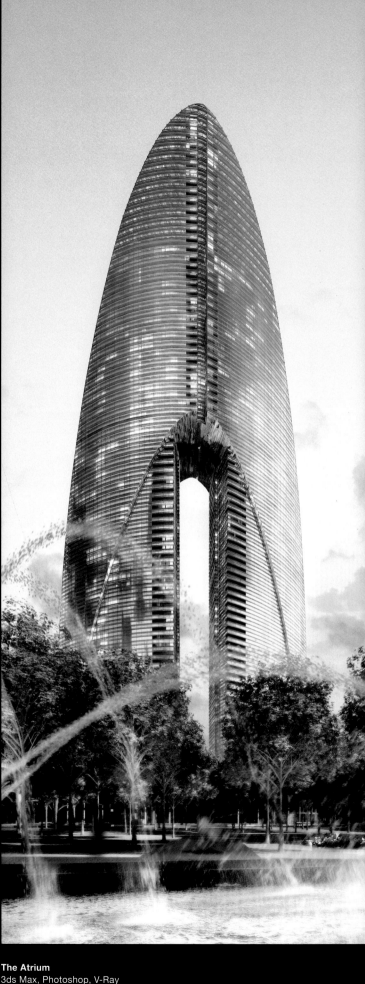

Headquarters Office
Rhino, V-Ray, 3ds Max, Photoshop
Jaroslaw Bieda and **Colin Benson**, HOK,
USA

The Atrium
3ds Max, Photoshop, V-Ray
Nick King, FloodSlicer,
AUSTRALIA

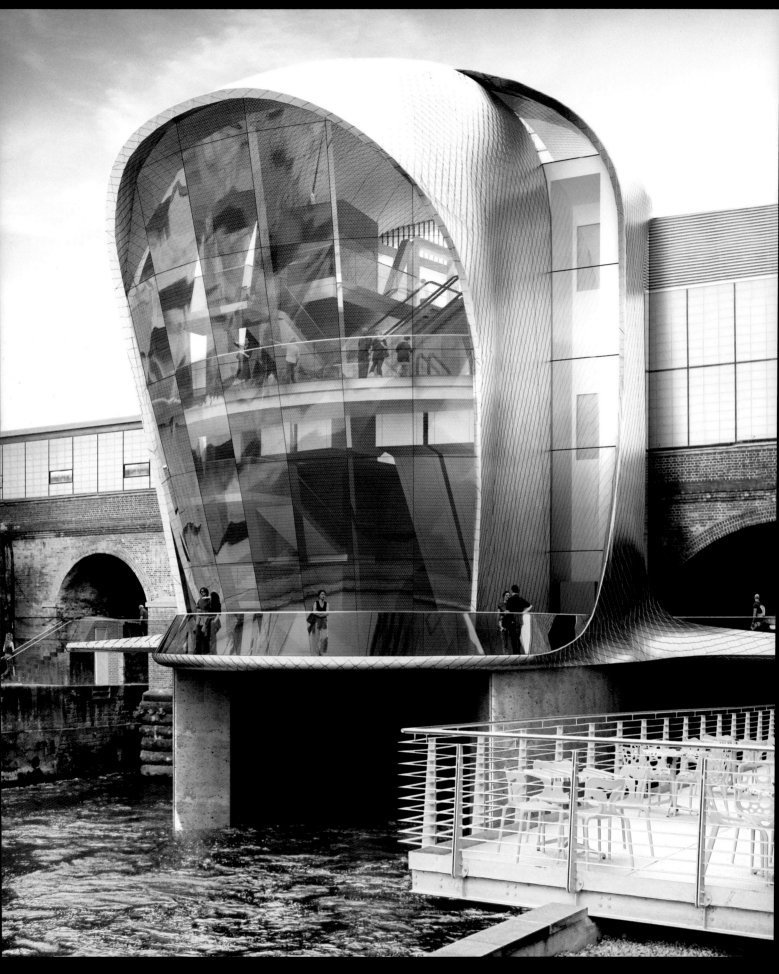

Leeds Station External
3ds Max, V-Ray, Photoshop
Aedas Imaging,
GREAT BRITAIN

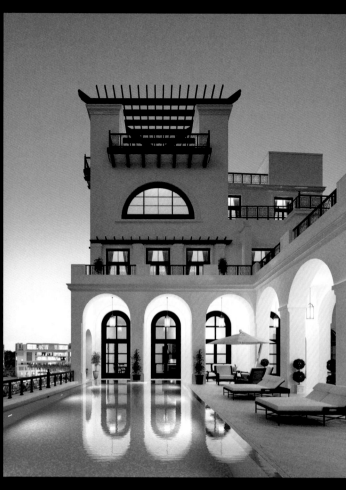

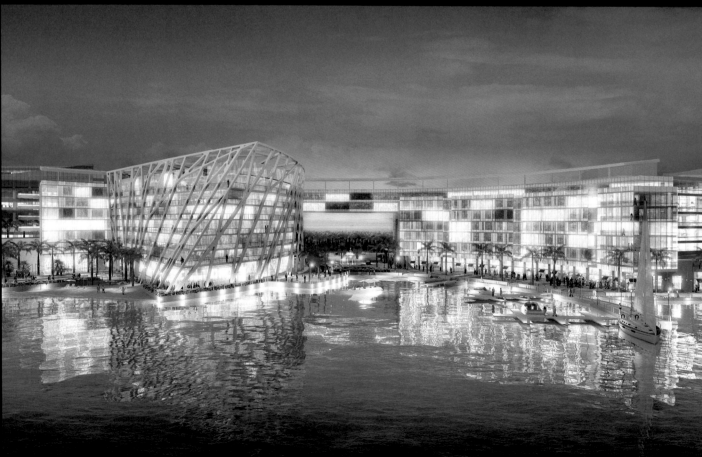

Schafberg Garden House
3ds Max, V-Ray, Photoshop
Architect: Johann Lettner
Tangram 3DS LLC, USA *[top]*

Abu Dhabi Nights
LightWave 3D, Photoshop, formZ
Jeff Pulford, **Manuel Sanchez**, **Jean Marc Labal** and
Matt Crisalli, Interface Multimedia, USA *[above]*

Albany Marina: Pool Terrace
3ds Max, Photoshop, V-Ray
Client: Tavistock Group
Lon Grohs, Neoscape, USA *[top]*

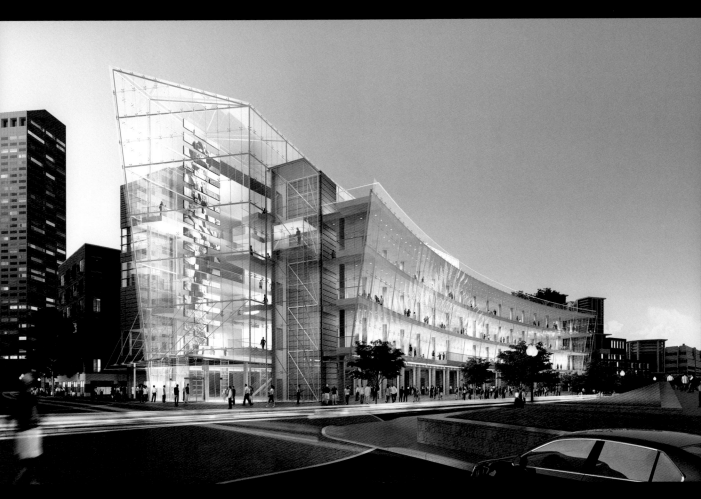

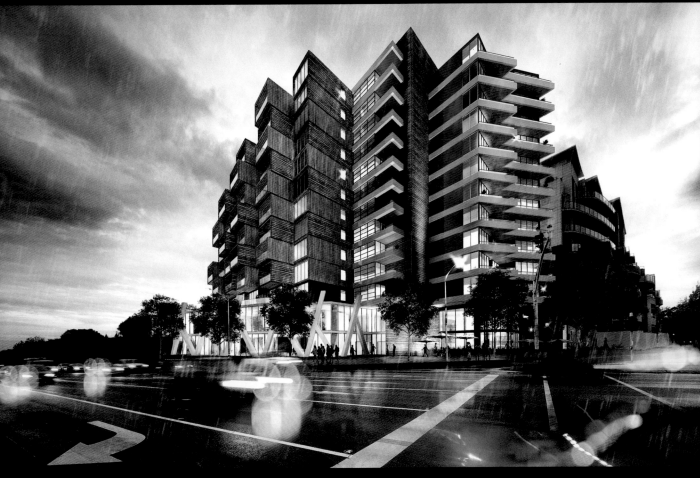

Boston Museum
3ds Max, V-Ray, Photoshop
Client: Cambridge Seven Associates Inc.
Tangram 3DS LLC, USA *[top]*

Maxx
3ds Max, Photoshop, V-Ray
Nick King, FloodSlicer, AUSTRALIA
[above]

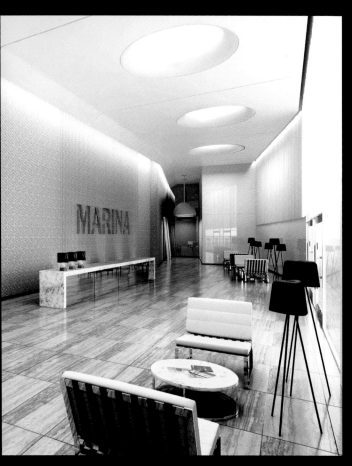

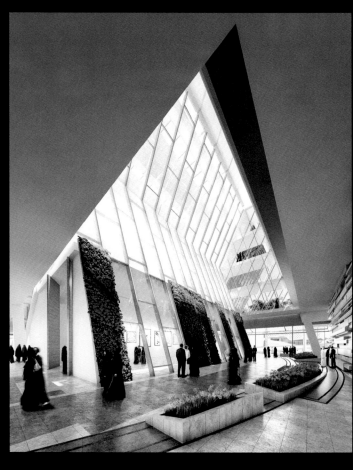

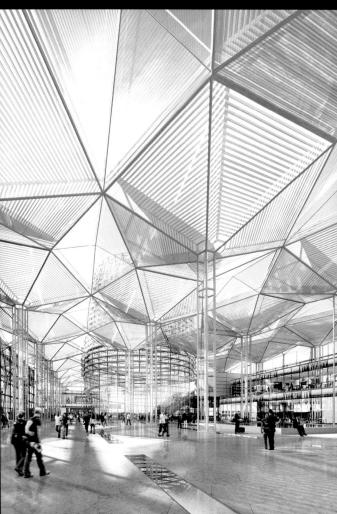

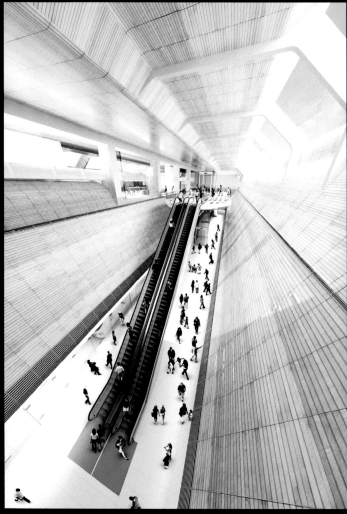

Marina: Residential Lobby
3ds Max, V-Ray, Photoshop
Simon Ng, RMJM,
CHINA
[top]

ARTIC: Train Hall
3ds Max, Photoshop, V-Ray
Client: HOK
Lon Grohs, Neoscape,
USA *[above]*

**Kuwait University College
of Arts and Education**
3ds Max, Photoshop, V-Ray
Client: Perkins+Will
Ryan Cohen, Neoscape, USA *[top]*

Interchange North America: Upper Level
3ds Max, V-Ray, Rhino, Photoshop
Aedas Imaging,
GREAT BRITAIN
[above]

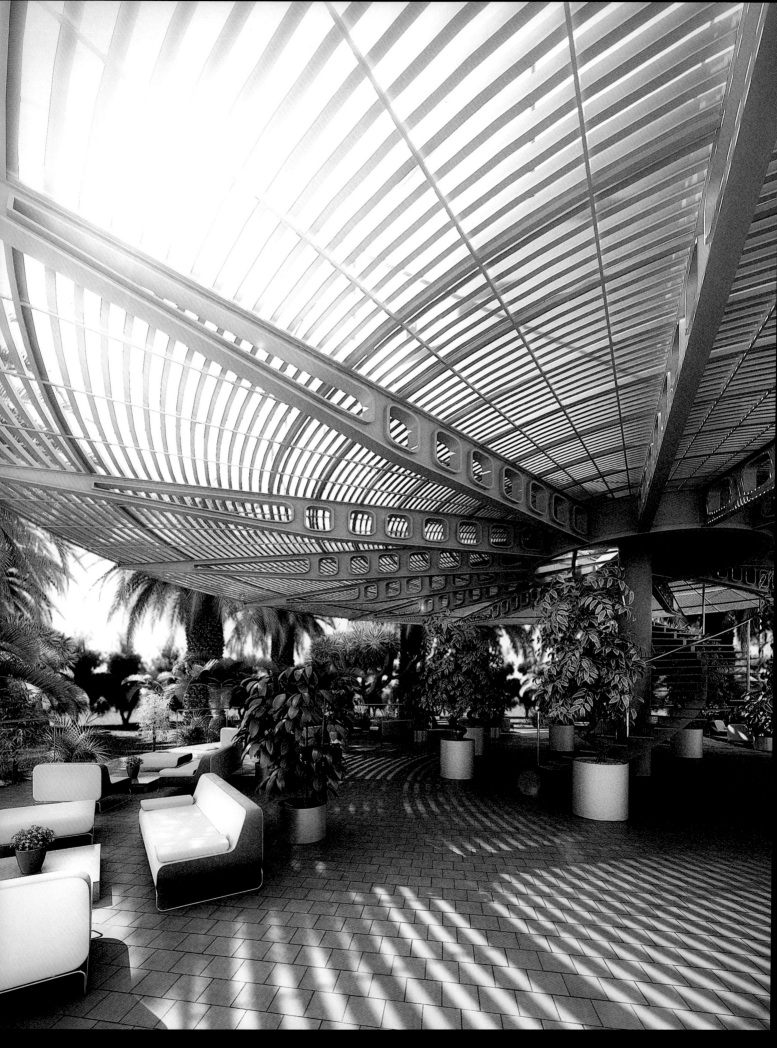

MASTER
Architecture (Interior)

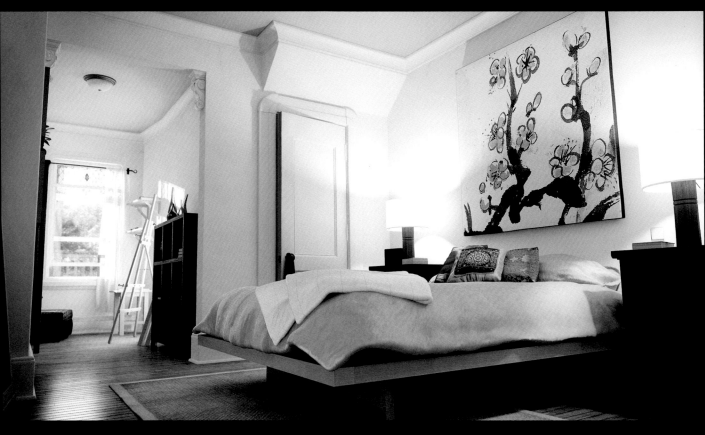

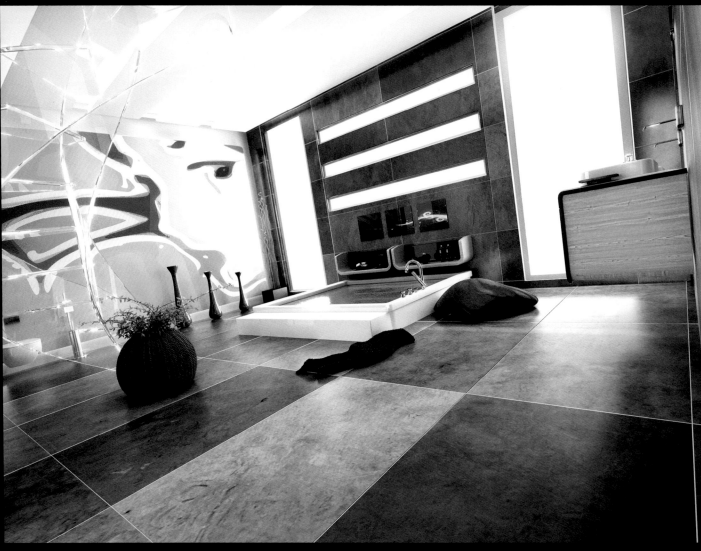

Montreal Bedroom
Maya, 3ds Max, V-Ray, Photoshop
Eve Berthelette, CANADA
[top]

Bathroom design
3ds Max, V-Ray
Jose Luis Sendra Noguera
SPAIN *[above]*

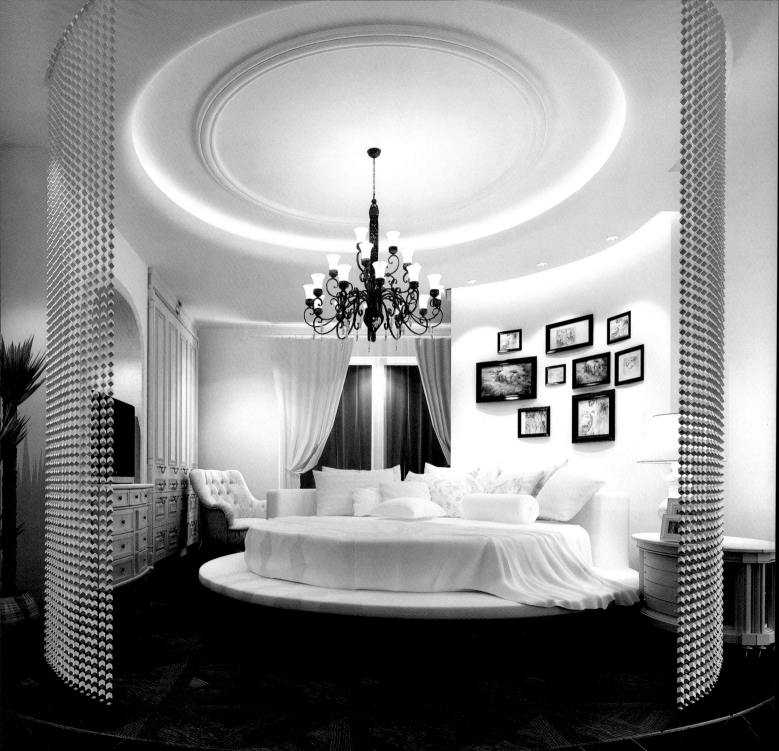

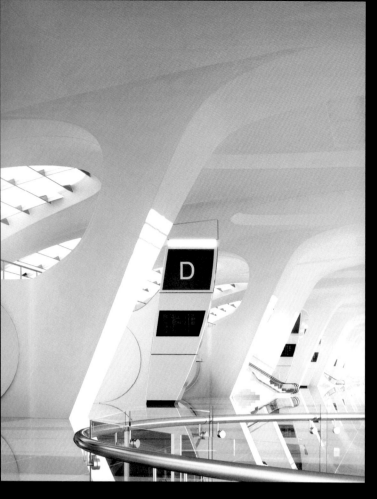

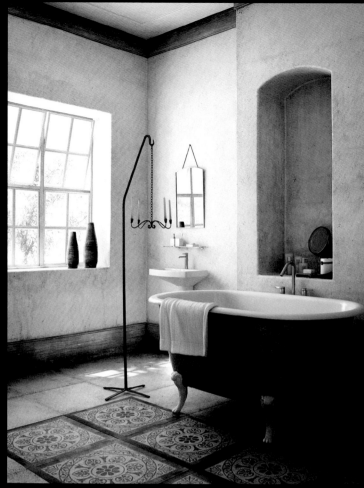

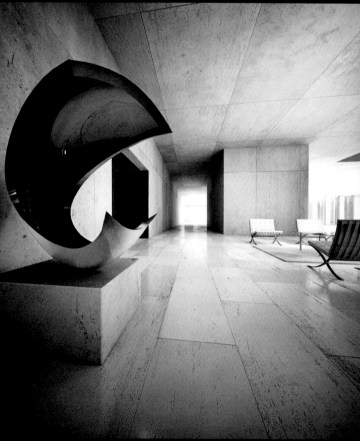

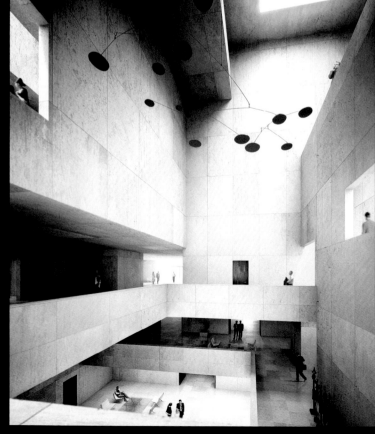

International Airport Design
3ds Max, Photoshop, V-Ray
Carlos Cristerna, Neoscape,
USA
[top]

Swiss Re: Zurich Headquarters
CINEMA 4D, V-Ray, Photoshop
Client: Claus & Kaan Architecten
Peter Hoste and **Kyra Frankort**, bmd,
BELGIUM *[above]*

Green Bathroom
Maya, V-Ray, Photoshop
Client: Alpha-Vision
Eve Berthelette, CANADA
[top]

Swiss Re: Zurich Headquarters
CINEMA 4D, V-Ray, Photoshop
Client: Claus & Kaan Architecten
Peter Hoste and **Kyra Frankort**, bmd.
BELGIUM *[above]*

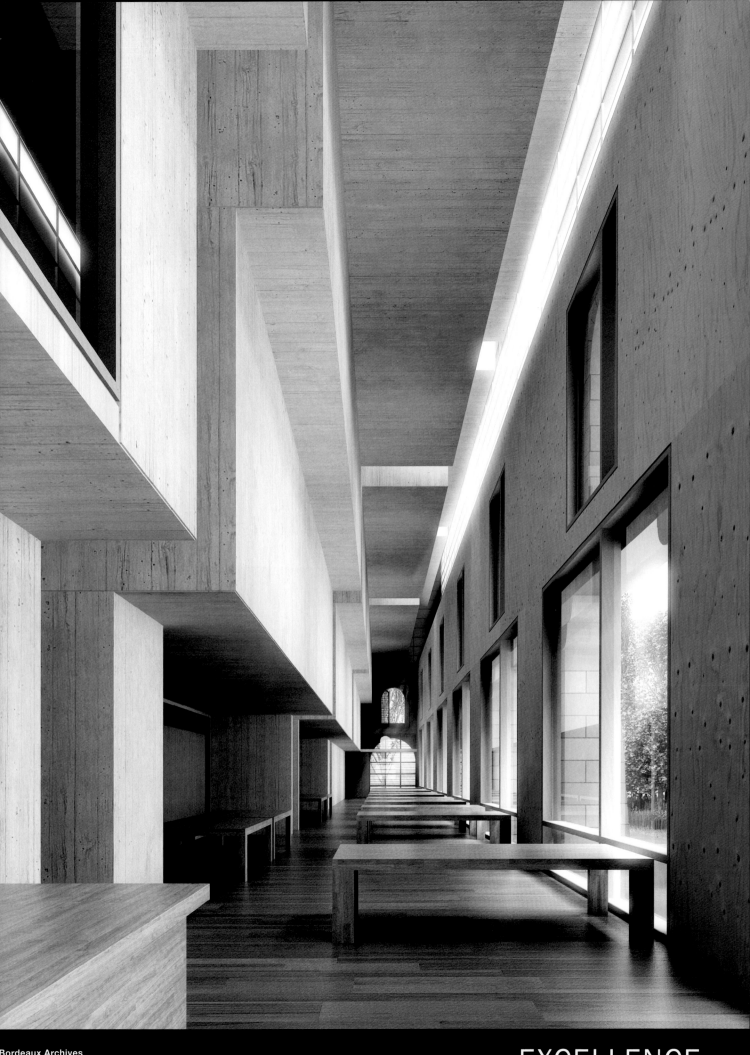

Bordeaux Archives
3ds Max, V-Ray, Photoshop
Architect: Robbrecht en Daem
Gert Swolfs, G2 BVBA,

EXCELLENCE
Architecture (Interior)

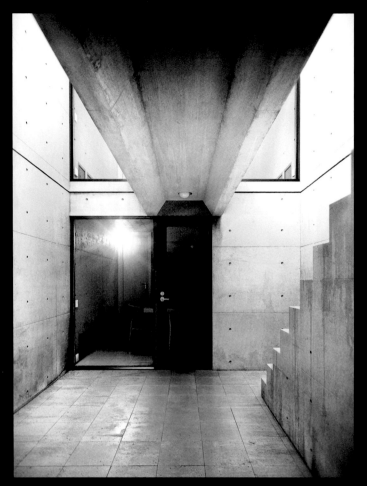

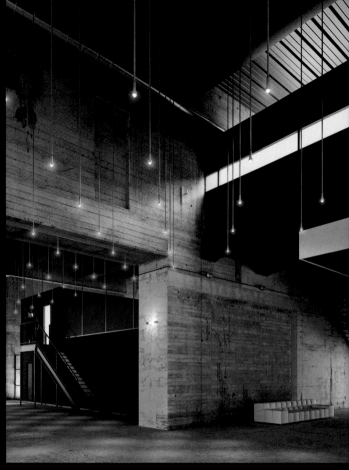

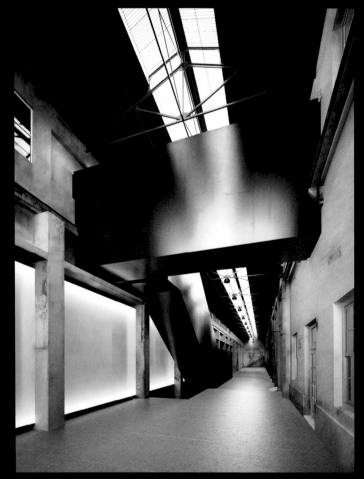

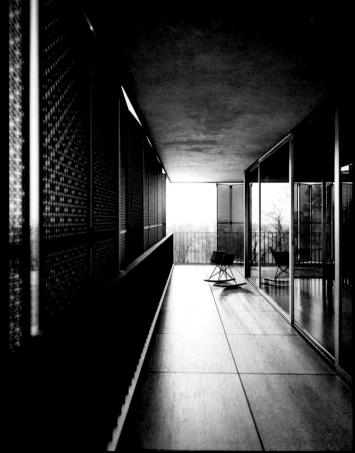

Row House
3ds Max
Architect: Tadao Ando
Viktor Fretyán, HUNGARY *[top]*

Dance School
3ds Max, V-Ray, Photoshop
Ricardo Silva, **Joana Couto** and **Miguel Miraldo**,
Black Box Lda, PORTUGAL *[above]*

Alveole
3ds Max, V-Ray, Photoshop
Gert Swolfs, G2 BVBA, BELGIUM
[top]

NY09
CINEMA 4D, V-Ray
Peter Hoste and **Kyra Frankort**, bmd,
BELGIUM *[above]*

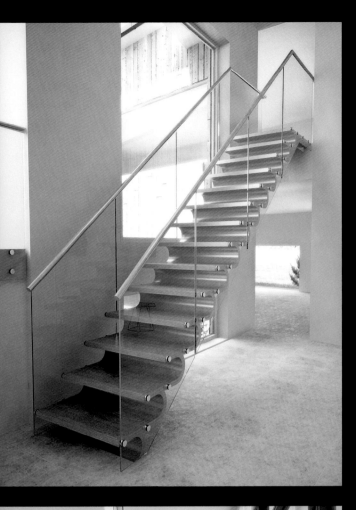

C-stack Timber
V-Ray, 3ds Max, Photoshop
Geoffrey Packer, EeDesign,
GREAT BRITAIN [top]

Modern Interior
3ds Max, V-Ray, Photoshop
David Hyde, GREAT BRITAIN
[above]

Leonardo Staircase
3ds Max, V-Ray, Photoshop
Inspired by: 3Deluxe's Leonardo Glass Cube
Geoffrey Packer, EeDesign, GREAT BRITAIN [top]

Stair No.9
3ds Max
Chen Qingfeng, CHINA
[above]

Volume light interior
3ds Max, V-Ray, Photoshop
Architects: Roozbeh Tabande
and Haleh Vedadi Nejad
Farrokh Tabande, IRAN
[left]

Spa therapy
3ds Max, V-Ray, Photoshop
Ricardo Silva, **Joana Couto** and
Miguel Miraldo, Black Box Lda,
PORTUGAL
[right]

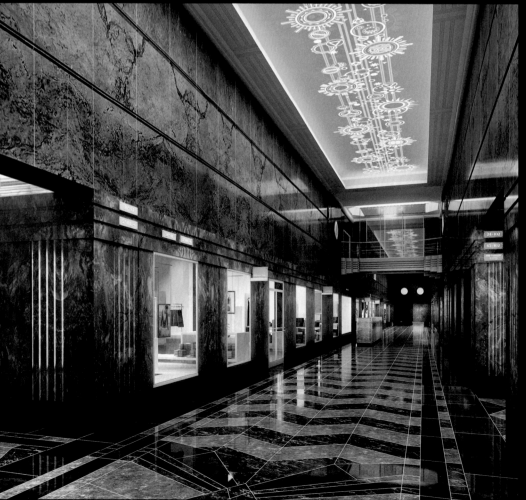

Empire State Building: Lobby
3ds Max, Photoshop, V-Ray
Client: Lorelli Associates
Shawn Grabko and **Ryan Cohen**
Neoscape, USA
[left]

Dining Room
3ds Max, V-Ray, Photoshop
Simon Ng, RMJM, CHINA
[right]

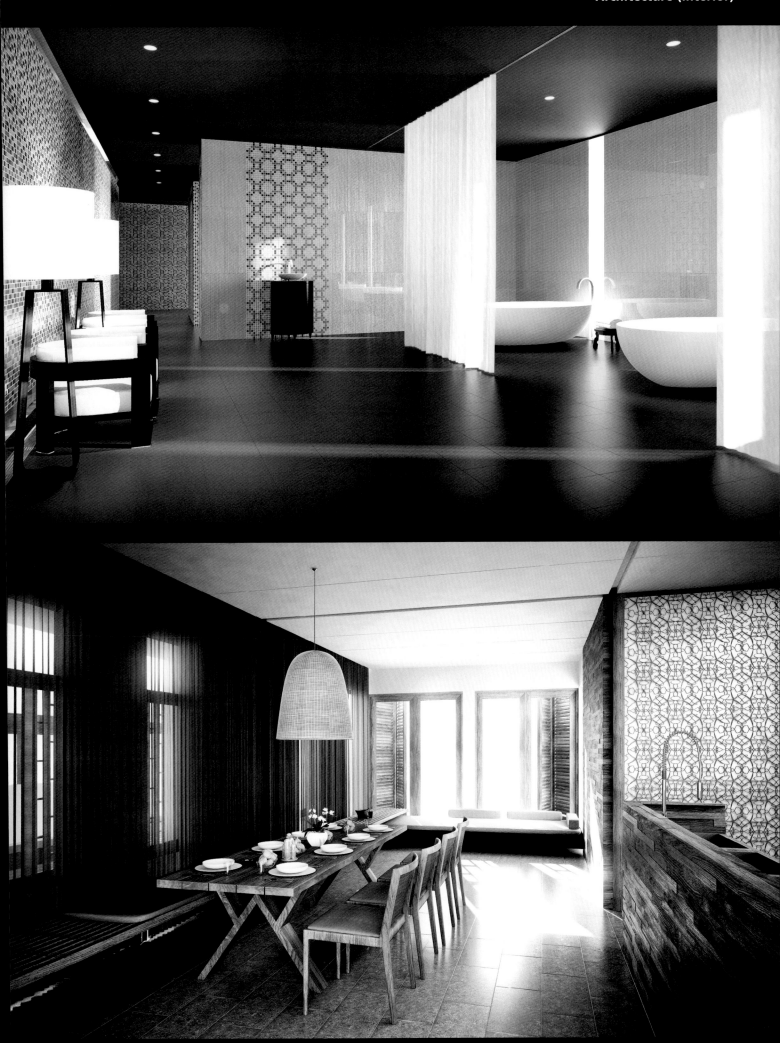

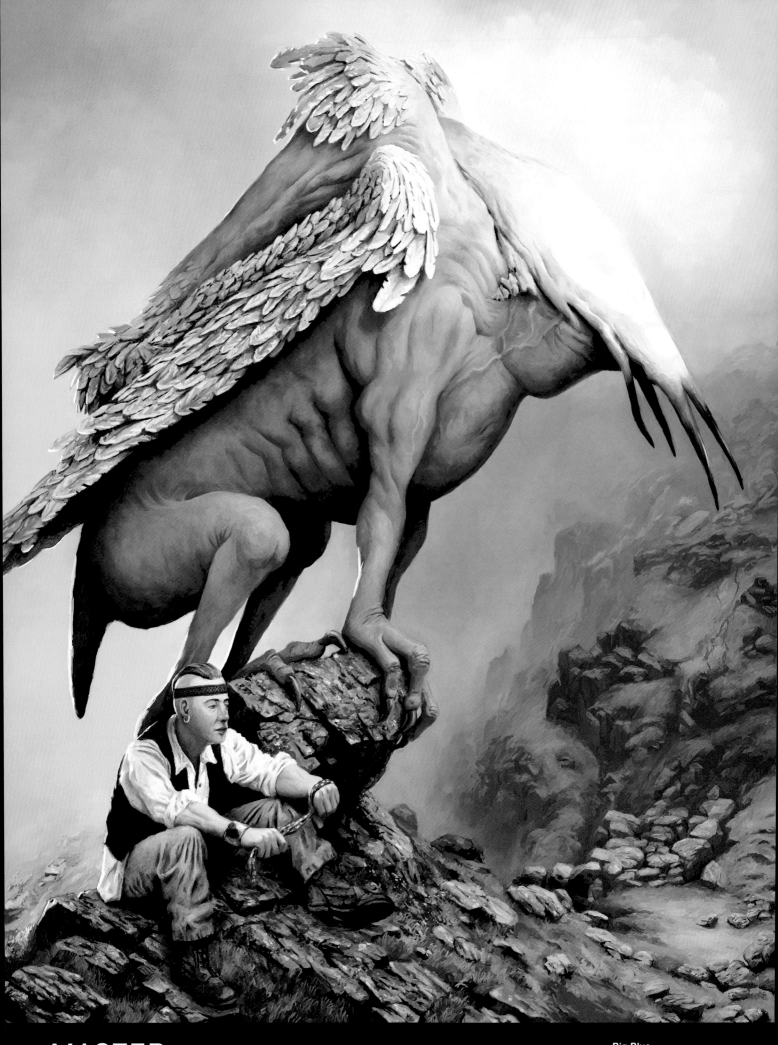

MASTER
Fantasy

Big Blue
ArtRage, Painter
Simon Dominic, GREAT BRITAIN

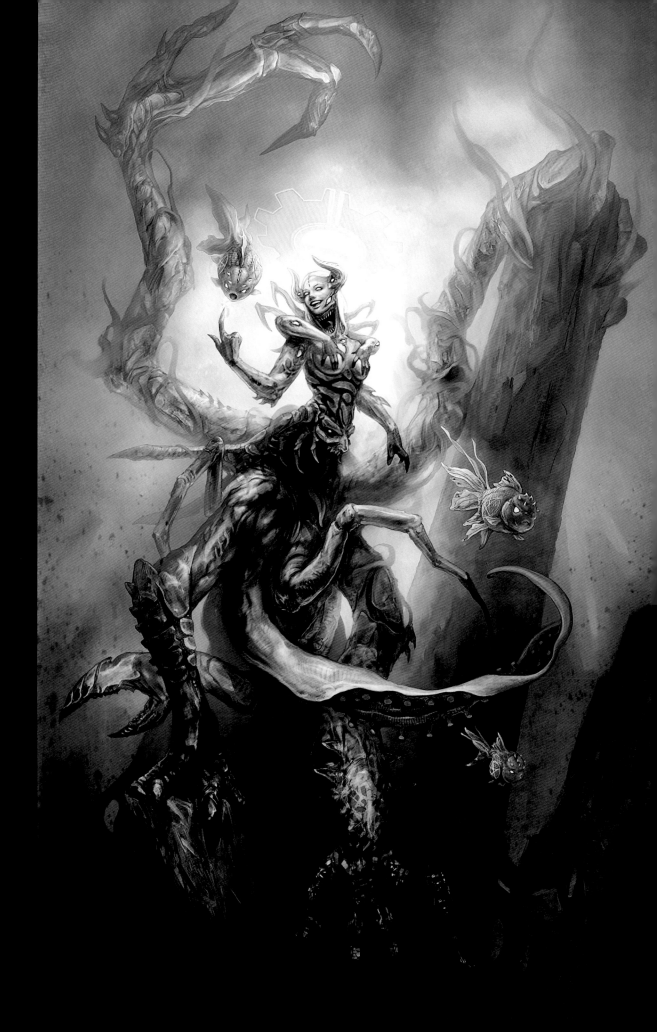

Dak-hana
Photoshop
Michele Chang, MALAYSIA

EXCELLENCE
Fantasy

The Abstract Dragon
Photoshop, Painter, ZBrush
Art Director: Olivier Souillé
Client: Editions Daniel Maghen

Azaziel
Painter, Photoshop
Kirsi Salonen,
FINLAND

Karnun
Photoshop, Painter
Art Director: Olivier Souillé
Client: Editions Daniel Maghen
J.S Rossbach, FRANCE

EXCELLENCE
Fantasy

The Web of the Witch World: Symbiosiss
PhotoPaint, Poser
Client: Nasza Księgarnia Publishing
Tomasz Maronski, POLAND *[top]*

The Cyclone Chamber
Photoshop
Kirsi Salonen, FINLAND
[above]

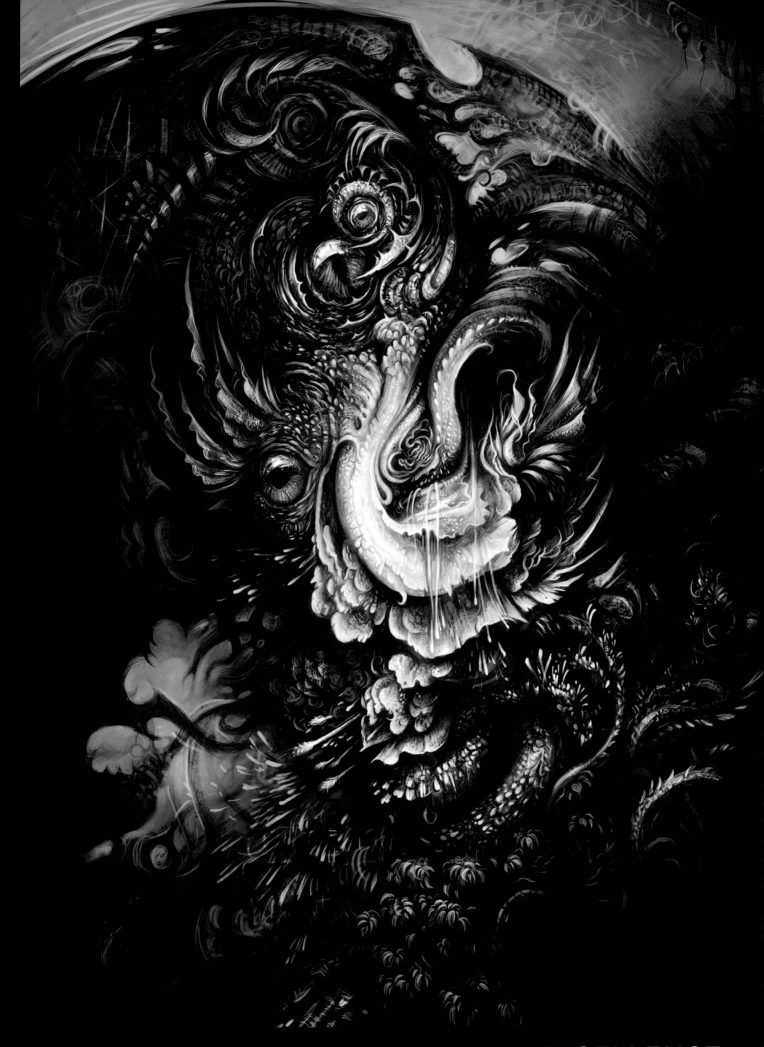

Blossom of Evil
Photoshop
Chaichan Artwichai,
THAILAND

EXCELLENCE
Fantasy

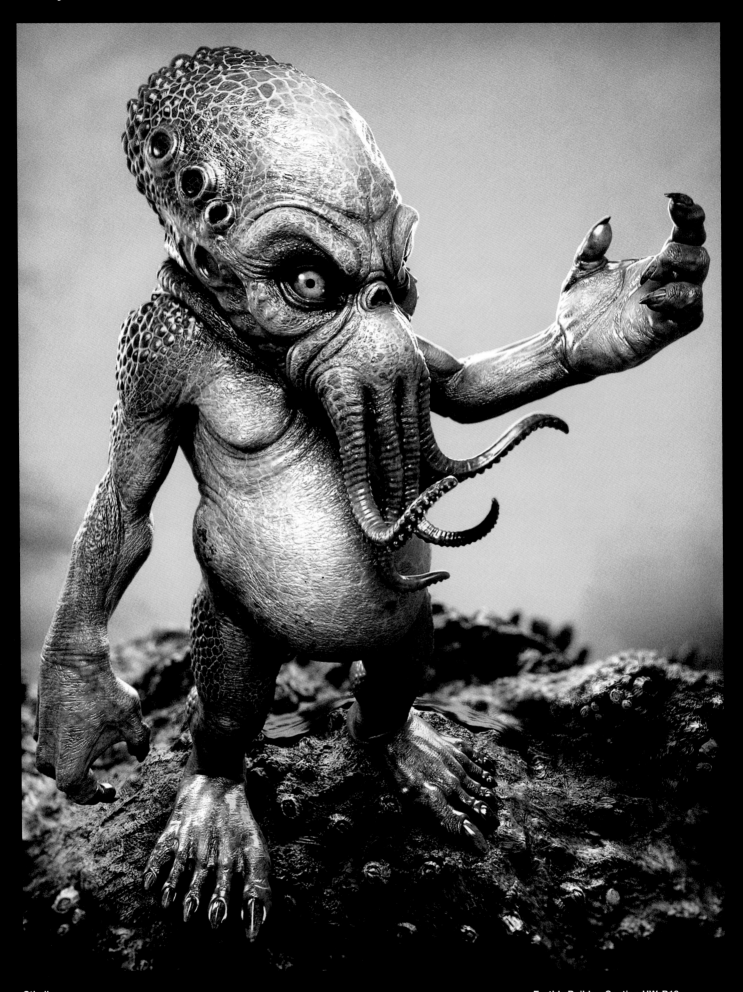

Cthulhu
mental ray, Maya, ZBrush
Chris Nichols, CANADA
[above]

Earth's Builder: Section UW-B18
3ds Max, ZBrush, Photoshop, mental ray
Miguel Ângelo Carvalho Bernardo Teixeira,
PORTUGAL *[right]*

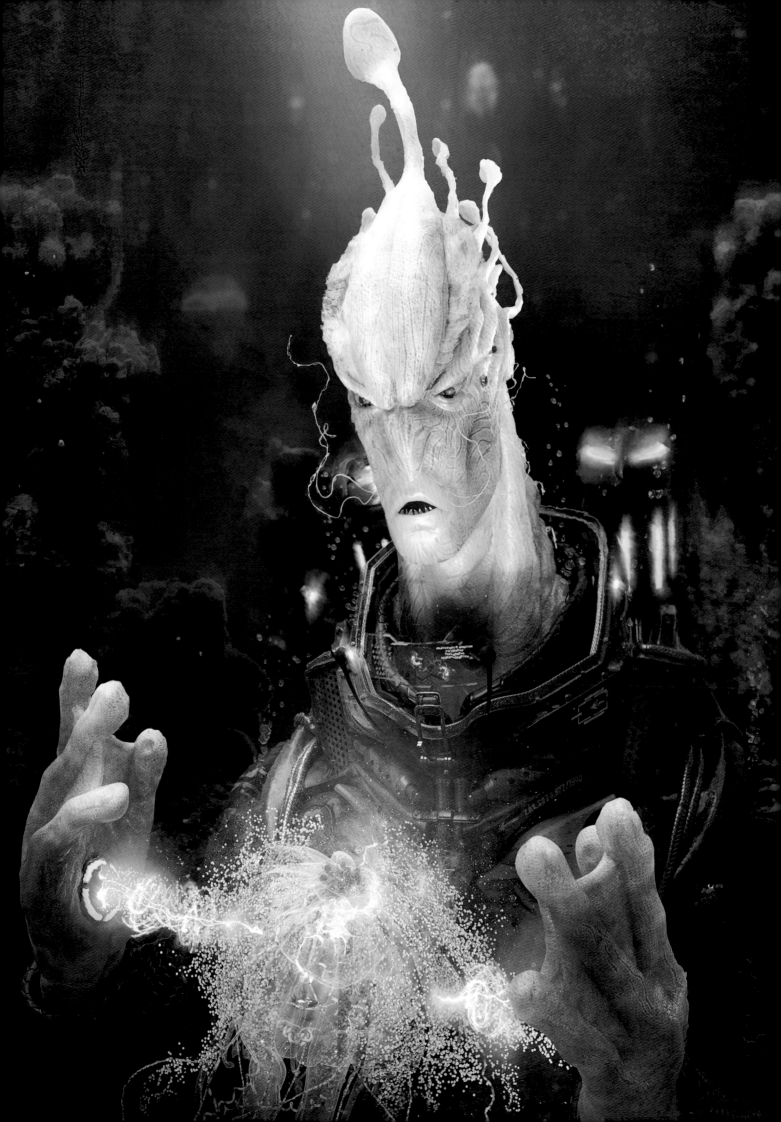

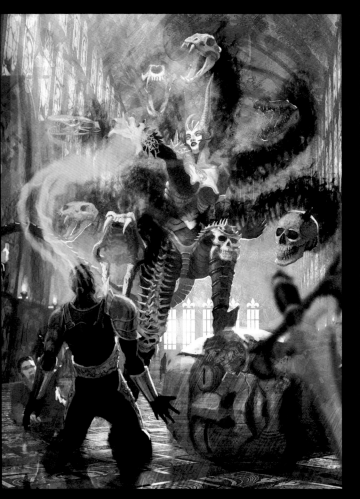

'The Dragons of Ordinary Farm' © Hobbit Presse/Klett Cotta

Darkspirit
Photoshop
HsinNan Hung, TAIWAN
[top]

Ray of Millennium
Photoshop
Thitipon Dicruen, THAILAND
[above]

The Dragons of Ordinary Farm
Photoshop
Client: Hilden Design
Kerem Beyit, TURKEY *[top]*

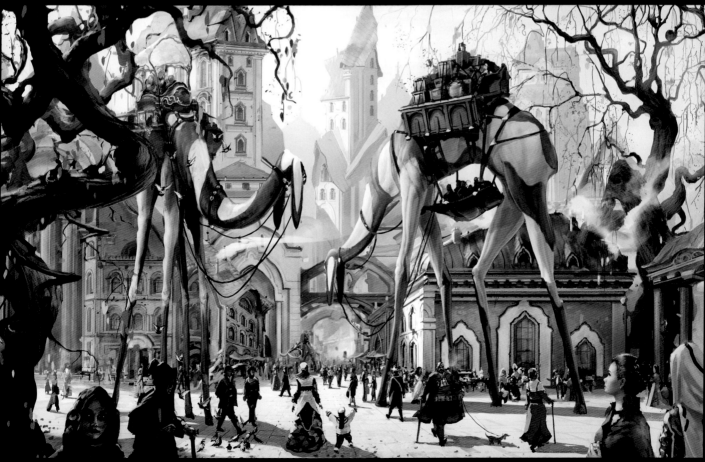

Fallen Angels
Photoshop

Sunny November
Photoshop

Birth
Photoshop

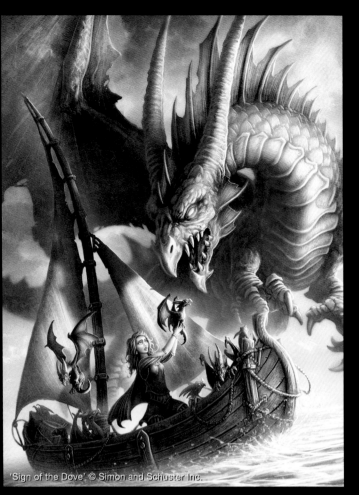

'Sign of the Dove' © Simon and Schuster Inc.

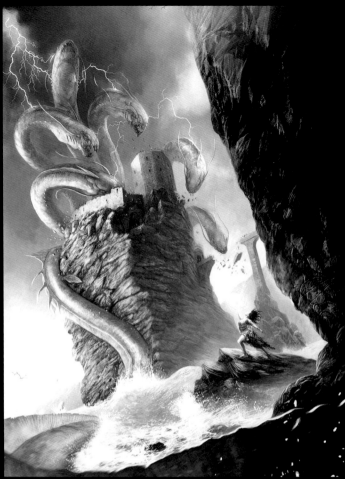

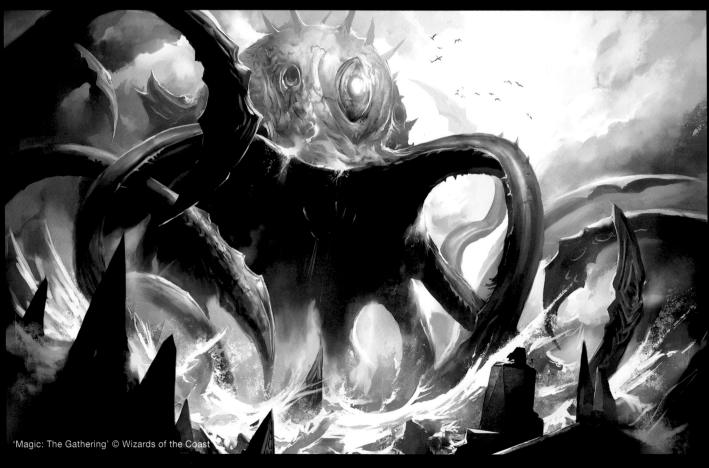

'Magic: The Gathering' © Wizards of the Coast

Sign of the Dove: Cover
Photoshop
Client: Simon and Schuster Inc.
Kerem Beyit, TURKEY
[top]

Magic: The Gathering (Lorthos the Tidemaker)
Photoshop
Client: Wizards of the Coast
Kekai Kotaki, USA
[above]

The summoning
Photoshop
John McCambridge
POLAND
[top]

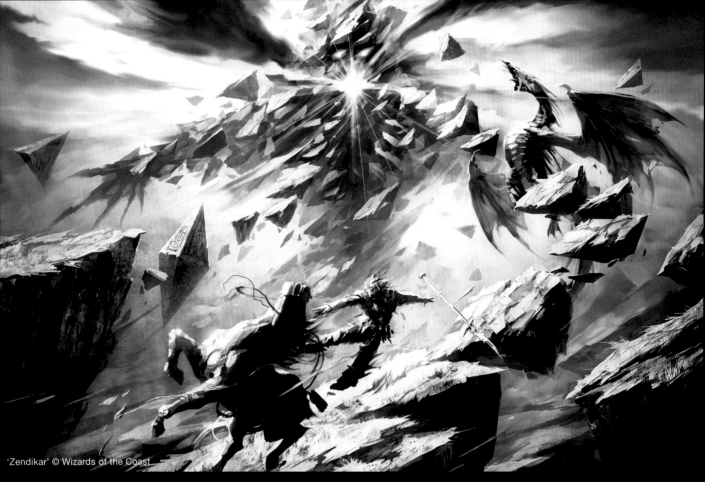

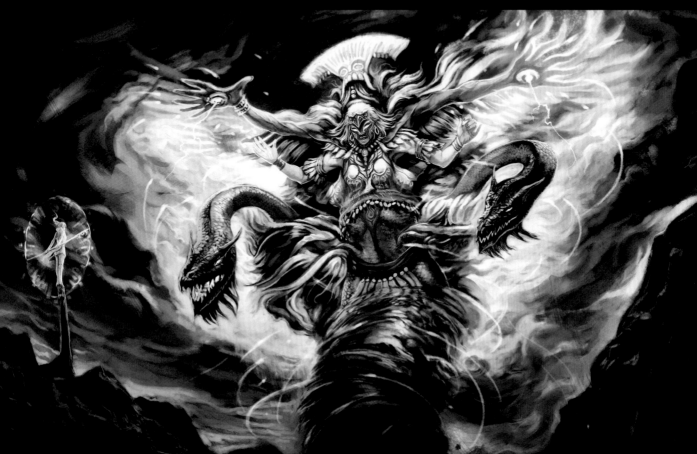

Zendikar: Roil Elemental
Photoshop

Horacanth
Photoshop

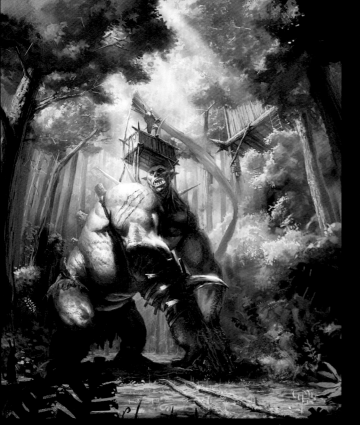

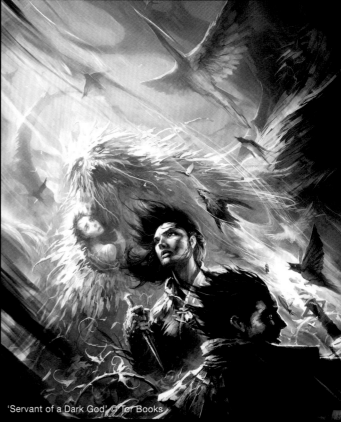

'Servant of a Dark God' © Tor Books

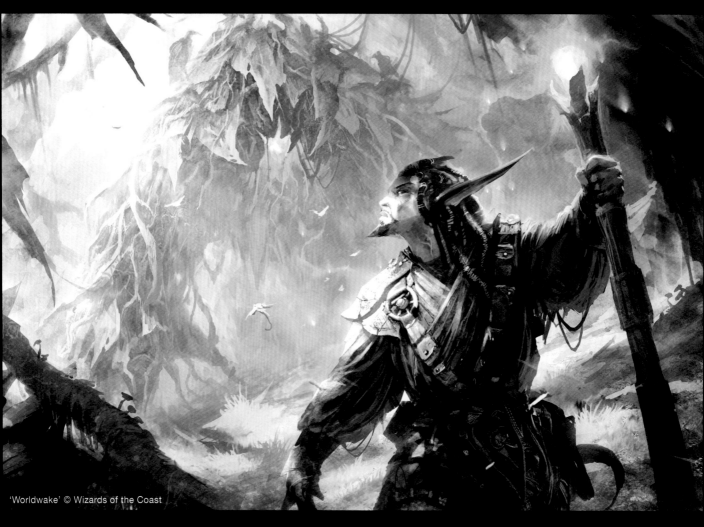

'Worldwake' © Wizards of the Coast

Hunter
Photoshop
Lin Bo,
CHINA
[top]

Worldwake: Vastwood Animist
Photoshop
Art Director: Jeremy Jarvis
Client: Wizards of the Coast
Raymond Swanland, USA [above]

Servant of a Dark God
Photoshop
Art Director: Irene Gallo
Client: Tor Books
Raymond Swanland, USA [top]

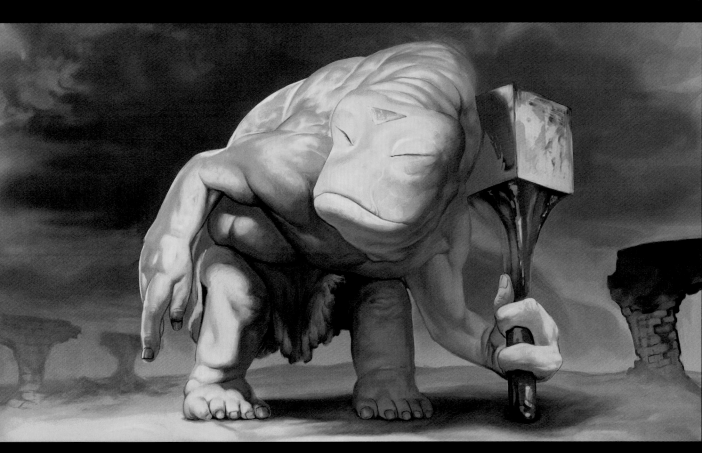

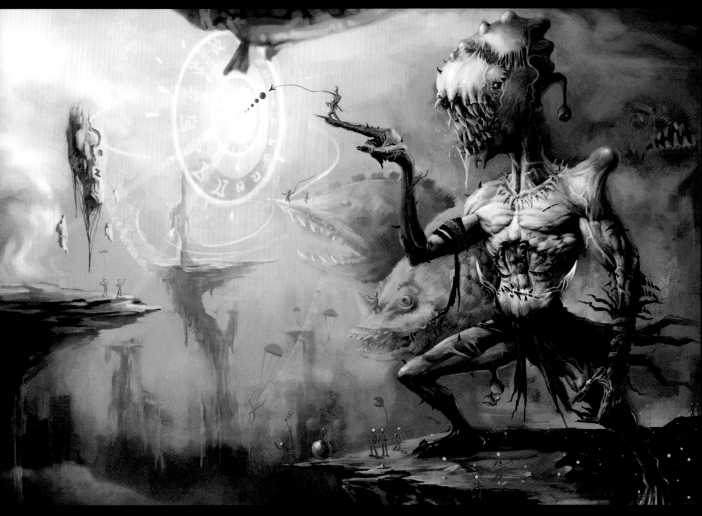

Sand Troll
Photoshop
Yukari Masuike,
JAPAN

Freddy
Photoshop
Chuan Zhong,
CHINA

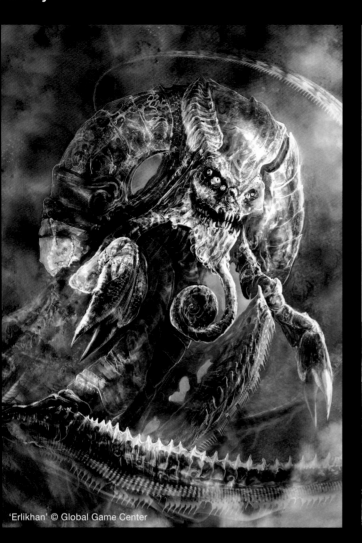

'Erlikhan' © Global Game Center

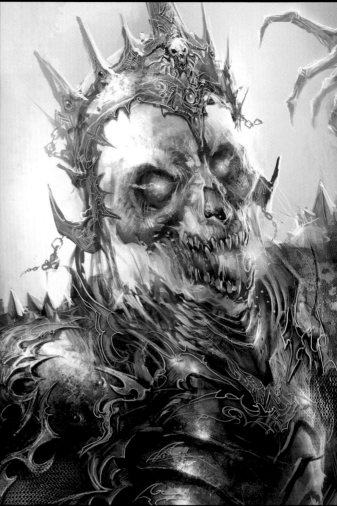

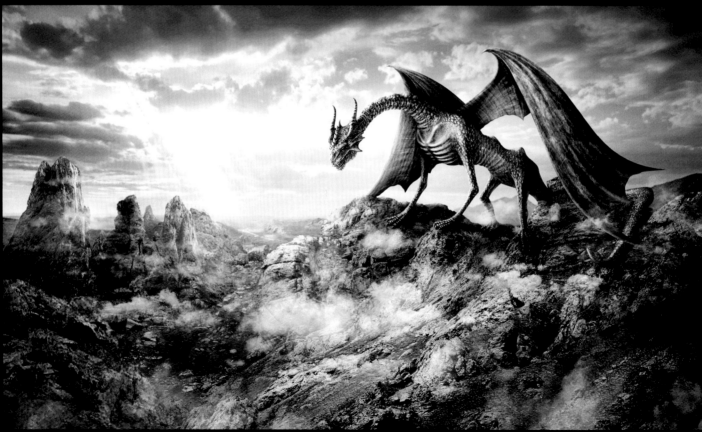

Erlikhan: Ne İdüğü Belirsiz
Photoshop
Client: Global Game Center
Ertaç Altinöz, TURKEY *[top]*

Skinny Dragon
Photoshop
Ong Chew Peng, Stardust Imaging Pte Ltd,
SINGAPORE *[above]*

Lord of the Undead
Photoshop
Feng Guo, CHINA
[top]

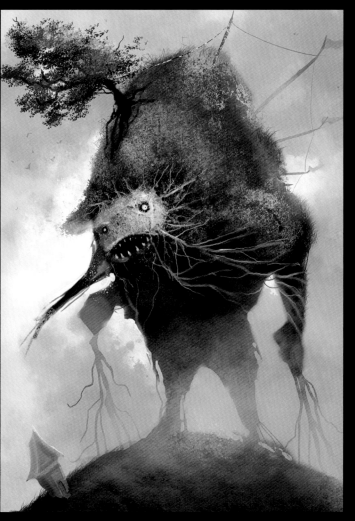

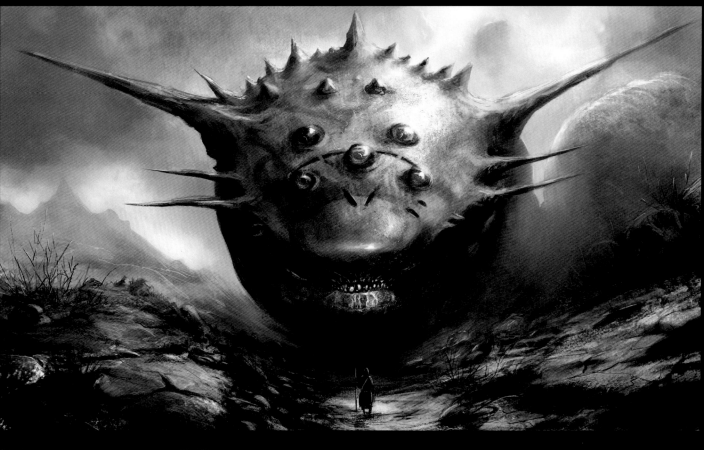

Giant
Photoshop
Ramses Melendez, MEXICO

The Worm
Photoshop
David Lecossu, FRANCE

Gar
Photoshop
Shreya Shetty, INDIA

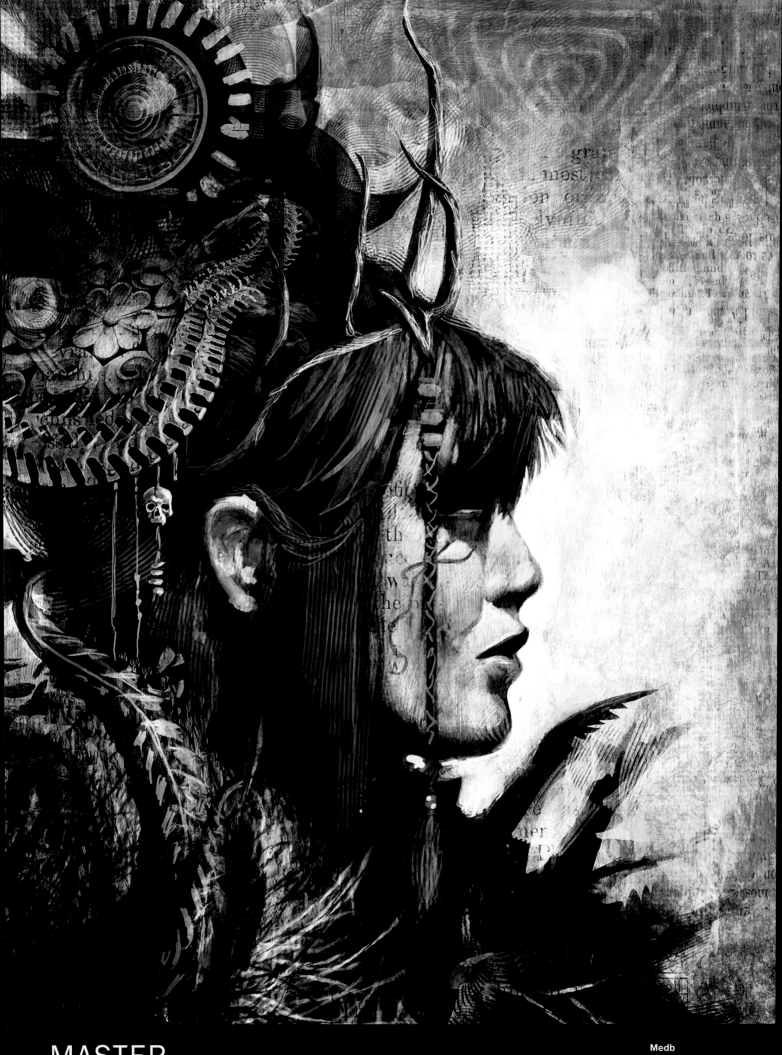

MASTER
Fantasy Femmes

Medb
Photoshop
J.S Rossbach, FRANCE

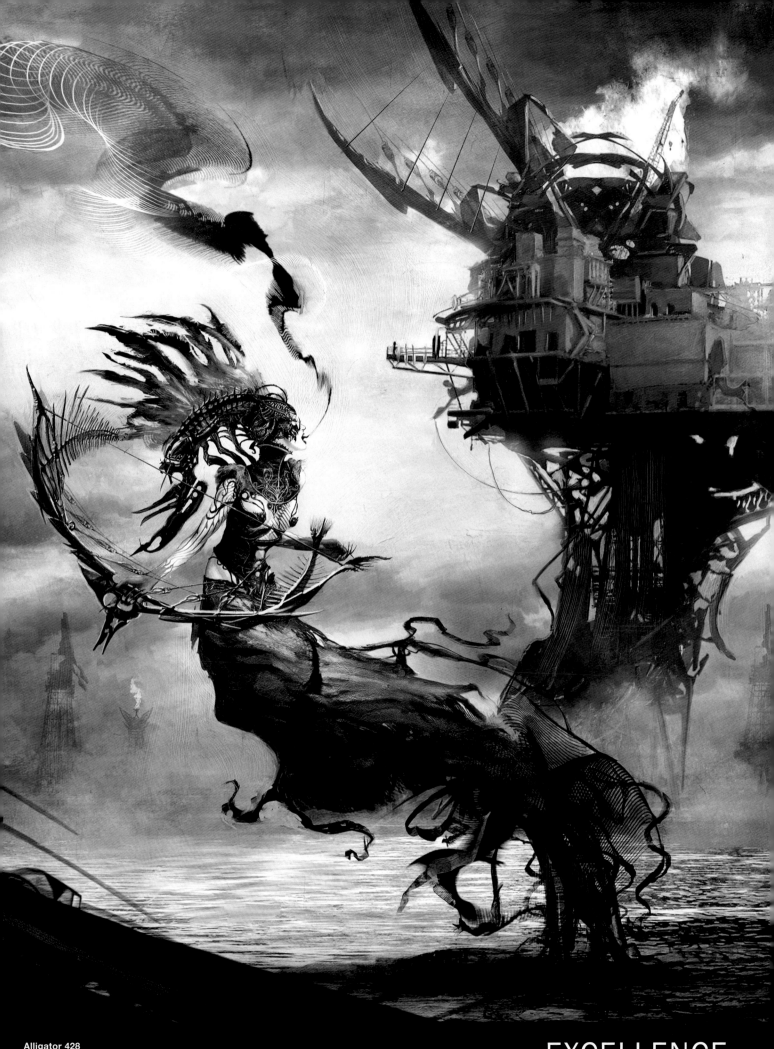

EXCELLENCE
Fantasy Femmes

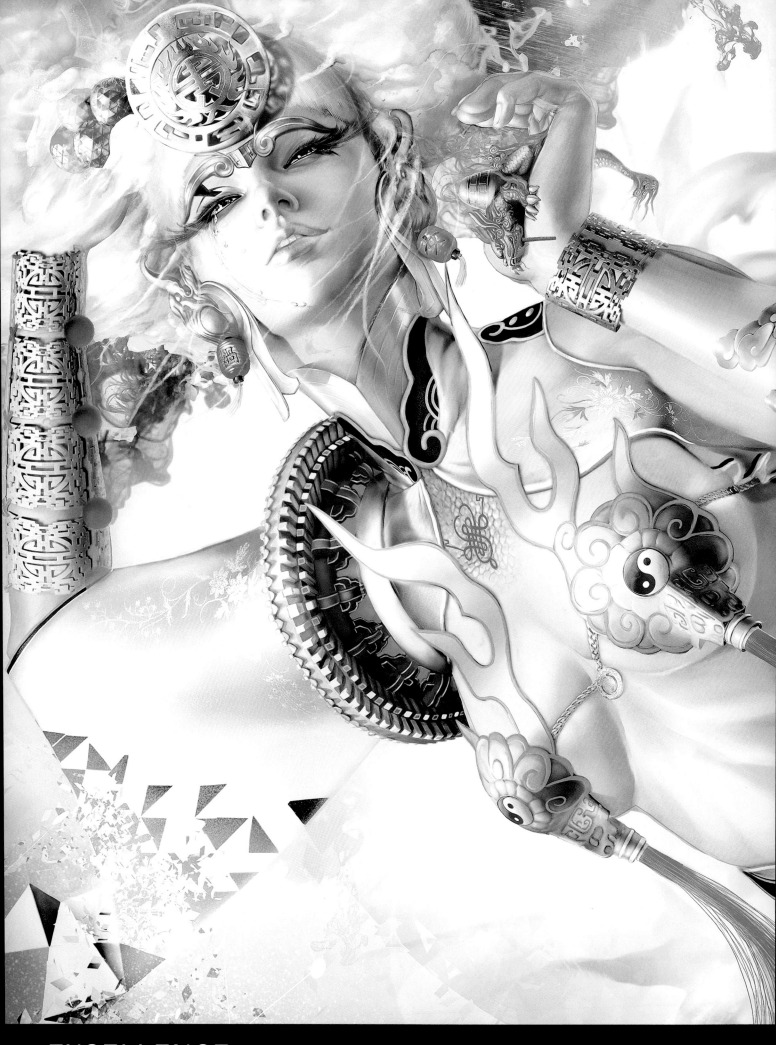

EXCELLENCE

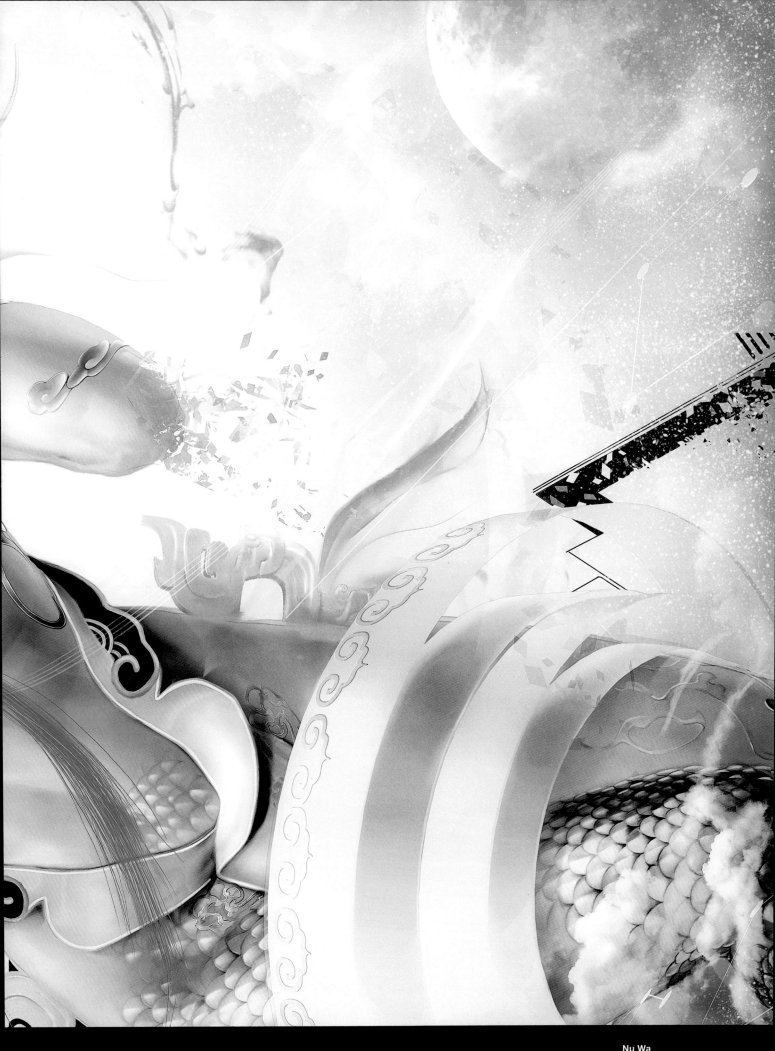

Nu Wa
Photoshop
Yu Cheng Hong, TAIWAN

Mystra
Photoshop
Ben Lo, CANADA
[top]

Autumn Faerie
Painter, Photoshop
J.S Rossbach, FRANCE
[above]

Dragon Priestess
Photoshop, Painter
Katrina Lin, CANADA
[top]

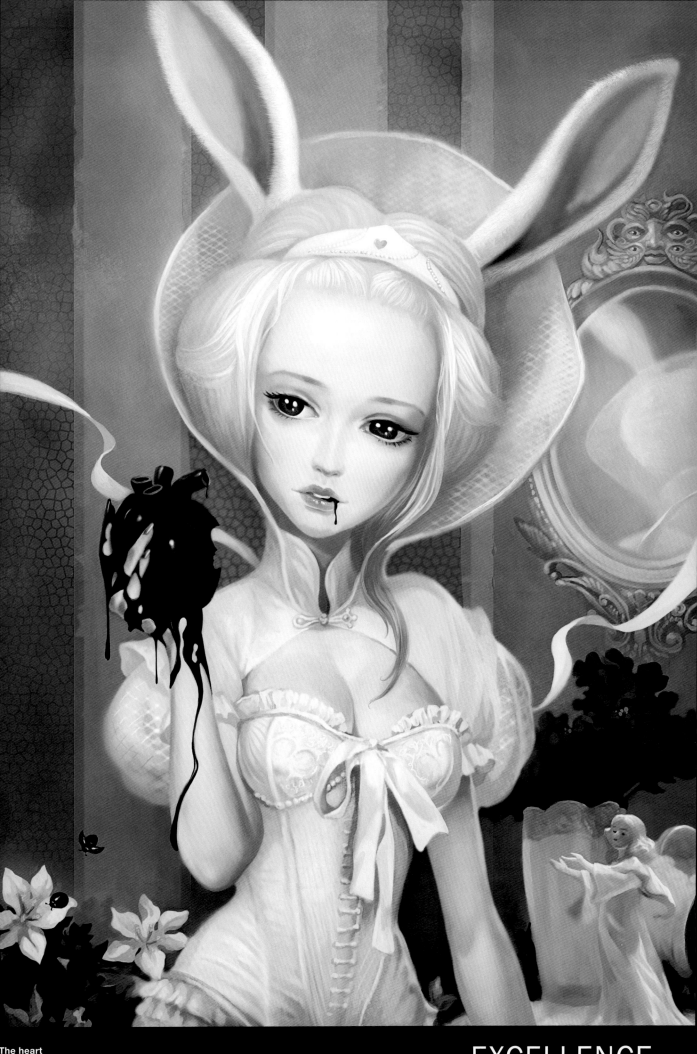

The heart
Photoshop, Painter
Jiansong Chain, Perfect World International.
CHINA

EXCELLENCE
Fantasy Femmes

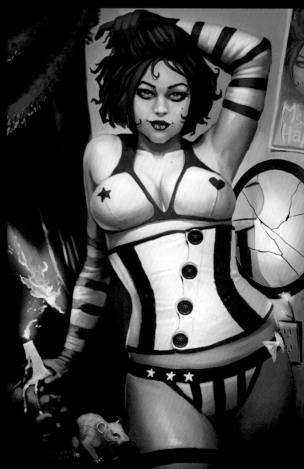

The Joker
Photoshop
Nakai Wen, Funny Lab, TAIWAN
[top]

Ordera: Apis Soulraider
Photoshop
Kirsi Salonen, FINLAND
[above]

Angel and Demon
Photoshop
Client: Living Art magazine
Haitao Su, Suhaitao Studio, CHINA [top]

Ms. Haps
Photoshop
Jhoneil Centeno, USA
[above]

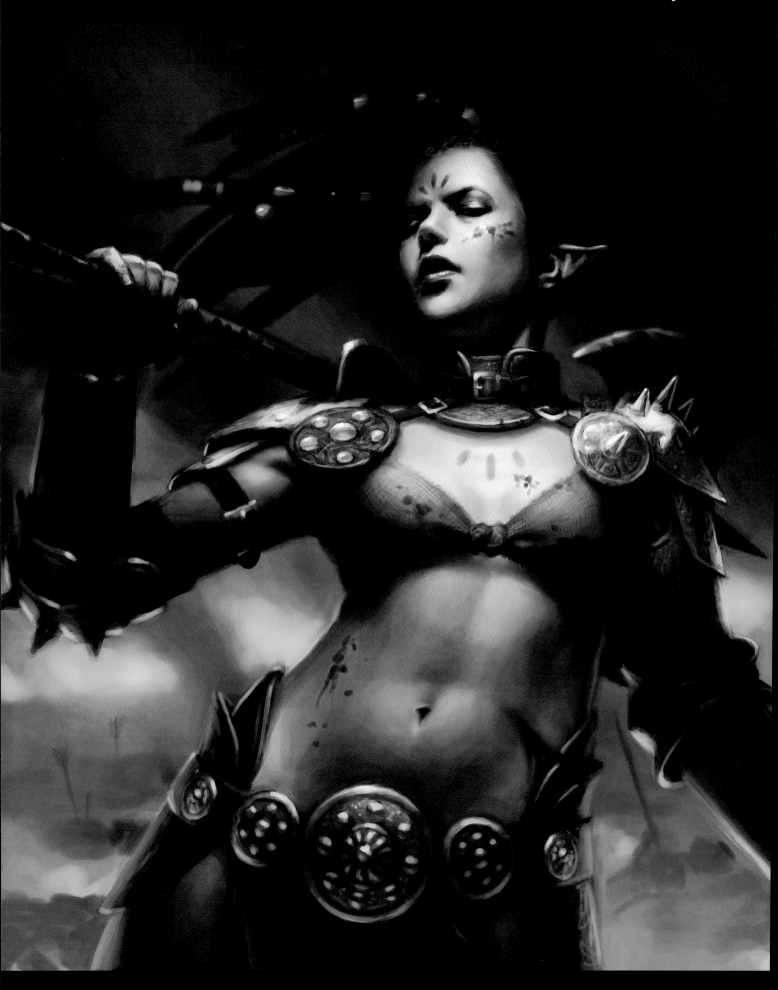

Battle Elf
Photoshop
Winona Nelson,
USA

Angel
Photoshop
Artem Borisov,
RUSSIA
[left]

Medic
Photoshop
Yigit Koroglu,
TURKEY
[right]

The Crow
Photoshop
Tatiana Vetrova,
RUSSIA
[far right]

World of Dust: Magic Makes
Photoshop
Client: Urlark Network
Feng Wei, CHINA
[left]

Reign of Darkness
Photoshop
Thitipon Dicruen, THAILAND
[right]

Viara Tenebrae
Photoshop
Tatiana Vetrova, RUSSIA
[far right]

'World of Dust' © Urlark Network

MASTER
Concept Art

Steampunk Highlands
Photoshop
Robh Ruppel, USA

EXCELLENCE
Concept Art

Treacherous
Photoshop
Li Tao,
CHINA

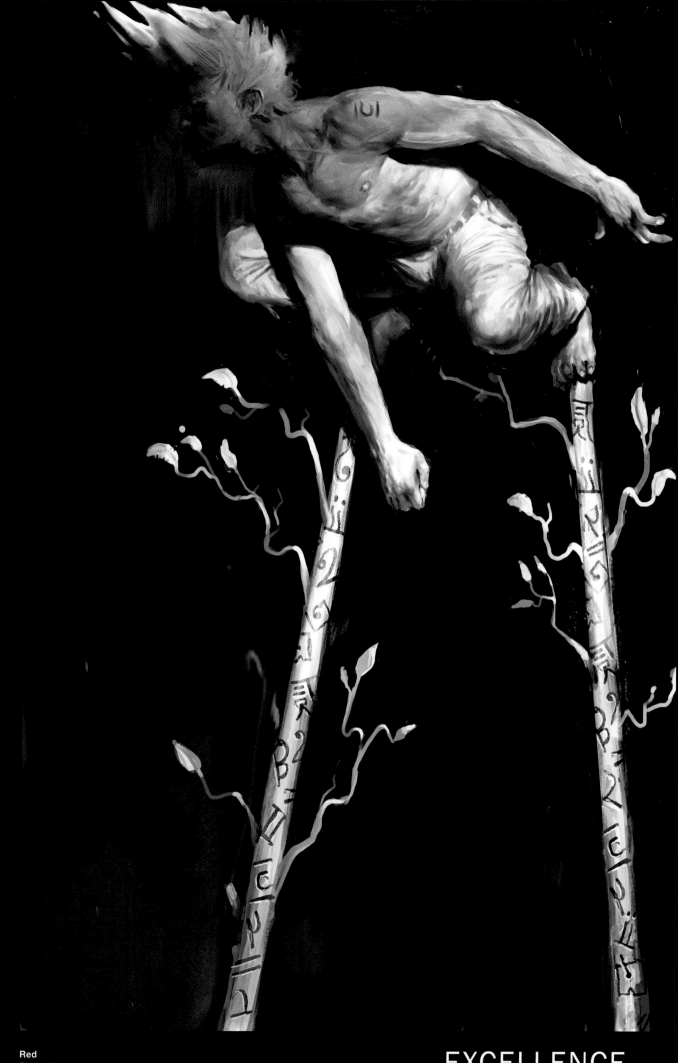

Red
Photoshop
Daniel Clarke,
SOUTH AFRICA

EXCELLENCE
Concept Art

EXCELLENCE

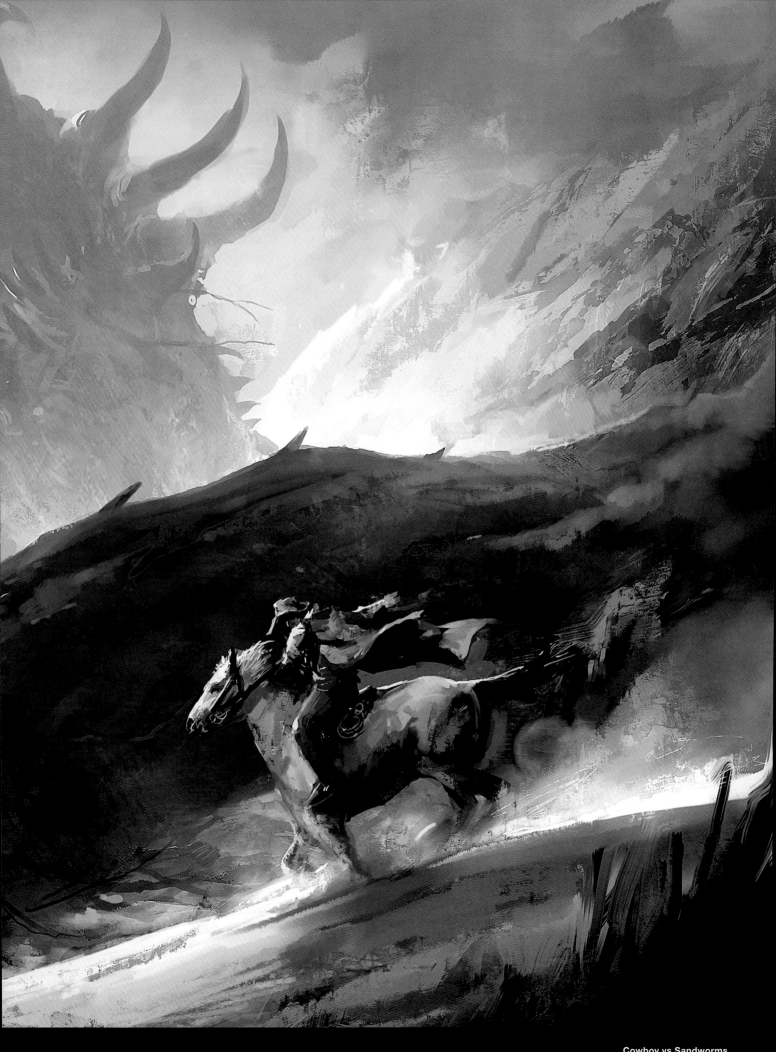

Cowboy vs Sandworms
Photoshop
Kekai Kotaki, USA

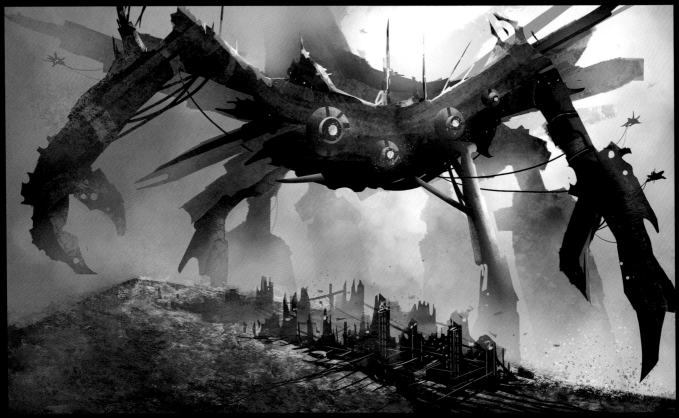

Diabolic
Photoshop
Amélie Hutt,
USA [top]

Guard city
Photoshop
Ramses Melendez,
MEXICO [above]

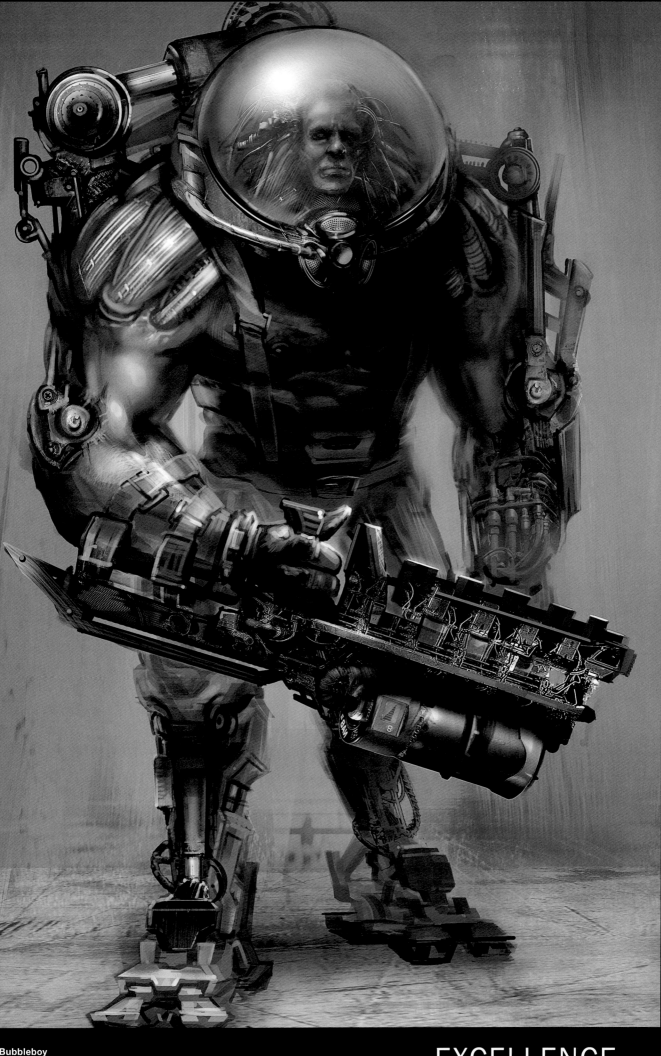

EXCELLENCE
Concept Art

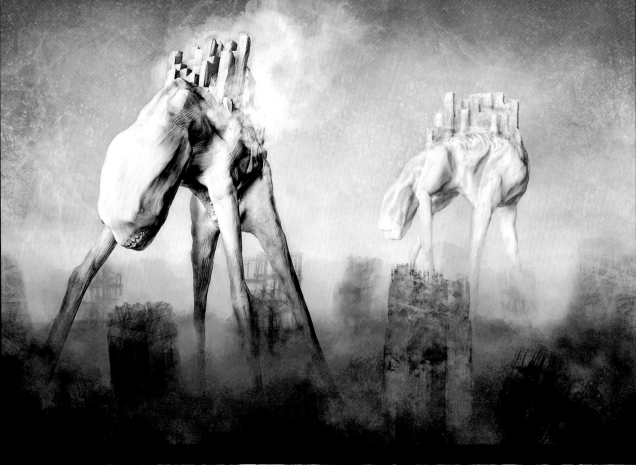

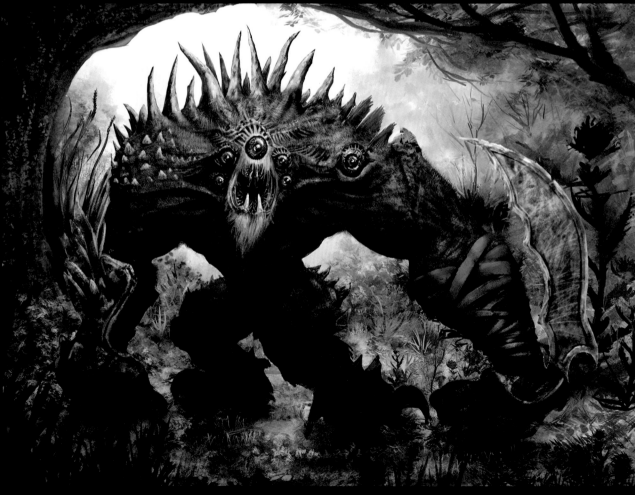

Defeat
CINEMA 4D, Photoshop, ZBrush
Andrzej Kuziola, GREAT BRITAIN
[top]

BigRed
Photoshop, ArtRage
Todd White, USA
[above]

Alien Freak
Photoshop
Todd White, USA
[right]

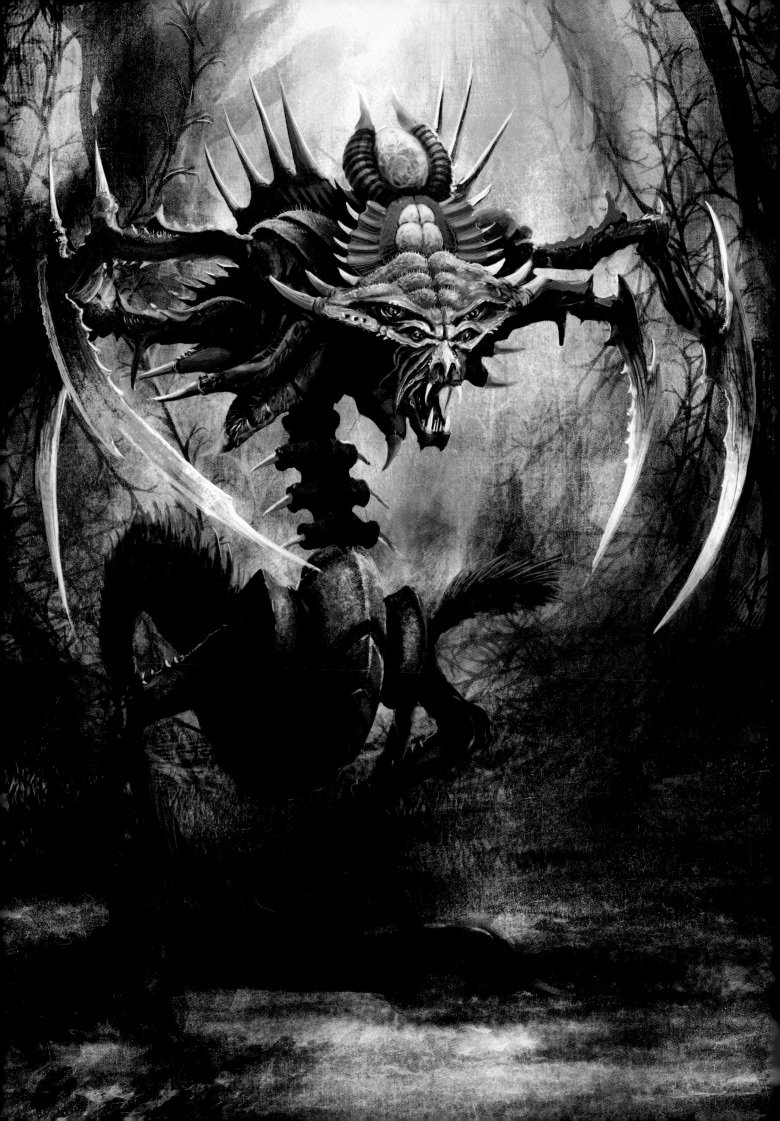

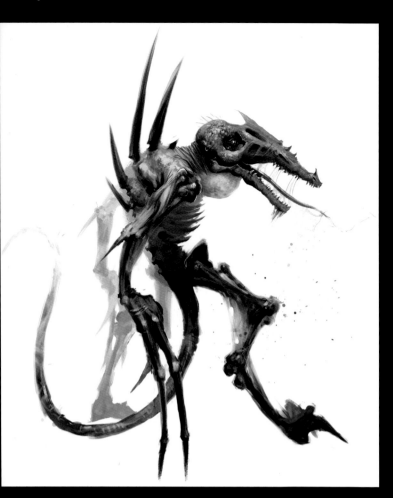

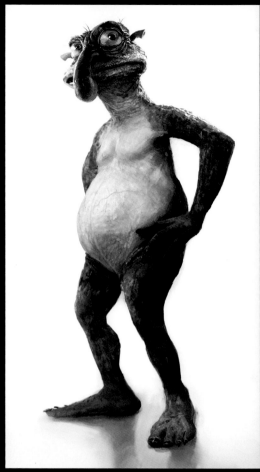

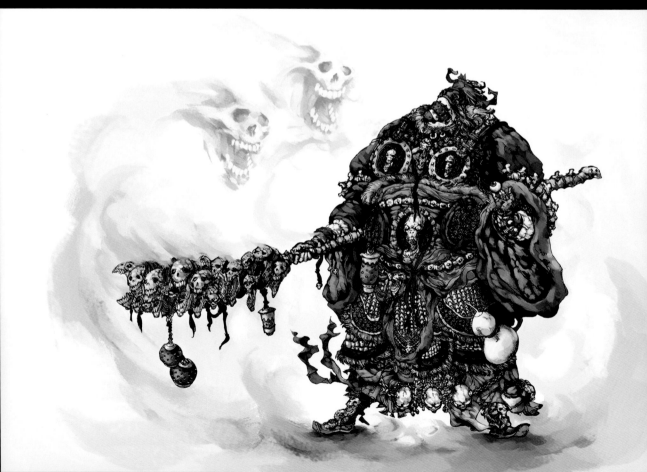

Ratlizard
Photoshop
Horia Dociu, USA
[top]

Butcher
Photoshop
Zhengtao Bai, CHINA
[above]

Bruce
Photoshop
Nacho Molina, SPAIN
[top]

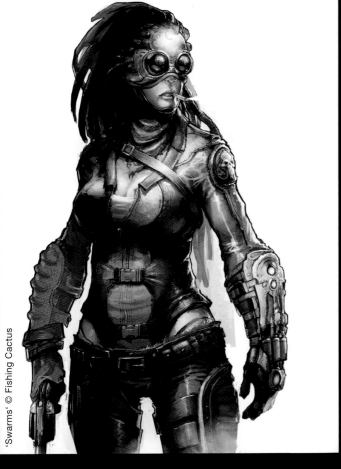

'Swarms' © Fishing Cactus

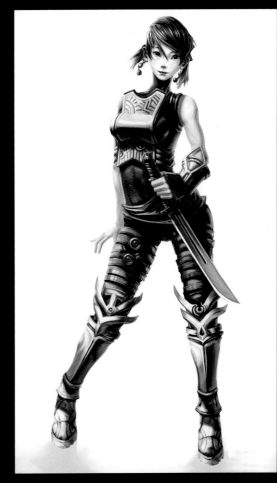

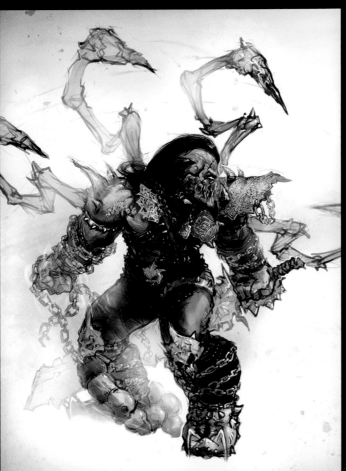

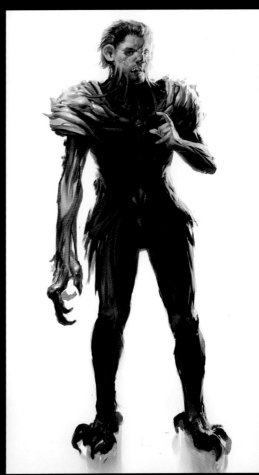

Swarms: Bio Engineer Concept
Photoshop
Client: Fishing Cactus
Remko Troost, CANADA [top]

Growler
Photoshop
Ivan Kashubo, RUSSIA
[above]

Woman
Photoshop
Zao Li, CHINA
[top]

Ugly
Photoshop
Daniel Clarke, SOUTH AFRICA
[above]

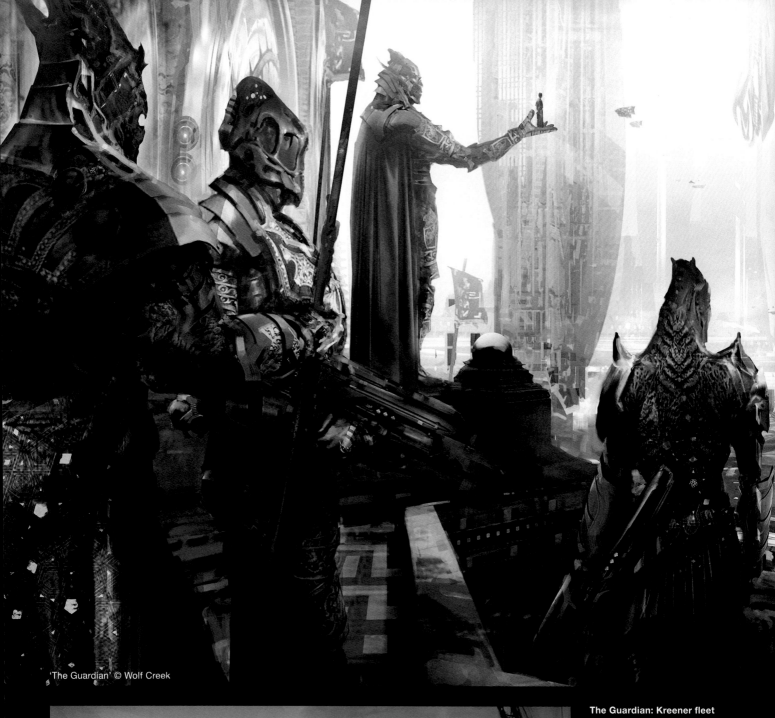

'The Guardian' © Wolf Creek

The Guardian: Kreener fleet
Photoshop, Painter
Client: Wolf Creek
Stephan Martiniere, USA
[above]

One man on the land
Photoshop
Seungjin Woo, SOUTH KOREA
[left, right]

Matte Painting

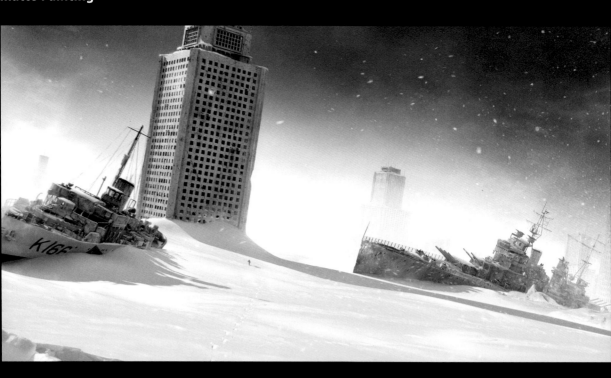

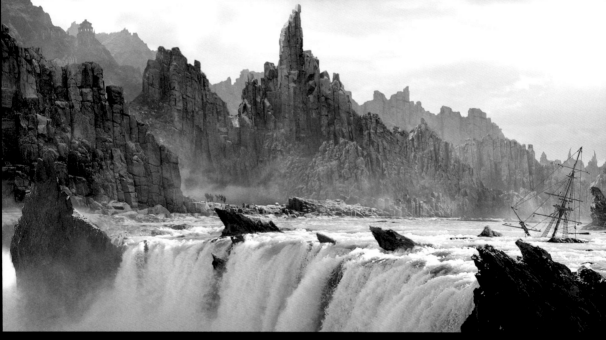

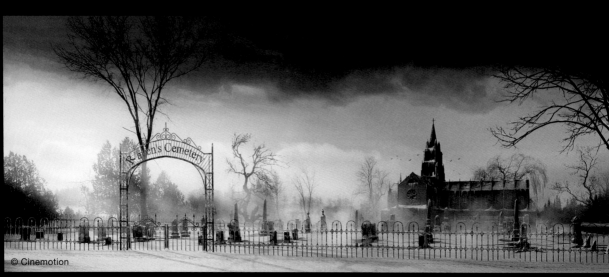

© Cinemotion

Aftermath
3ds Max, Photoshop, After Effects
Nikita Buyanov, RUSSIA
[top]

Epic Environment
Photoshop
Lubos dE Gerardo Surzin,
dEMP, GREAT BRITAIN *[center]*

Raven's cemetery
Maya, Photoshop
Valentin Petrov, BULGARIA
[above]

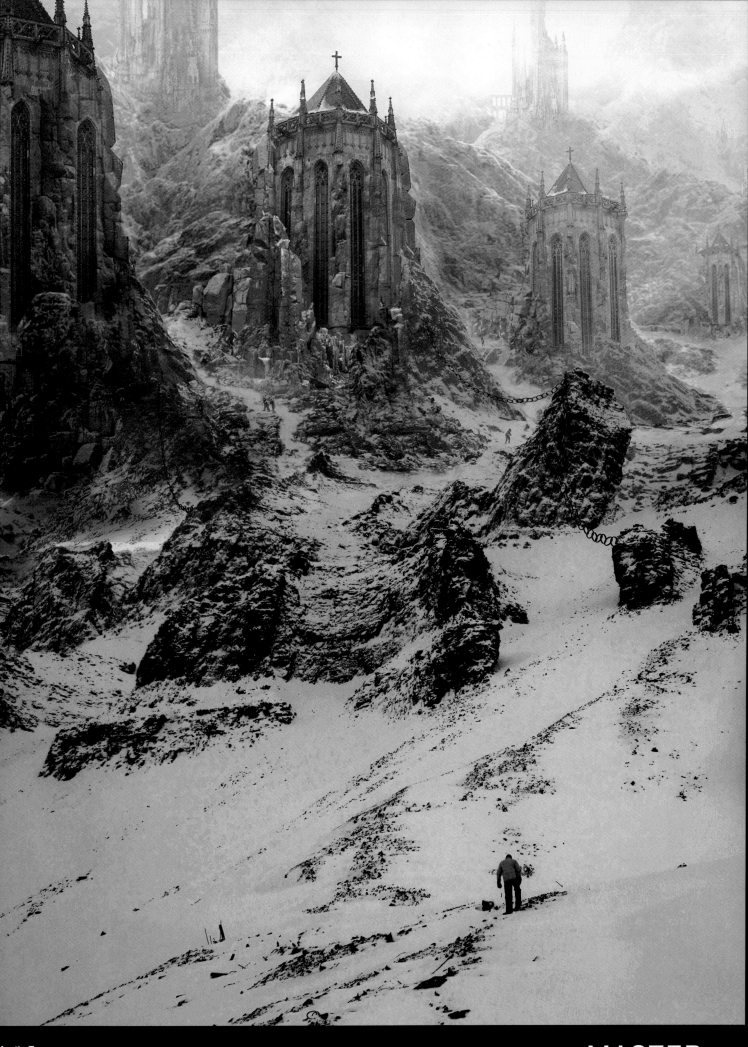

Arctic Towers
Photoshop, 3ds Max
Lubos dE Gerardo Surzin,
dEMP, GREAT BRITAIN

MASTER
Matte Painting

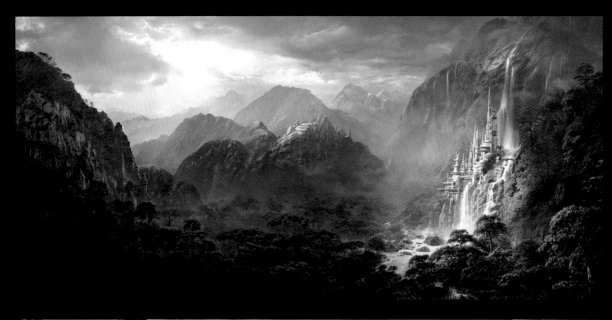

Sky God City
Photoshop
Sarel Theron,
SOUTH AFRICA
[left]

Rainforest city
3ds Max, Photoshop
Lubos dE Gerardo Surzin,
dEMP, GREAT BRITAIN
[right]

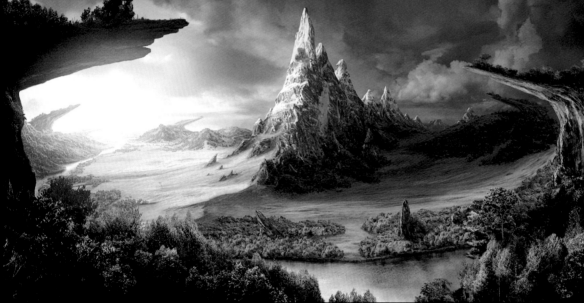

Forsaken lands
Photoshop
Mark Jordan,
SLOVENIA
[left]

2012
Photoshop
Inspired by: Roland
Emmerich's '2012'
Frank Hong,
CANADA
[right]

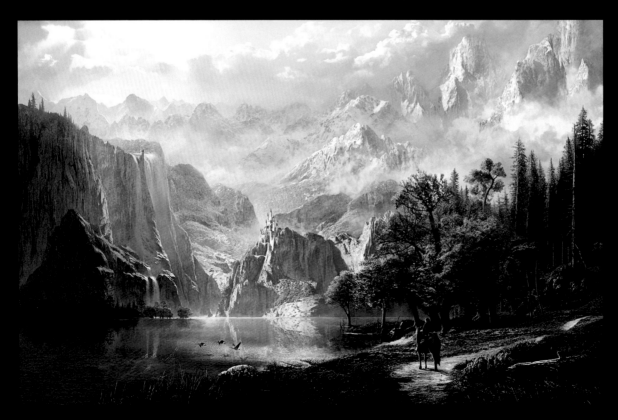

Idyll's Fall
Photoshop
Sarel Theron,
SOUTH AFRICA
[left]

Into the fog
Photoshop
Inspired by: James
Cameron's 'Avatar'
Dana Daukshta,
LATVIA
[right]

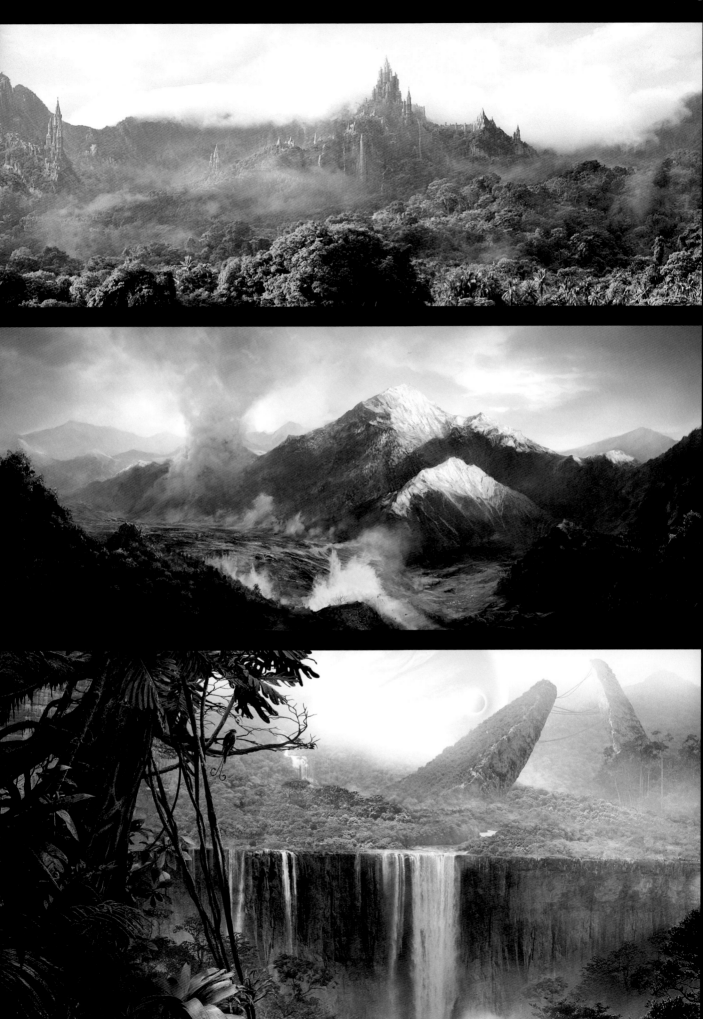

Lost
Photoshop
Valentin Petrov,
BULGARIA
[above]

A Farewell to Arms
Photoshop
Dmitry Mitsuk,
CANADA
[left]

Tortuga
3ds Max,
Photoshop, Poser
Dmitriy Glazyrin,
RUSSIA
[right]

Scifi Valley
Photoshop
Inspired by: Dylan Cole
Simon Weaner,
CANADA
[left]

Rebuilding the Ruins
Photoshop, Maya
Mark Goldsworthy,
USA
[right]

Big waves
Photoshop
Mojtaba Naderloo,
IRAN
[left]

New Mechana
LightWave 3D,
Photoshop
Sarel Theron,
SOUTH AFRICA
[right]

Valley
Photoshop
Simon Weaner,
CANADA
[left]

The Last Day
Photoshop
Bence Kresz,
HUNGARY
[right]

Translucence
Photoshop, Painter
Arthur Haas, THE NETHERLANDS

EXCELLENCE
Environment

'Planechase' © Wizards of the Coast

Gondor
Photoshop
Inspired by: J.R.R. Tolkien's 'Lord of the Rings'
César Rizo, VENEZUELA

Planechase: Turri Island
Photoshop
Art Director: Jeremy Jarvis
Client: Wizards of the Coast

Harbour
Maya, mental ray, ZBrush, Photoshop
Aleksandar Jovanovic, SERBIA

EXCELLENCE
Environment

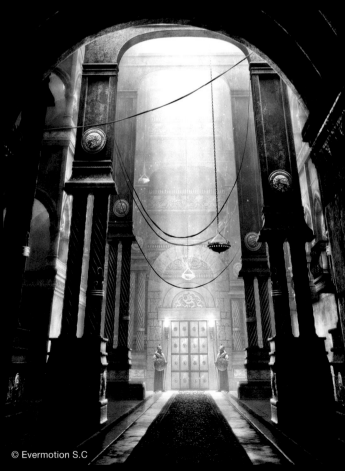

Lightbringer
Photoshop, 3ds Max
Jesse van Dijk,
THE NETHERLANDS
[top]

Dark Alley
Photoshop
Lorenz Hideyoshi Ruwwe,
GERMANY
[above]

Young souls
CINEMA 4D, V-Ray,
Photoshop, Vectorworks
Cyril Charmet, FRANCE
[top]

Temple
3ds Max, V-Ray, Photoshop
Concept by: Bruno 'Hydropix' Gentile
Client: Evermotion S.C
Rafa Waniek, POLAND *[above]*

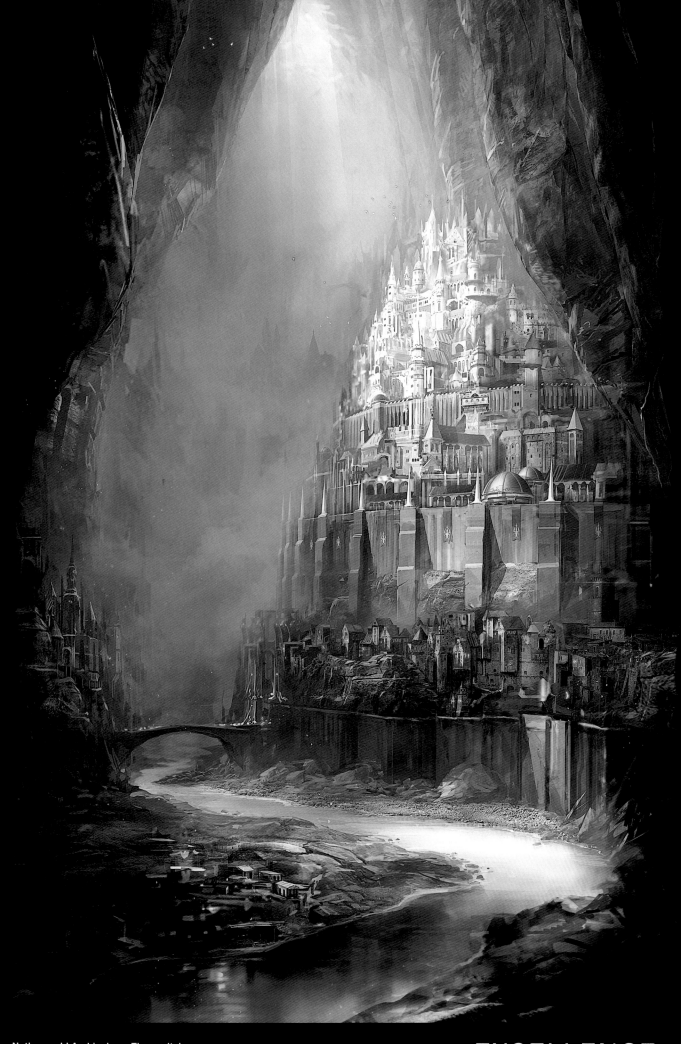

Netherworld Archipelago: The capital
Photoshop
Jesse van Dijk,
THE NETHERLANDS

EXCELLENCE
Environment

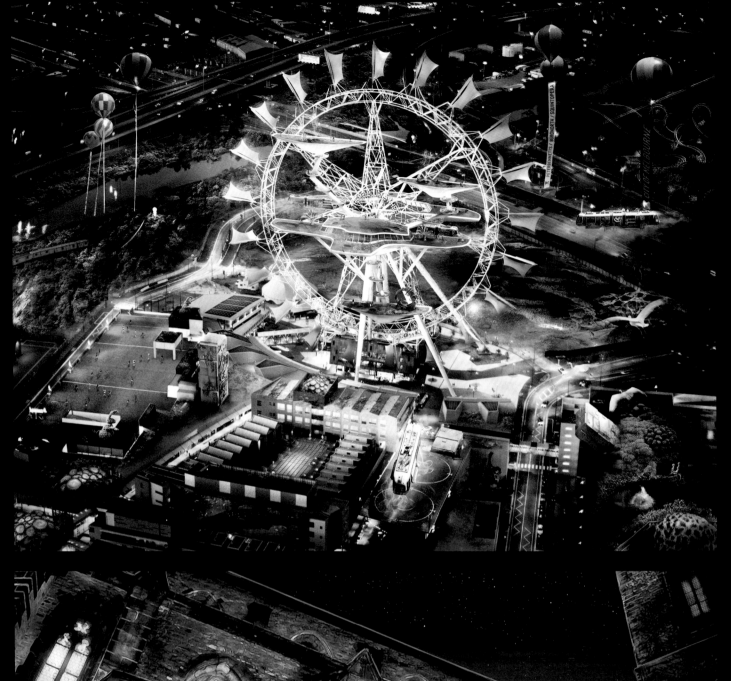

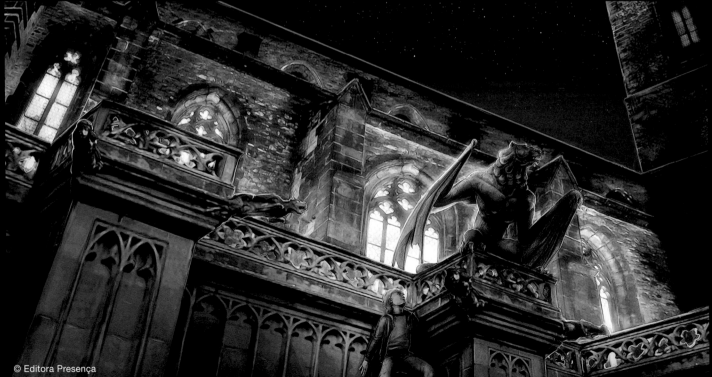

Melbourne Future Wheel
3ds Max, Photoshop
Photographer: Peter Bennetts
Fooch Chi Sung, Squint Opera, AUSTRALIA *[top]*

Stoneheart: Iron Hand cover
Photoshop
Client: Editora Presença
Tiago da Silva, PORTUGAL *[above]*

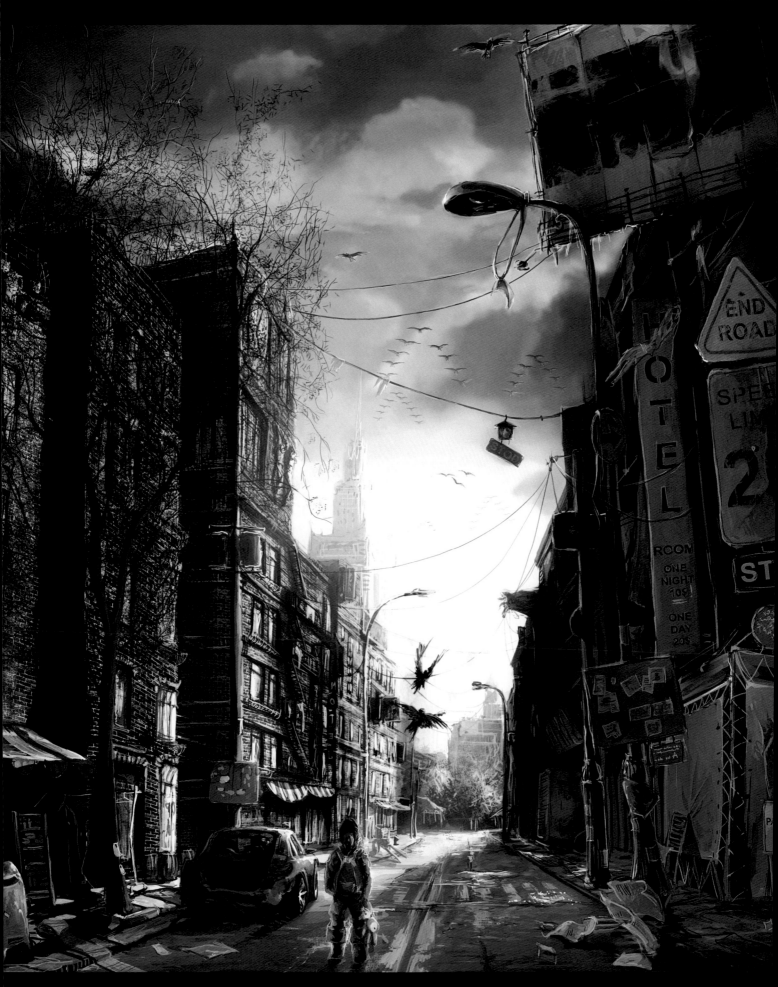

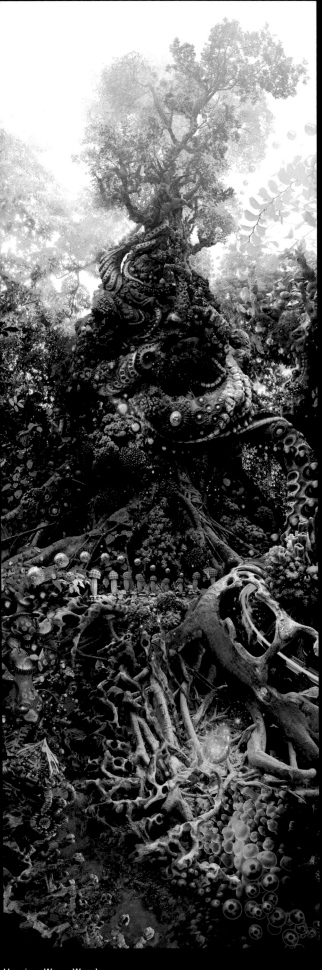

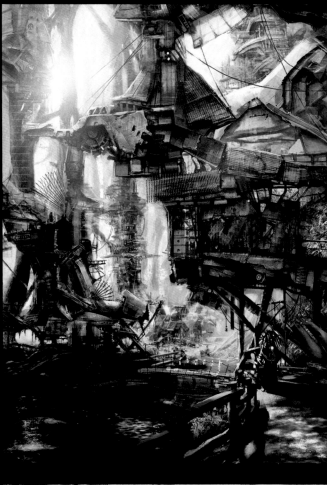

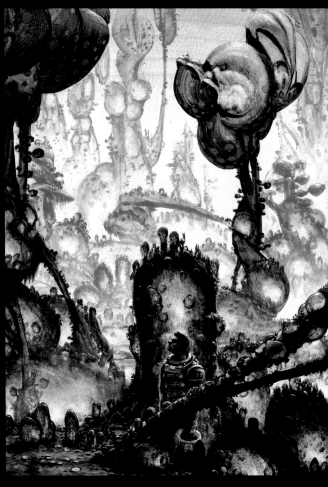

Uranium Worm Wood
3ds Max, ZBrush, V-Ray, Photoshop
Andy Thomas, Android, AUSTRALIA
[above]

Hooga Chooga
Photoshop
Dmitry Zaviyalov, ESTONIA
[top]

Exploration
Photoshop
Arthur Haas, THE NETHERLANDS
[above]

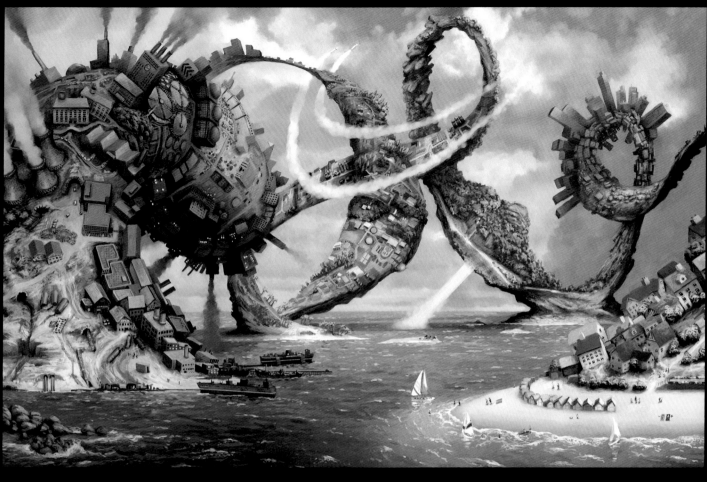

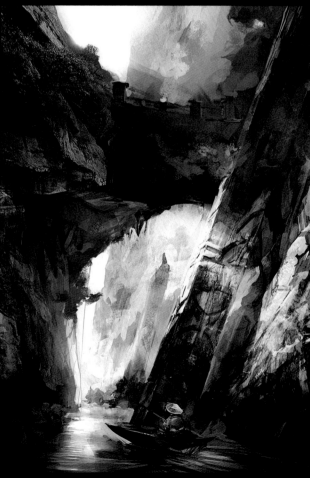

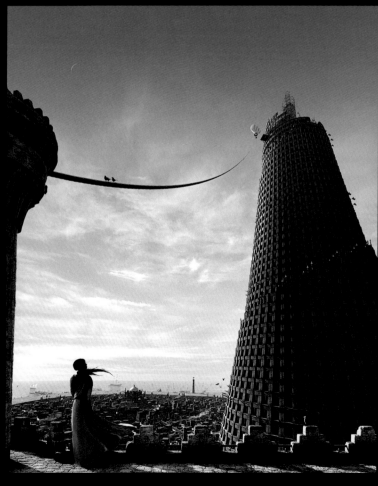

Industry
Painter
Simon Dominic, GREAT BRITAIN
[top]

The Temple of Czenheng
Photoshop
Ben Lo, CANADA
[above]

Reaching out
Blender 3D, GIMP
Soenke Maeter, GERMANY
[above]

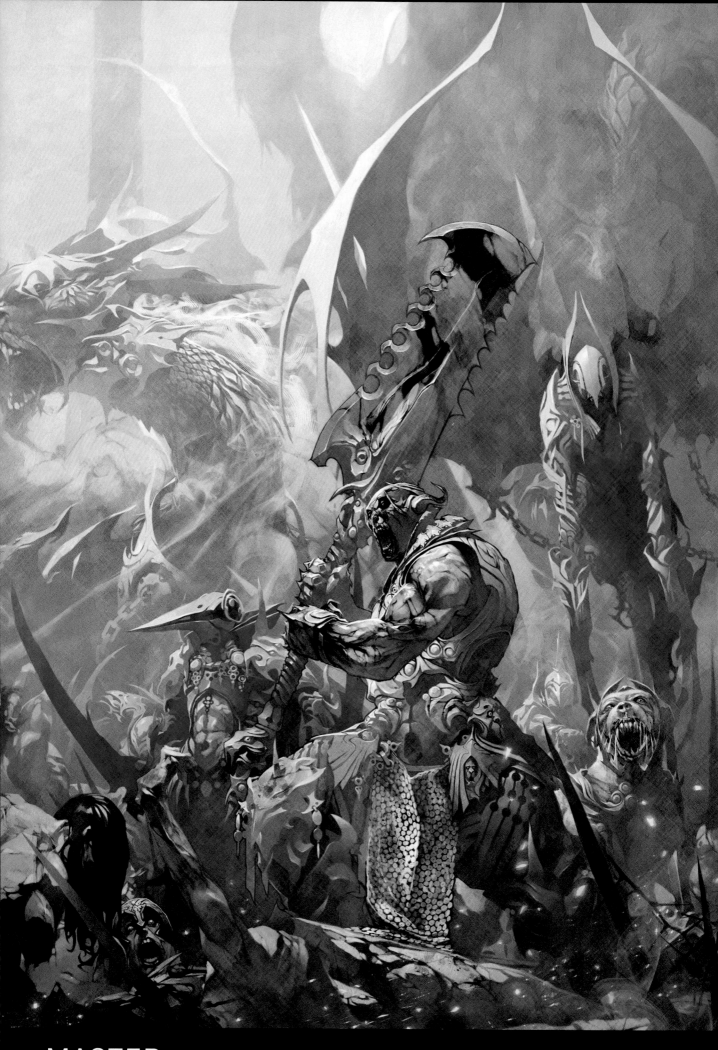

MASTER
Warriors & Conflict

Knights of Abomination
Photoshop
Reynan Sanchez,
THE PHILIPPINES

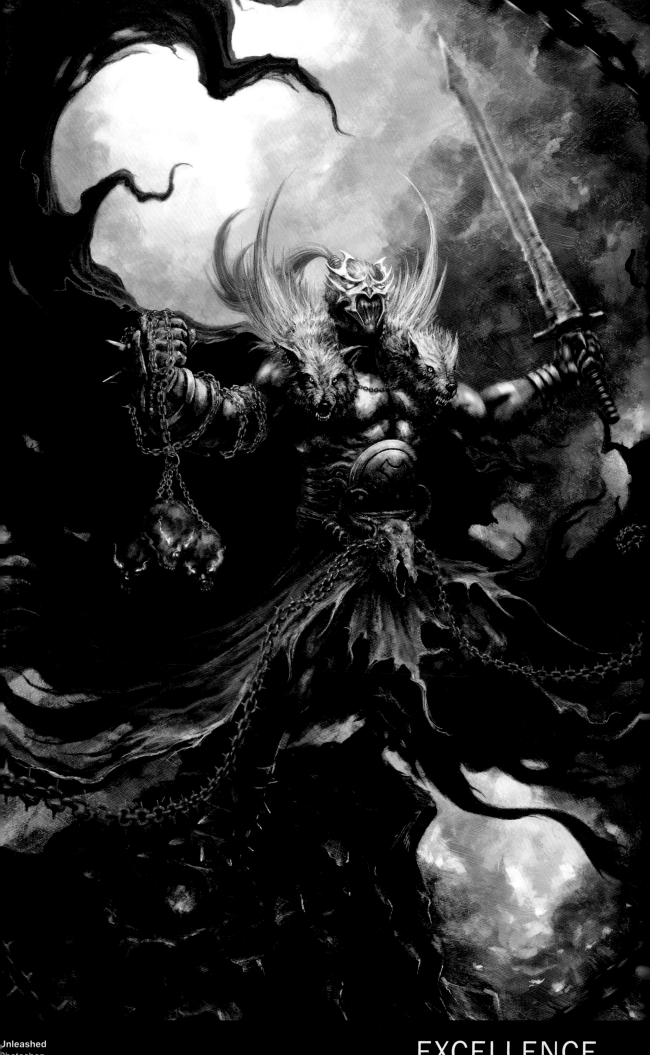

Unleashed
Photoshop
Inspired by: Spawn
Jeffrey M. de Guzman, THE PHILIPPINES

EXCELLENCE
Warriors & Conflict

EXCELLENCE
Warriors & Conflict

'Zendikar' © Wizards of the Coast

Ruinous Minotaur
Photoshop
Art Director: Jeremy Jarvis
Client: Wizards of the Coast
Raymond Swanland, USA

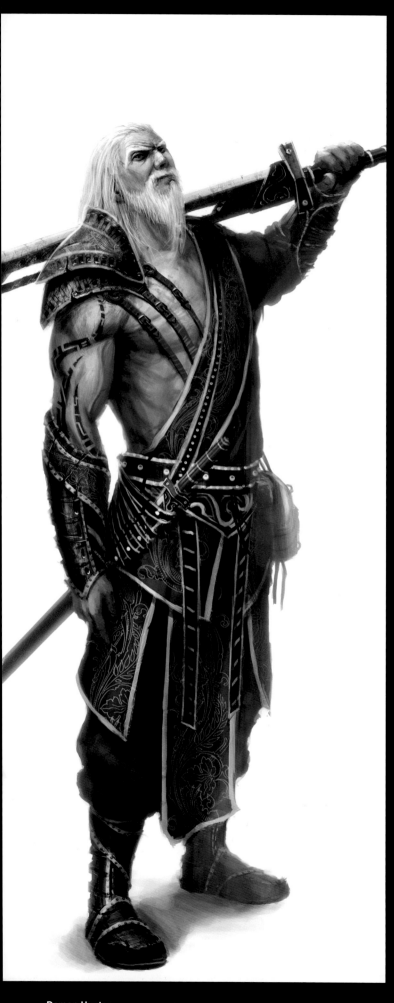

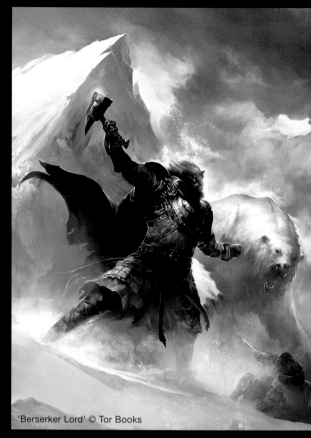

'Berserker Lord' © Tor Books

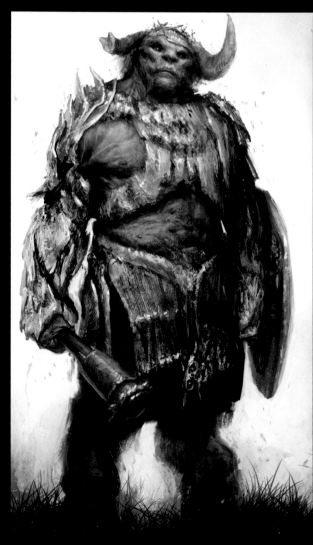

Demon Hunter
Photoshop
Tu Bui, USA
[above]

Berserker Lord
Photoshop
Client: Tor Books
Kekai Kotaki, USA [top]

Intimidation
Photoshop
Branko Bistrovic, CANADA
[above]

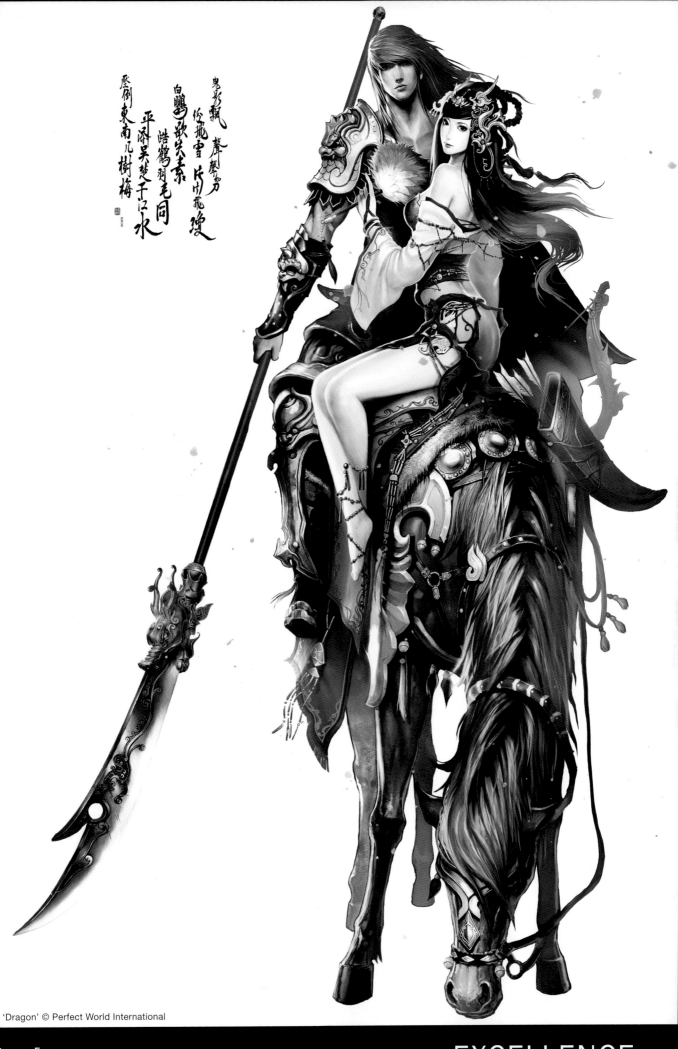

鬼影飄 聲聲刃勇
白鷗歌失素 俊飛龍雪 片竹飛縵
平深吳楚千江水 皓鶴羽毛同
歷劍東南几樹梅

'Dragon' © Perfect World International

Dragon: Envoy
Photoshop
Wenjun Lin, Perfect World International,
CHINA

EXCELLENCE
Warriors & Conflict

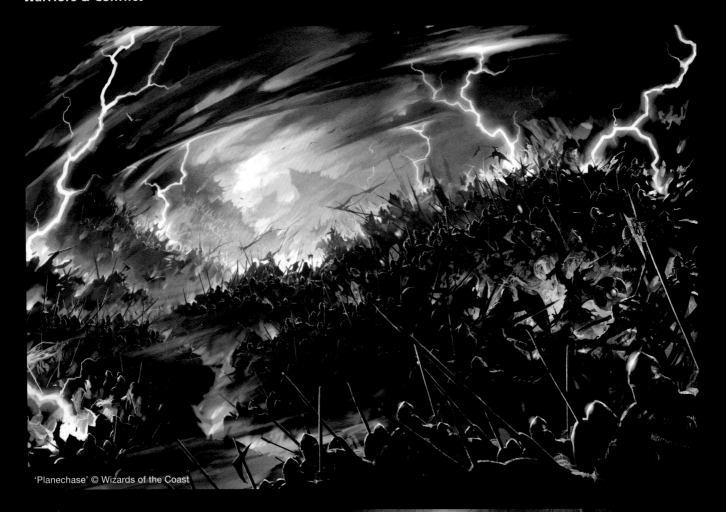

'Planechase' © Wizards of the Coast

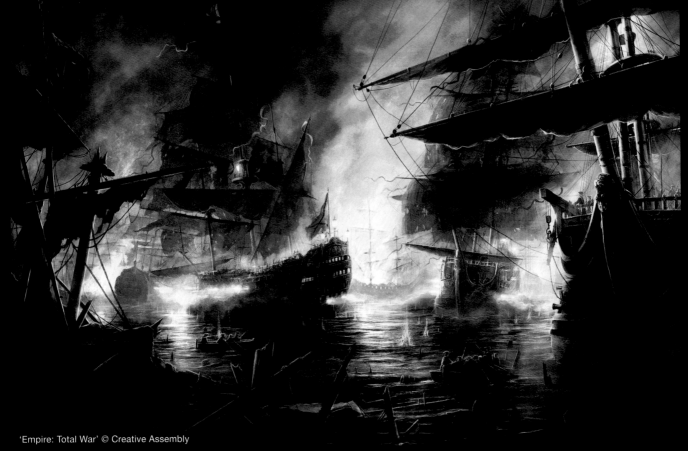

'Empire: Total War' © Creative Assembly

Planechase: Immersturm
Photoshop
Art Director: Jeremy Jarvis
Client: Wizards of the Coast
Raymond Swanland. USA *[top]*

Empire: Total War (The Fire)
Photoshop
Client: Creative Assembly
Rado Javor. SLOVAKIA
[above]

Merciless
Photoshop
Michal Ivan,
SLOVAKIA
[right]

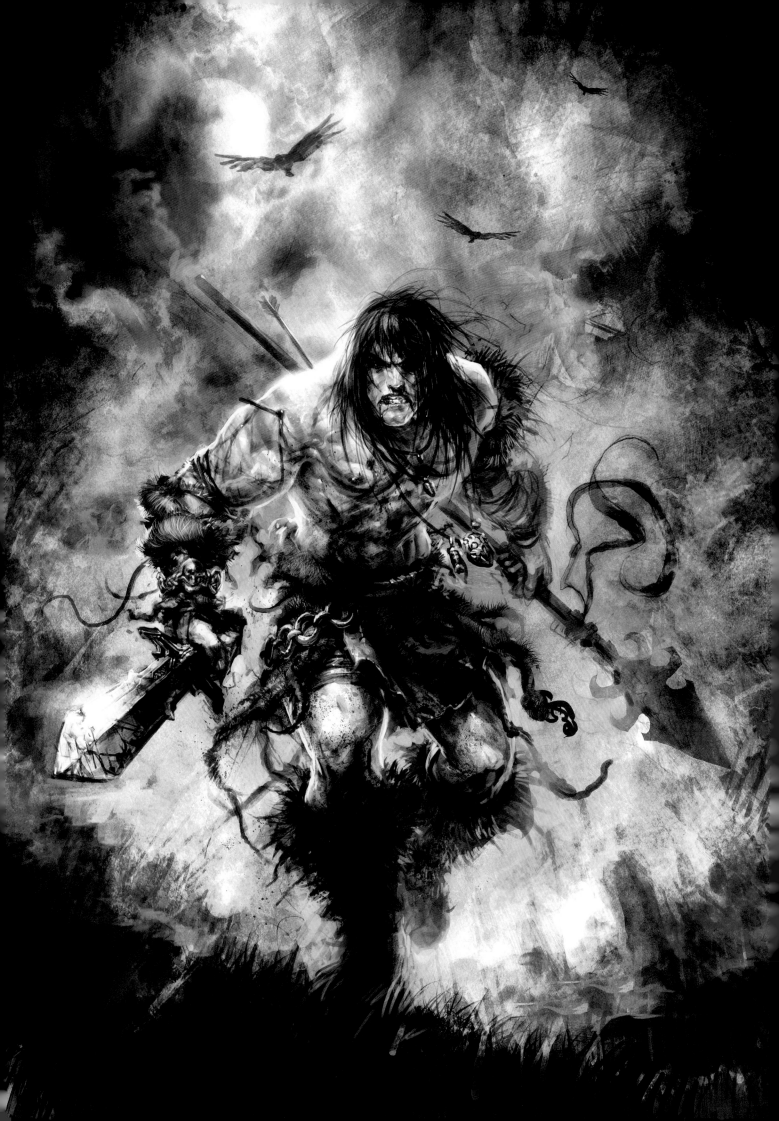

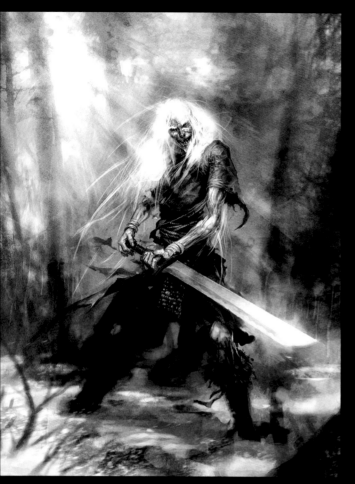

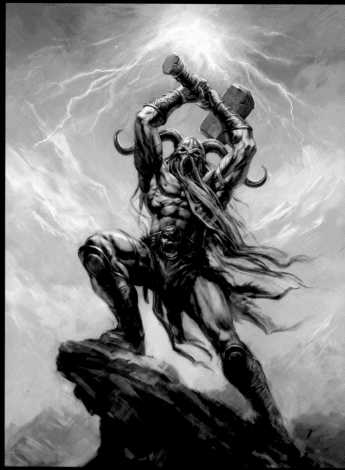

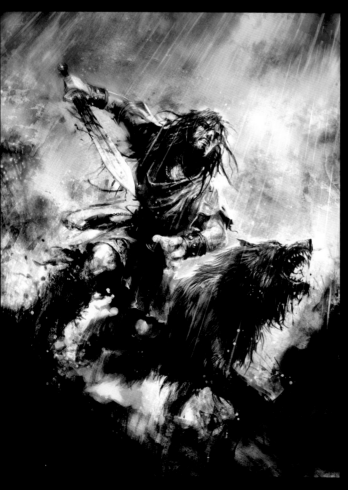

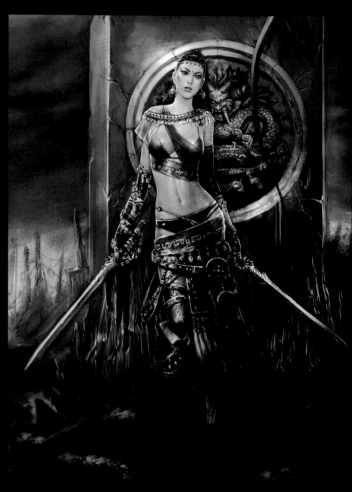

Madman's smile
Photoshop
Michal Ivan, SLOVAKIA
[top]

Lord of Wolves
Photoshop
Michal Ivan, SLOVAKIA
[above]

Thor
Painter, ArtRage
Alan Lathwell, GREAT BRITAIN
[top]

Moonshadow
Photoshop
Huang DaHong, CHINA
[above]

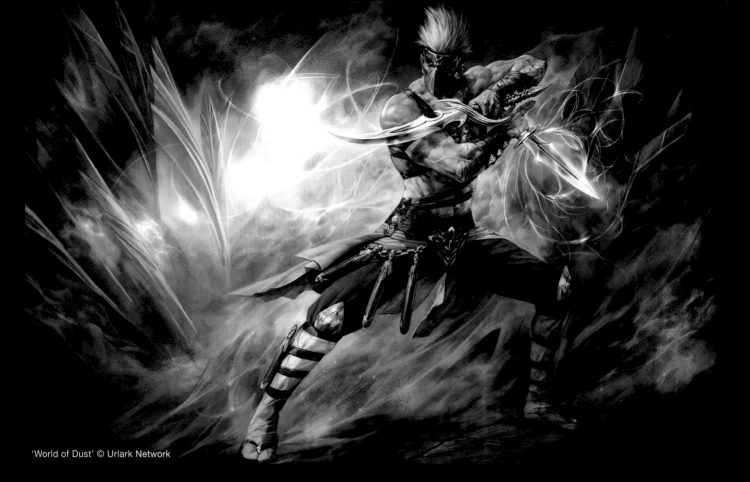

'World of Dust' © Urlark Network

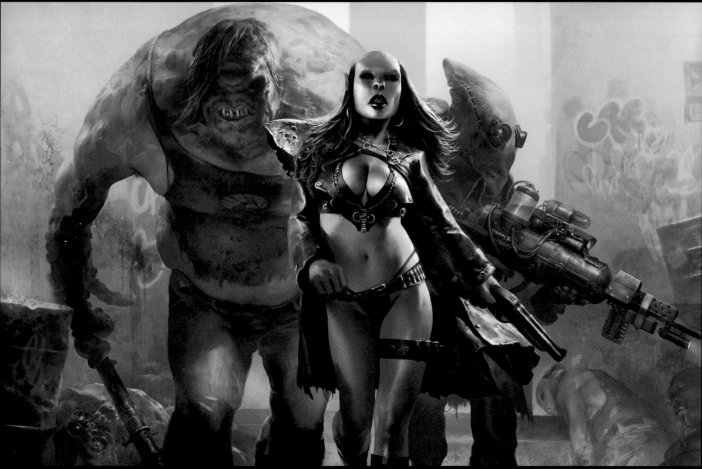

World of Dust: Assassin
Photoshop
Client: Urlark Network
Feng Wei, CHINA *[top]*

A Hostile Takeover
Photoshop
Brad Rigney, USA
[above]

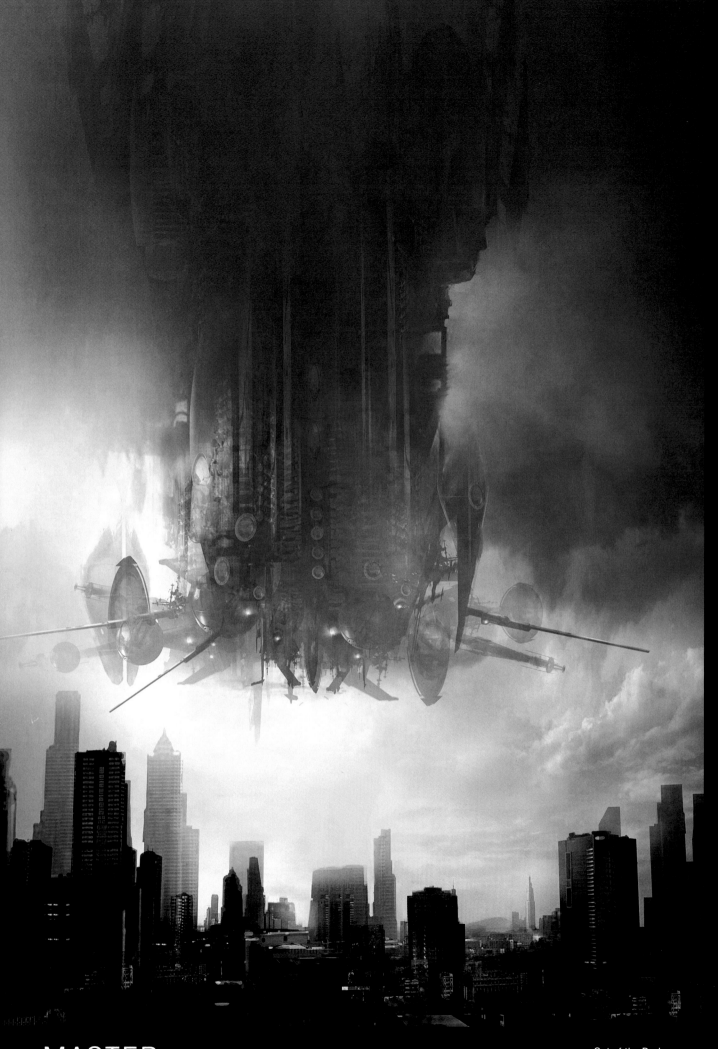

MASTER
Science Fiction

Out of the Dark
Photoshop, Painter
Client: Tor Books
Stephan Martiniere, USA

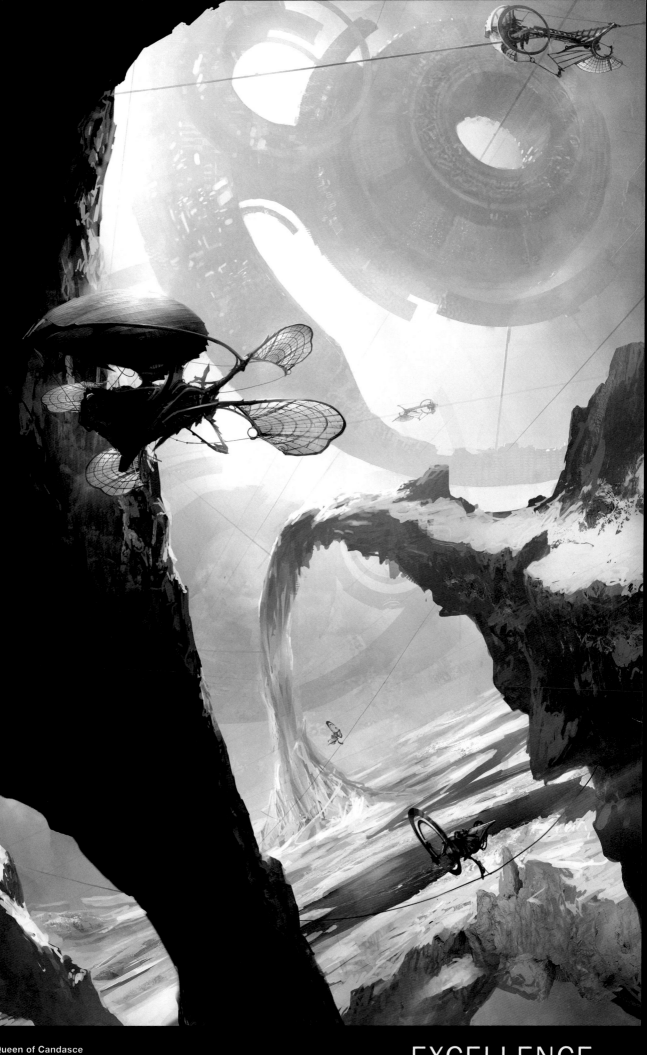

EXCELLENCE
Science Fiction

Techscape
Photoshop, Painter
Arthur Haas, THE NETHERLANDS
[top]

Exogenesis
Photoshop
Maciej Rebisz, POLAND
[above]

Enforcer and the Towers of Sirius
PhotoPaint, Alchemy
Dimitri Patelis, CANADA
[top]

Cathedral
Photoshop, Painter
Client: Solaris books
Stephan Martiniere, USA

EXCELLENCE
Science Fiction

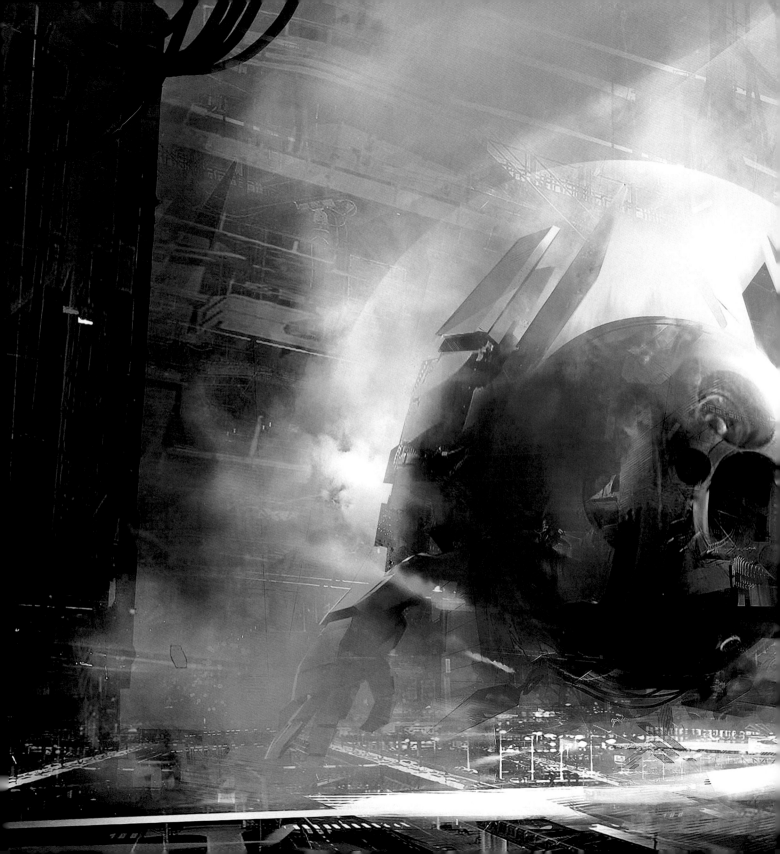

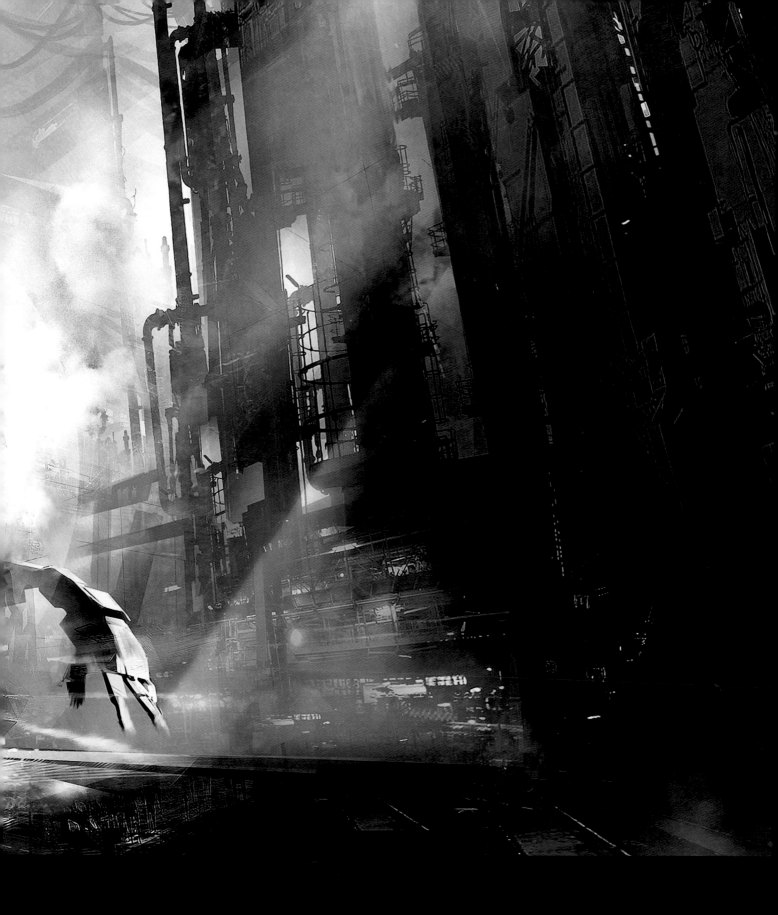

Roboneko
Photoshop
Eduardo Peña,
Universidad de Los Andes,
COLOMBIA

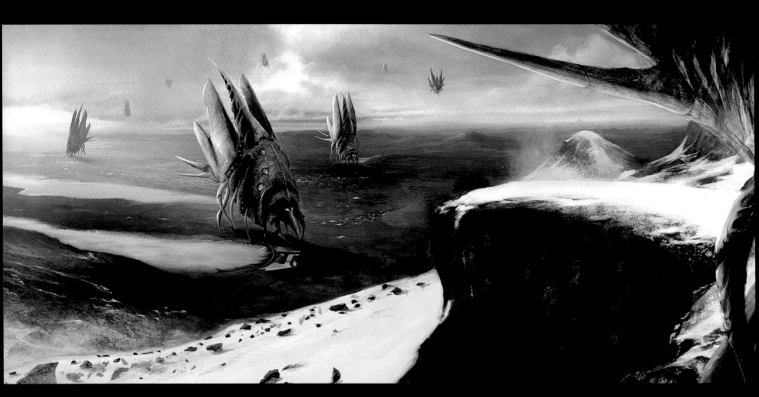

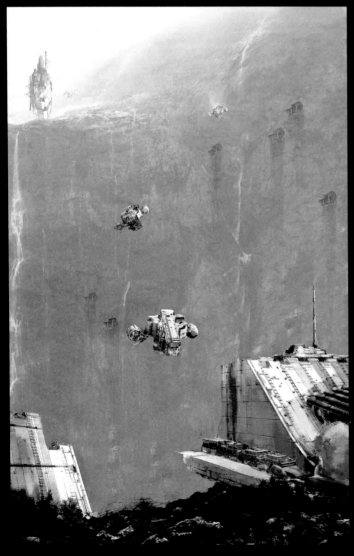

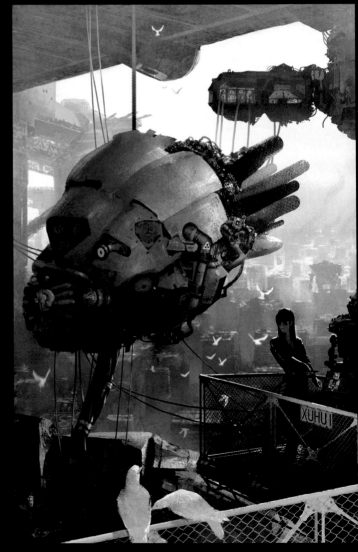

Them
Photoshop
Kentaro Kanamoto,
USA
[top]

Flyers
Photoshop, modo
Hugh Sicotte,
USA
[above]

Maintenance
Photoshop
Xu Hui,
CHINA
[above]

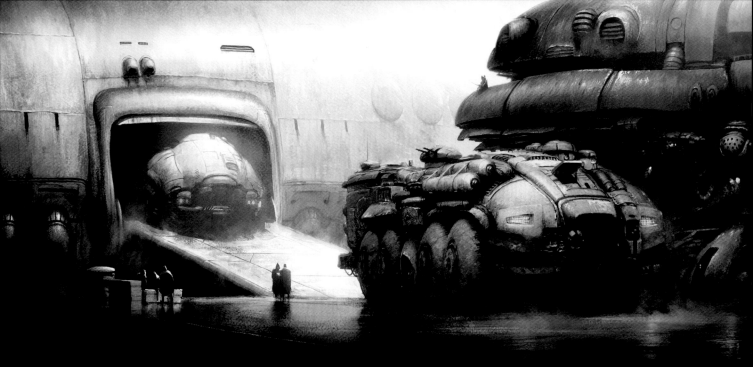

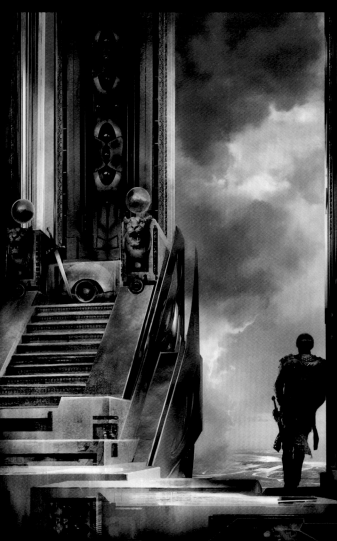

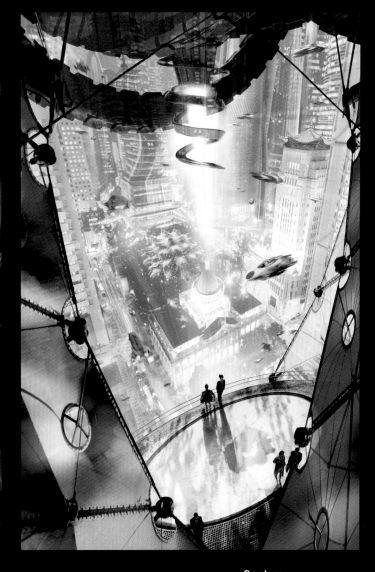

Transporter
Photoshop
Marcin Jakubowski,
POLAND
[top]

Prince of Storm
Photoshop, Painter
Client: Pyr Books
Stephan Martiniere, USA
[above]

Cryoburn
Photoshop
Art Director: Toni Weisskopf
Client: Baen Books
Dave Seeley, USA *[above]*

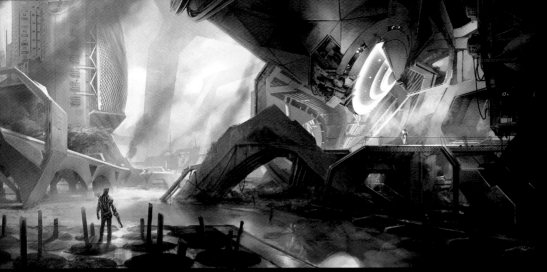

Days of Victory
Photoshop
Ioan Dumitrescu,
ROMANIA
[left]

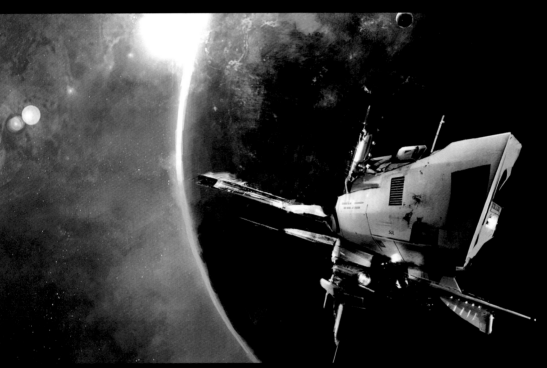

Space Scene 6
Photoshop
Hugh Sicotte, USA
[left]

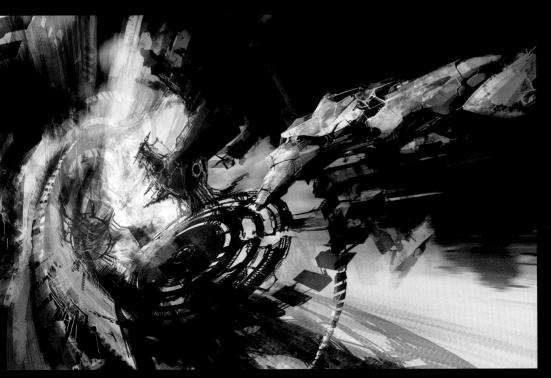

Subspace
Photoshop
Alexander Preuss,
GERMANY
[left]

Steam City
3ds Max, finalRender,
Photoshop
Stefan Morrell,
NEW ZEALAND
[right]

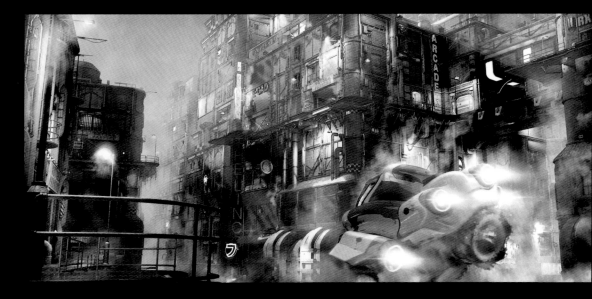

The Wood
Photoshop
David Lecossu, FRANCE
[right]

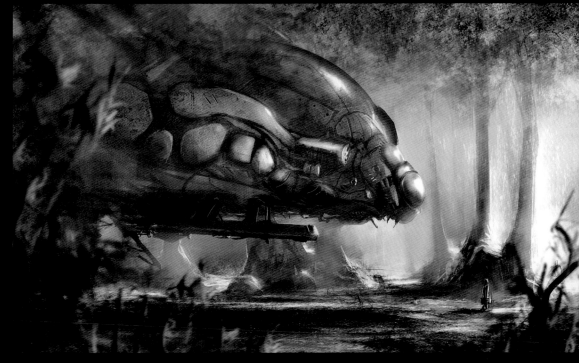

New Eden
CINEMA 4D, Photoshop
Adam Benton,
GREAT BRITAIN
[right]

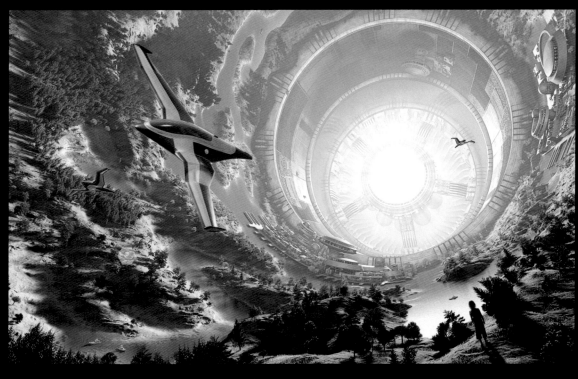

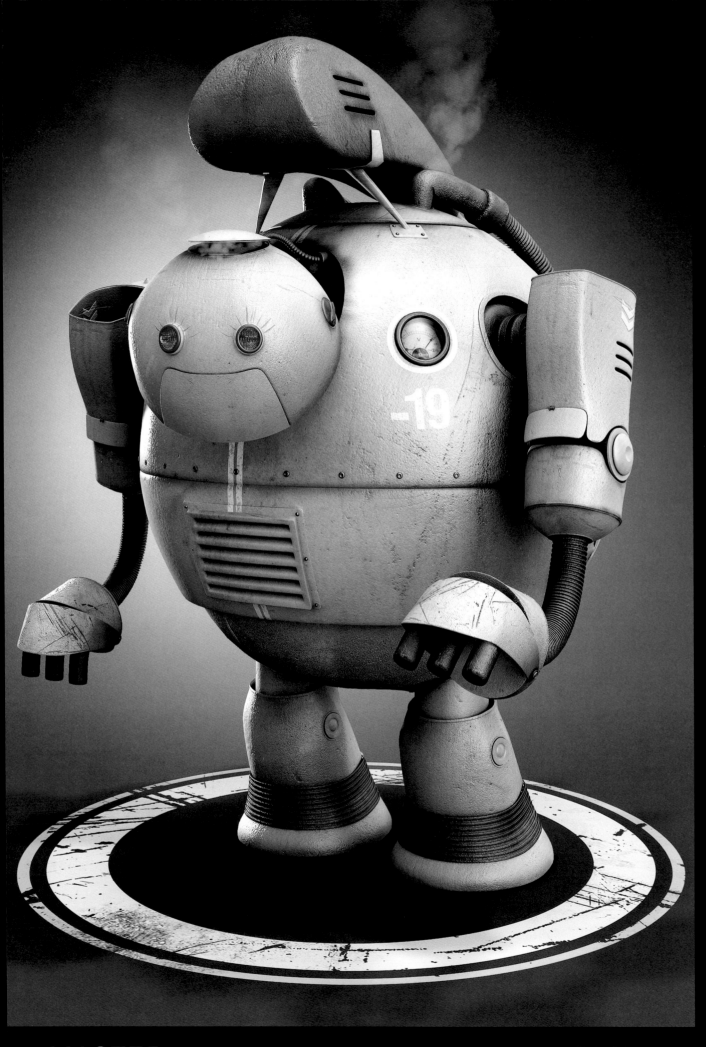

MASTER
Robotic/Cyborg

Worker Robot
3ds Max, Photoshop, V-Ray
Hossein Afzali, IRAN

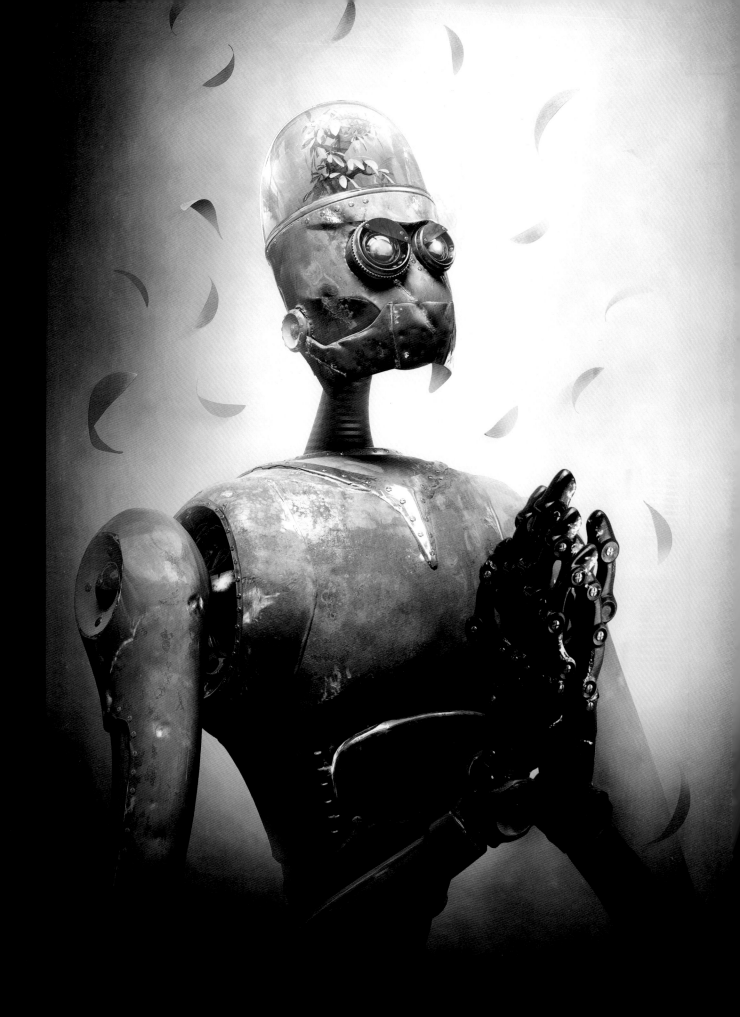

Mastermind
3ds Max, ZBrush, Photoshop
Andrzej Sykut, POLAND

EXCELLENCE
Robotic/Cyborg

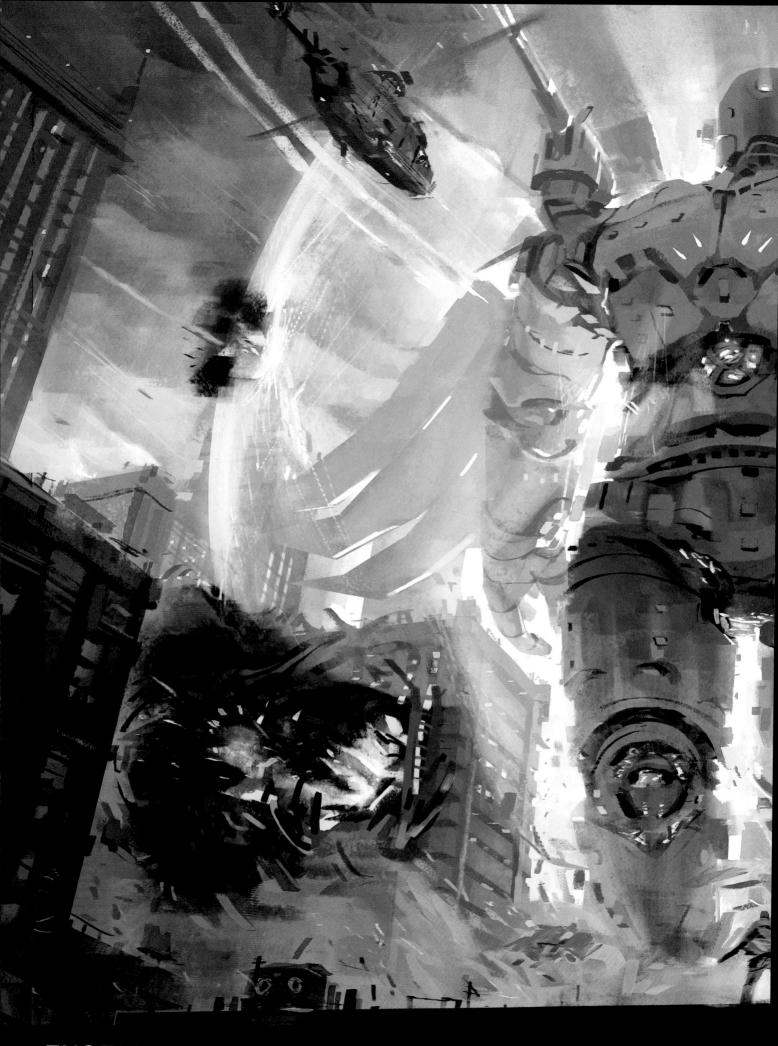

EXCELLENCE
Robotic/Cyborg

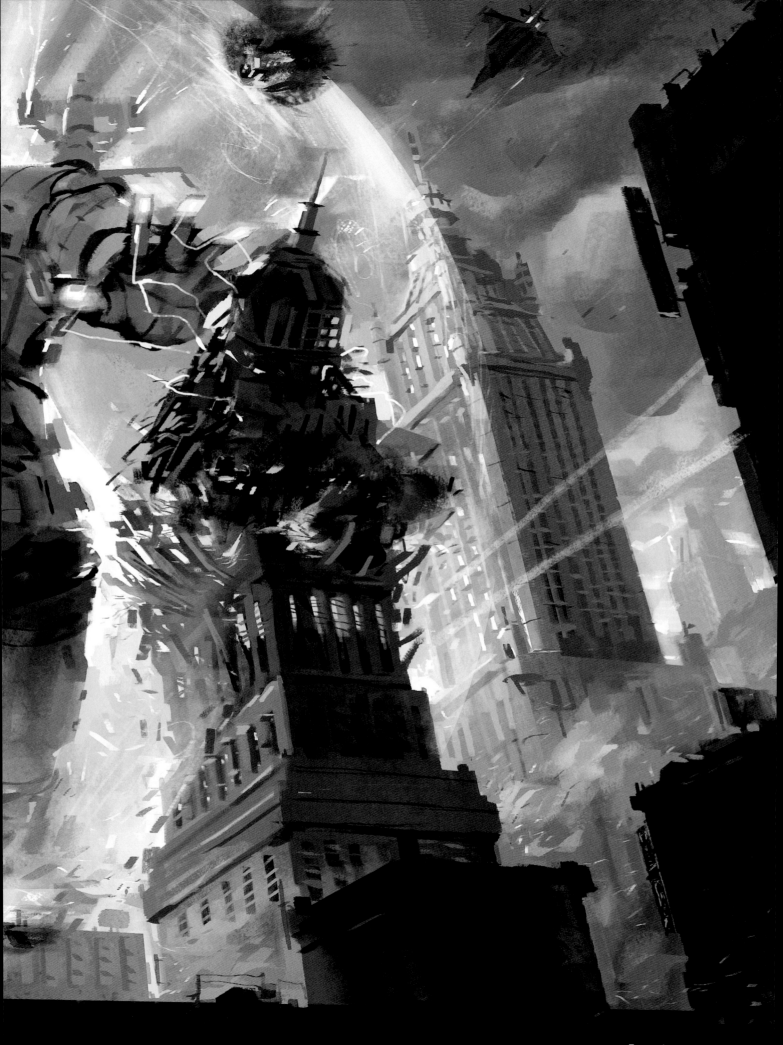

Encounter
Photoshop
Anthony Wolff. FRANCE

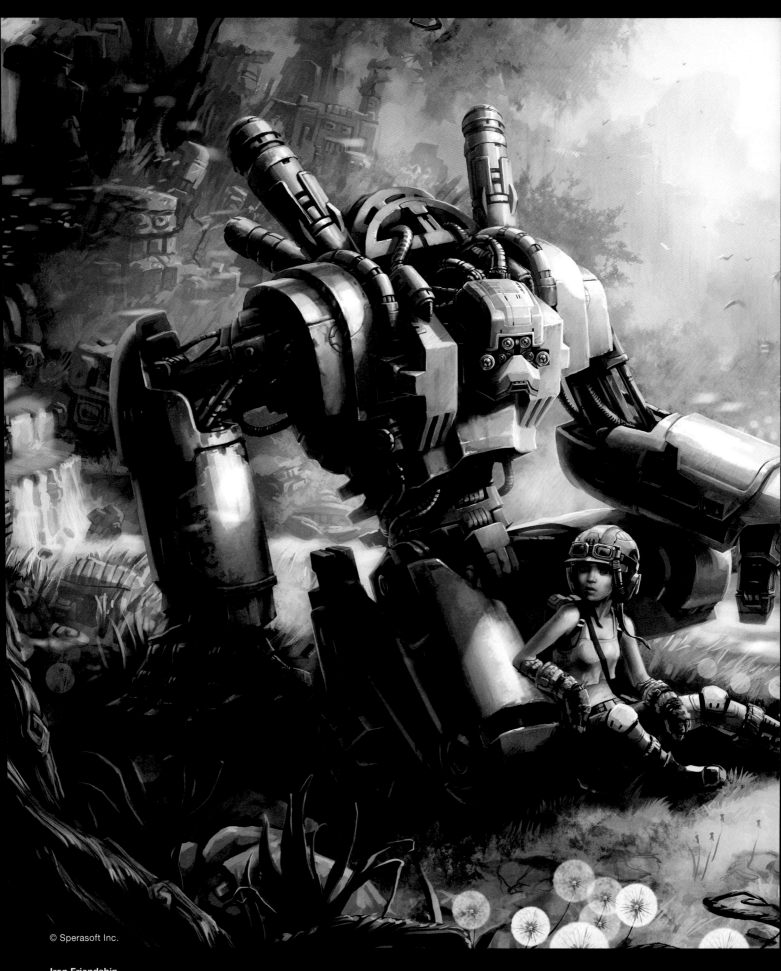

Iron Friendship
Photoshop
Client: Sperasoft Studios
Roman Artamonov, RUSSIA

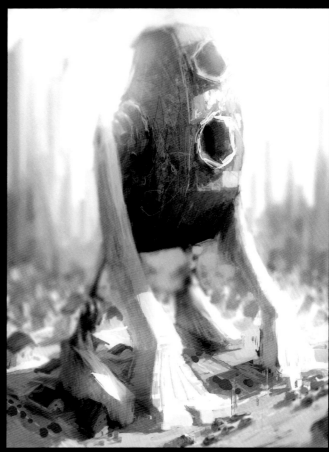

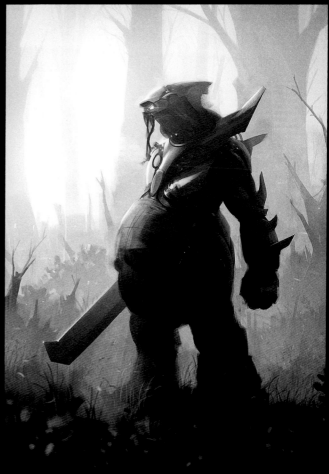

Bot
Photoshop
Marco Bucci, CANADA

The beast
Photoshop
Jama Jurabaev, TAJIKISTAN

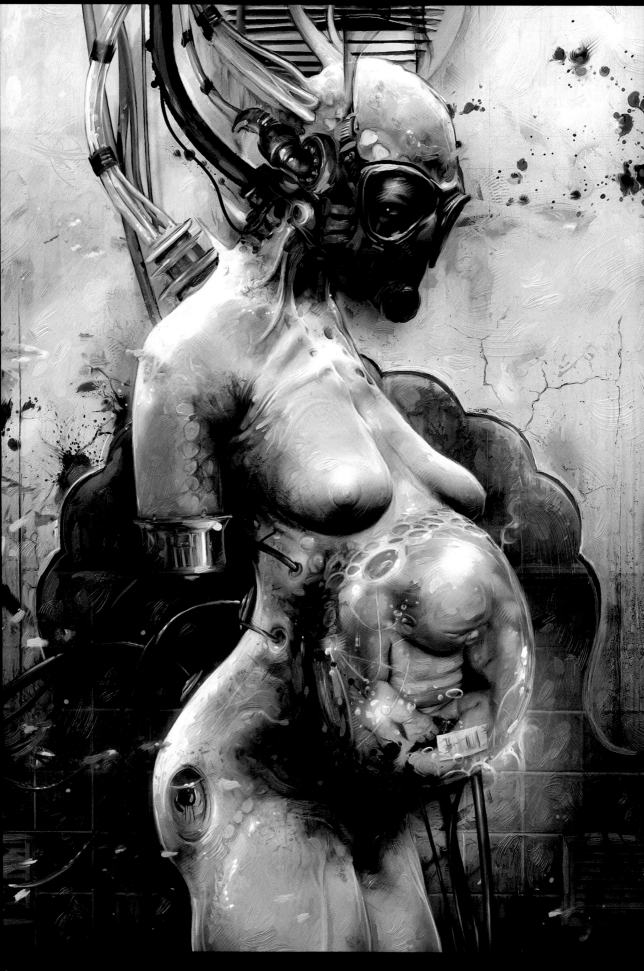

Genese
Photoshop, ArtRage. ZBrush
Bruno Wagner, FRANCE
[above]

Double Ride
Maya, mental ray, ZBrush, Photoshop
Ilhan Yılmaz, TURKEY
[right]

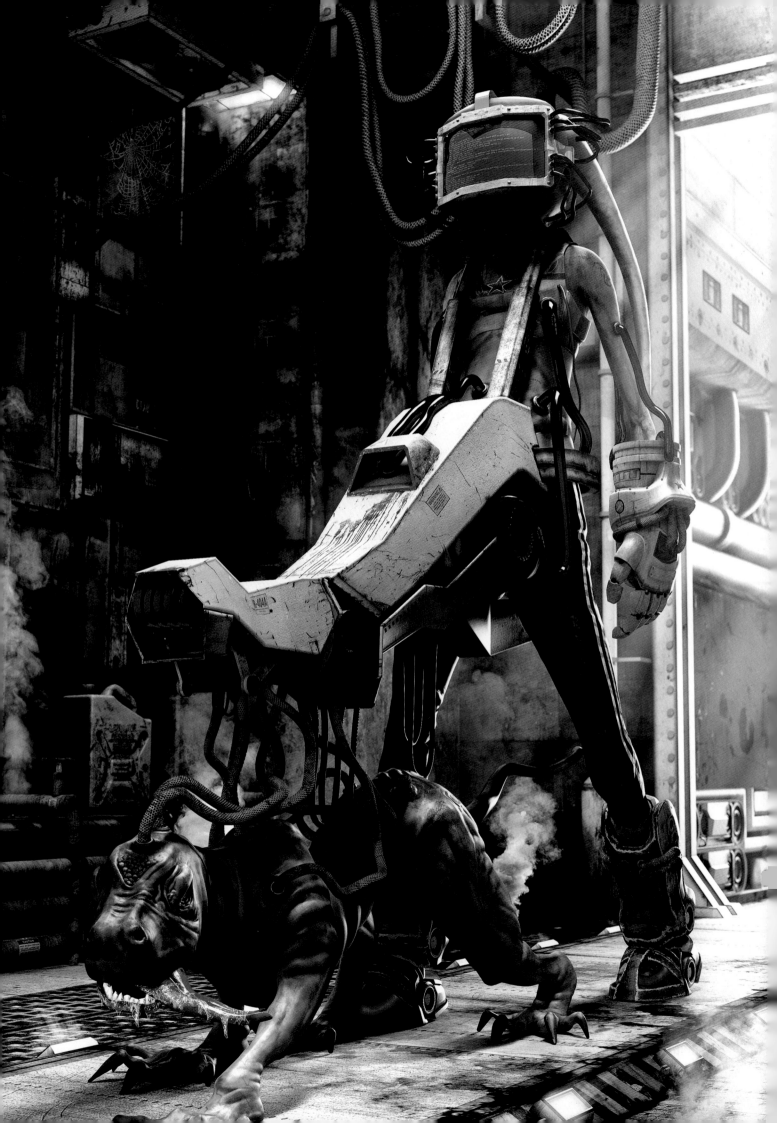

Hi-tech nature: Beatlebot
CINEMA 4D, Photoshop
Dave Davidson, GREAT BRITAIN
[top]

Hi-tech nature: BirdBot
CINEMA 4D, Photoshop
Dave Davidson, GREAT BRITAIN
[above]

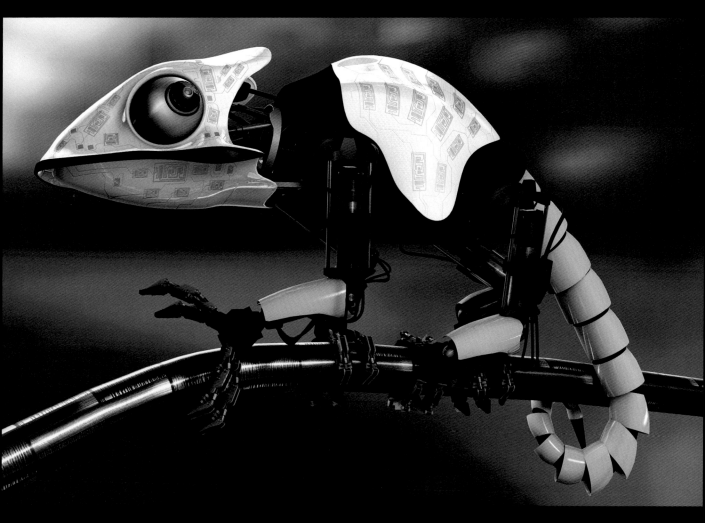

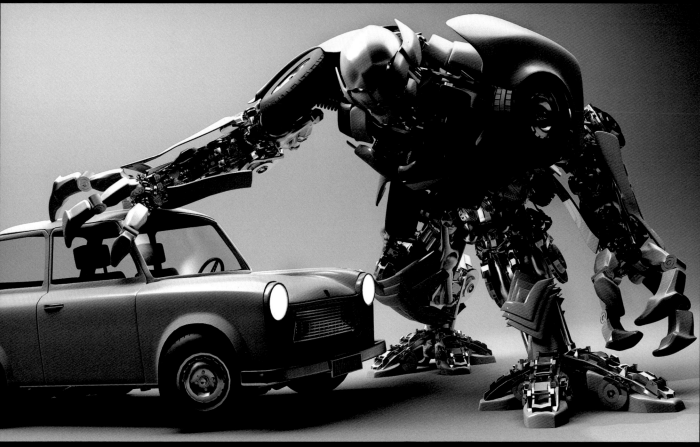

Mech Chameleon
CINEMA 4D, BodyPaint 3D
Tommaso Sanguigni, ITALY

Robot in disguise
3ds Max, mental ray, Photoshop
Valentin Yovchev, BULGARIA

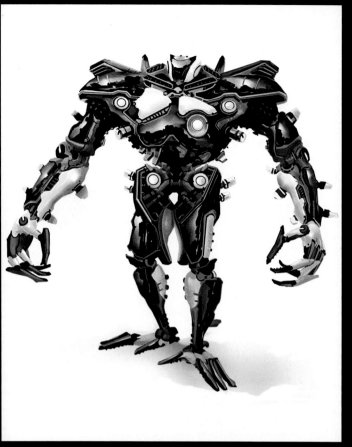

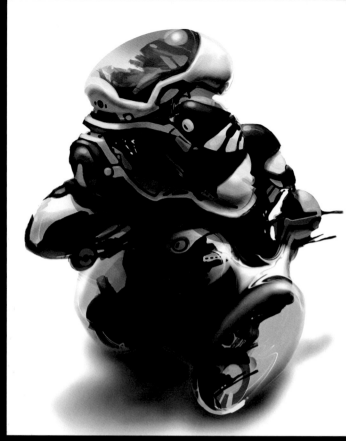

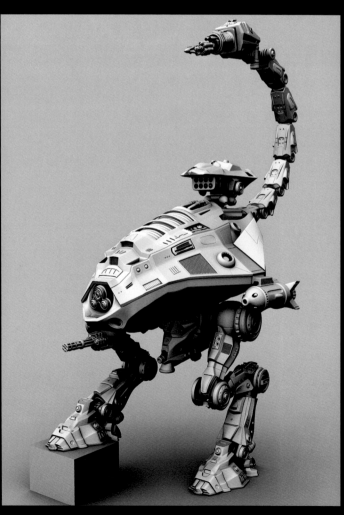

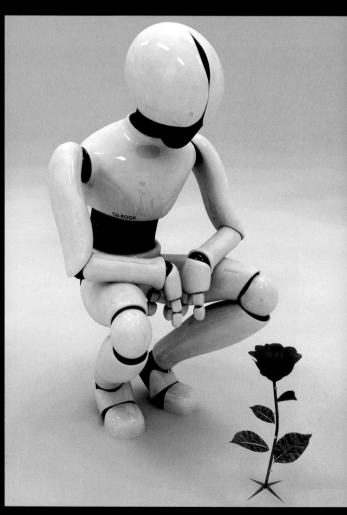

UX-40 Berserker
Photoshop
Nikolay Yeliseyev, RUSSIA
[top]

Scorponic
Maya, mental ray, Photoshop
Kiran Naidu, INDIA
[above]

Droid 3
Photoshop, Painter
Arthur Haas, THE NETHERLANDS
[top]

CU-KOQX
CINEMA 4D, Photoshop
Christian Unterdechler, AUSTRIA
[above]

'Cyborg' © Mad Catz Interactive, Inc.

Cyborg
modo, Photoshop
Benjamin Parry,

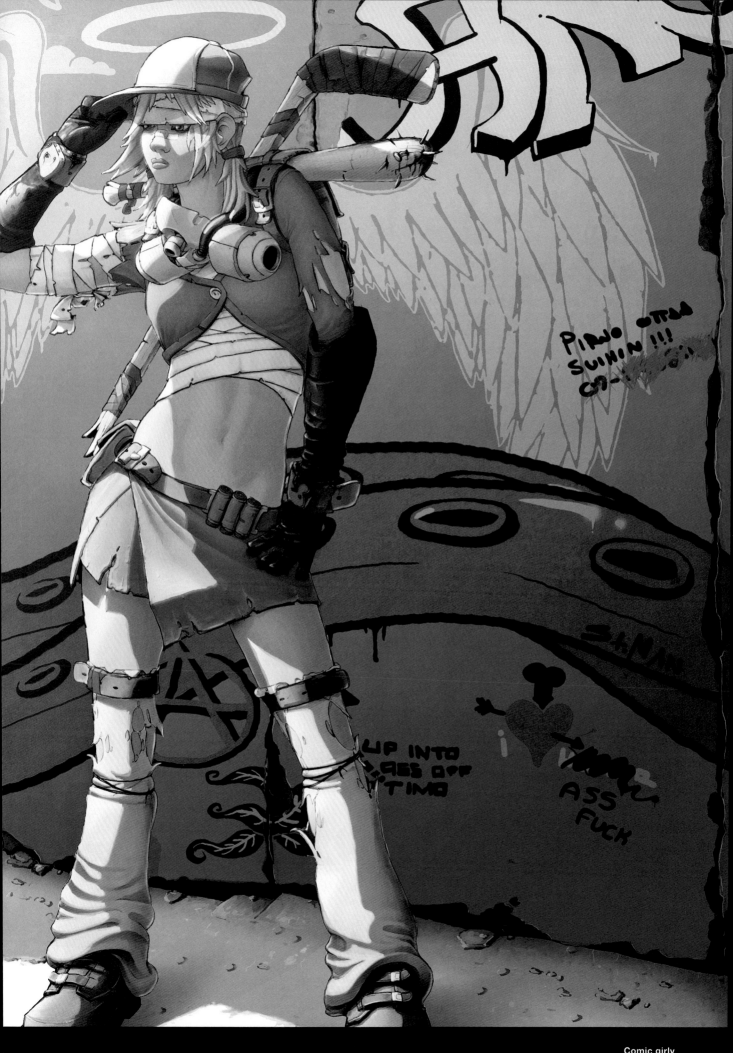

Comic girly
Photoshop
Mikko Kautto, FINLAND

165

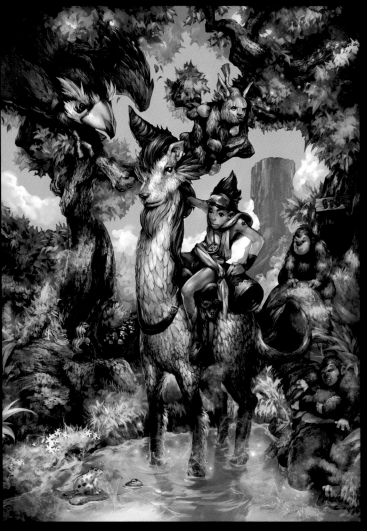

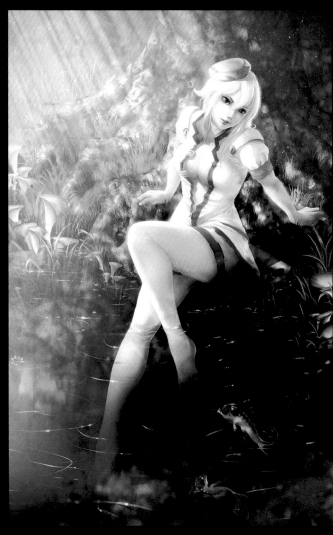

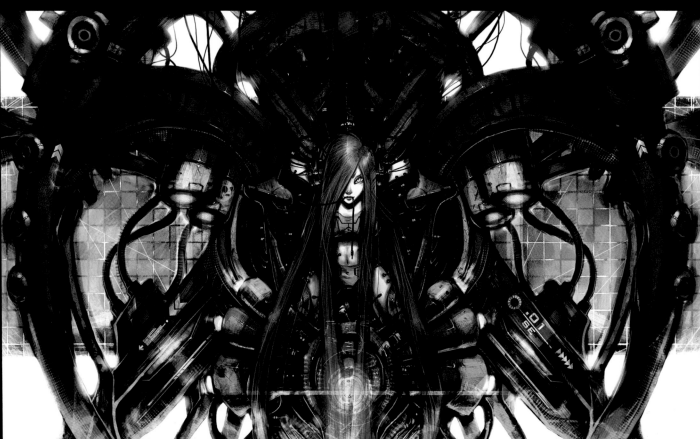

Happy rider
Photoshop
Lee Dae Hoon, Bluehole Studio,
SOUTH KOREA *[top]*

Escape
Photoshop
Yee-Ling Chung. MALAYSIA
[above]

Mana
Photoshop
Dzung Phungdinh, VIETNAM
[top]

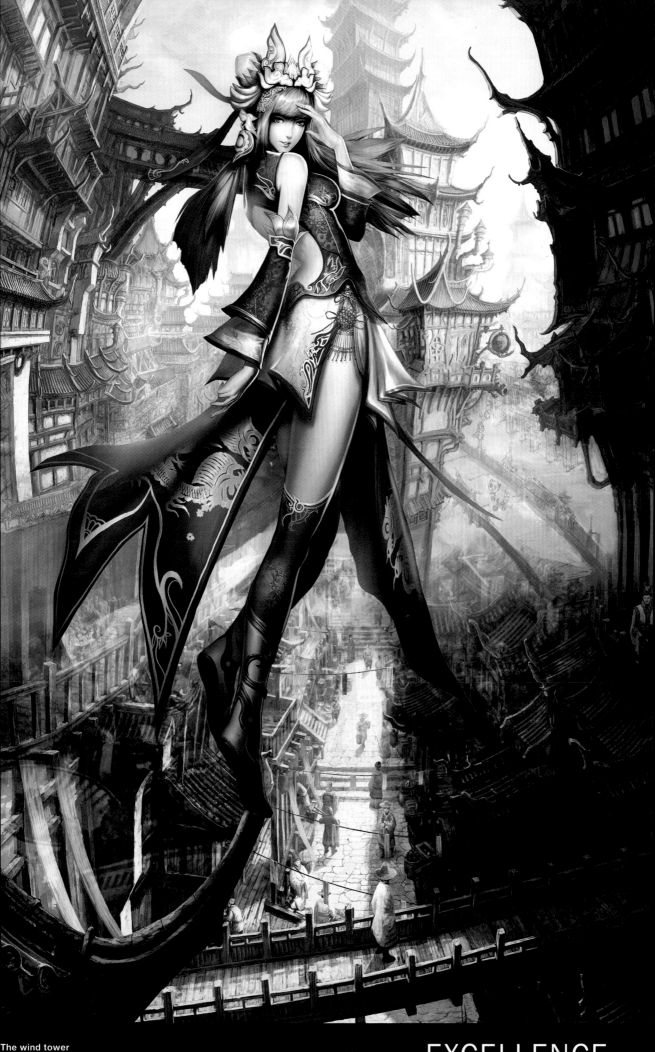

The wind tower
Photoshop
Wenjun Lin, Perfect World International.
CHINA

EXCELLENCE
Comic/Manga

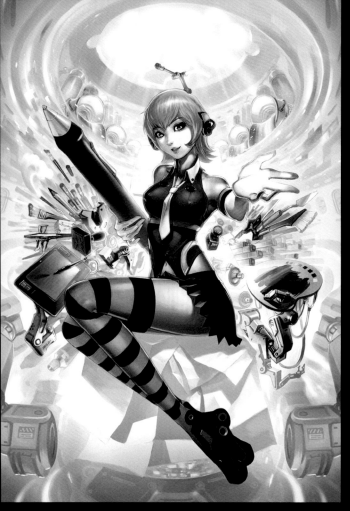

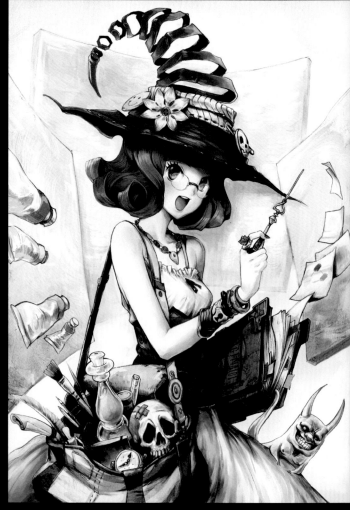

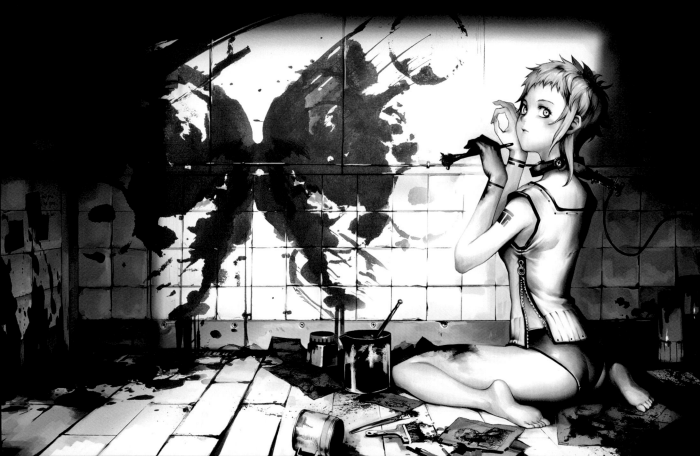

Painter Girl
Photoshop, Painter
Chao Chin Kung,
TAIWAN [top]

Inkblot
Photoshop
Patipat Asavasena,
THAILAND [above]

Carnelia
Photoshop
Patipat Asavasena
THAILAND [top]

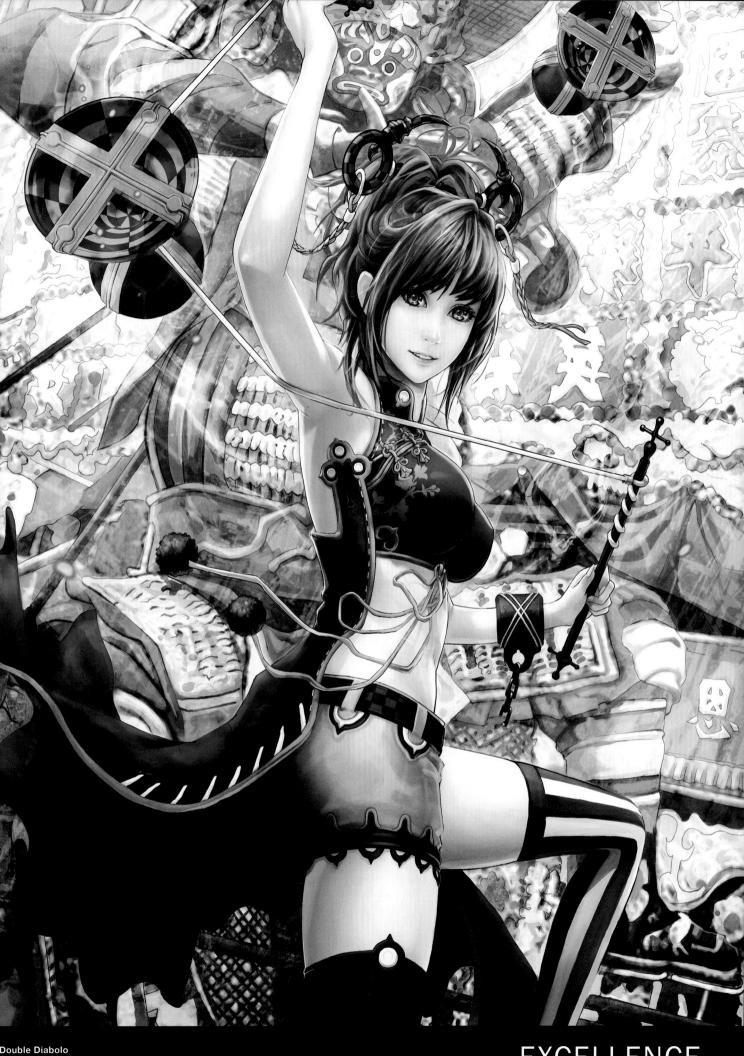

Double Diabolo
Photoshop, Painter
I-Chen Lin, TAIWAN

EXCELLENCE
Comic/Manga

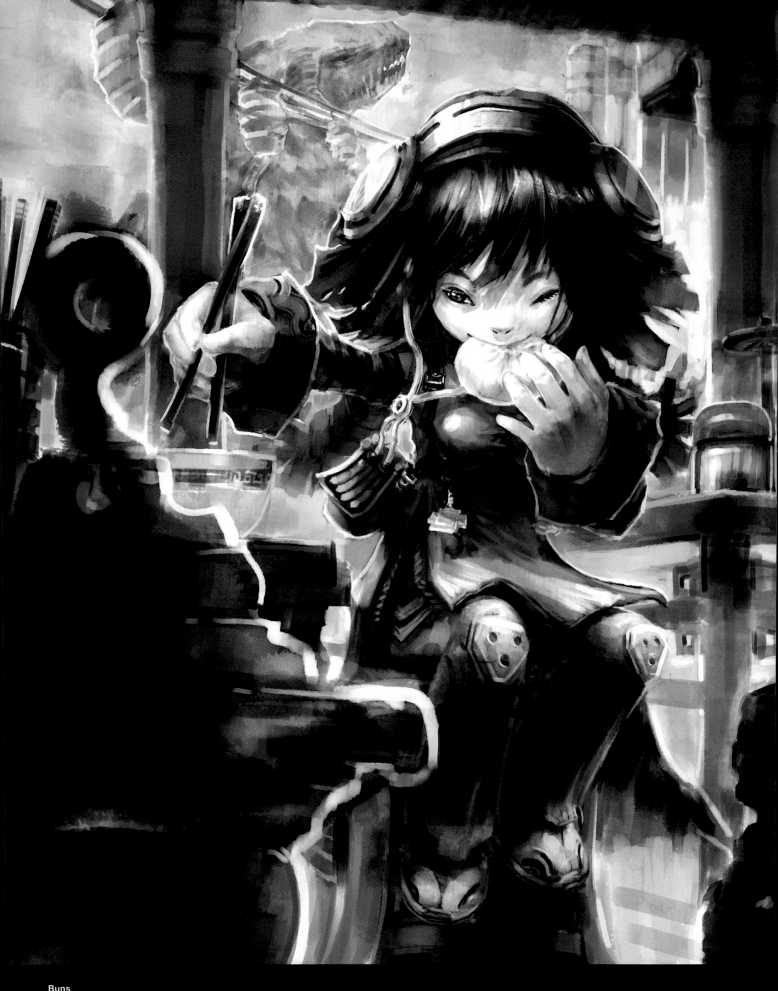

Buns
Photoshop
Zao Li, CHINA

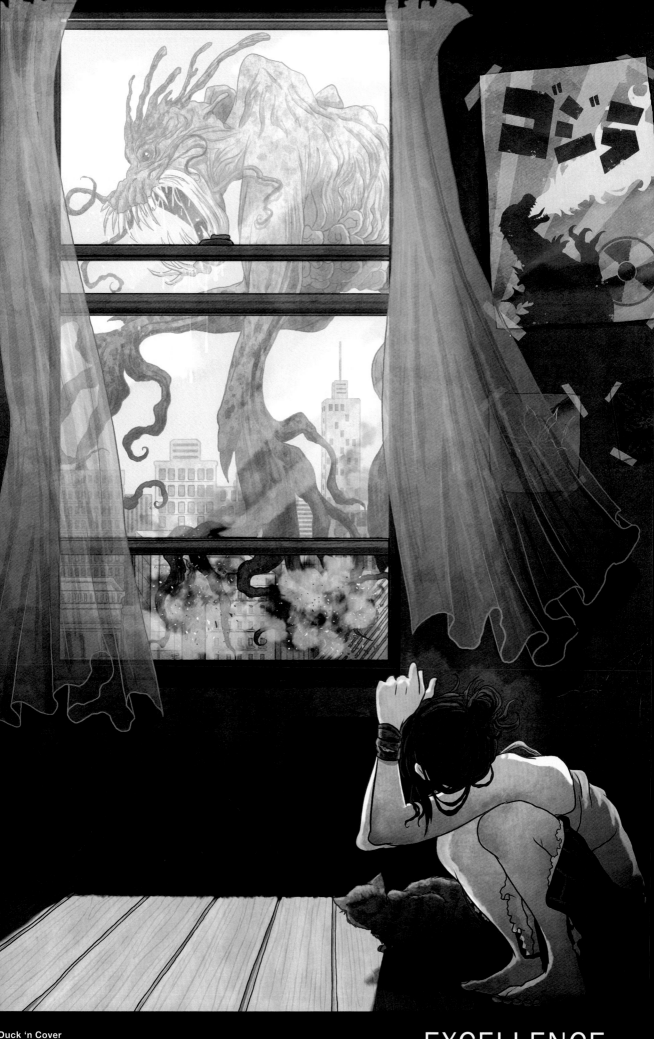

Duck 'n Cover
Photoshop
Kim Herbst, USA

EXCELLENCE
Comic/Manga

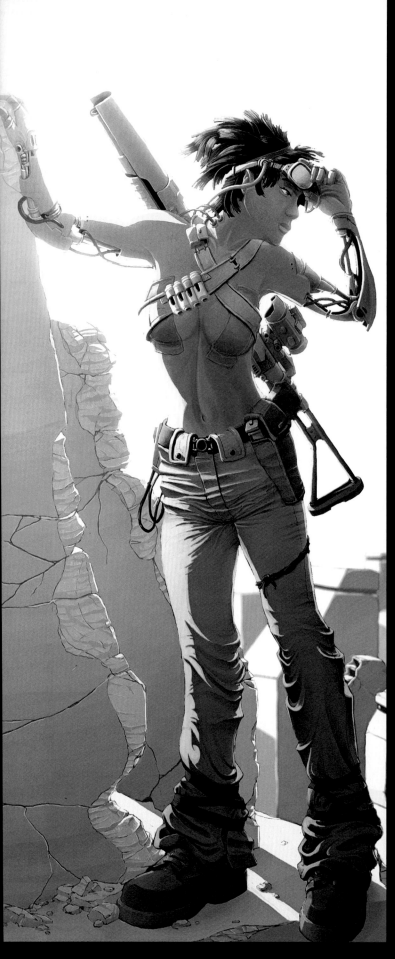

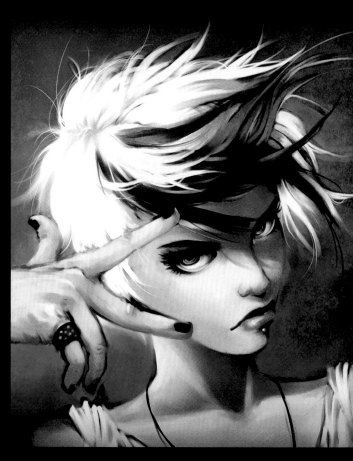

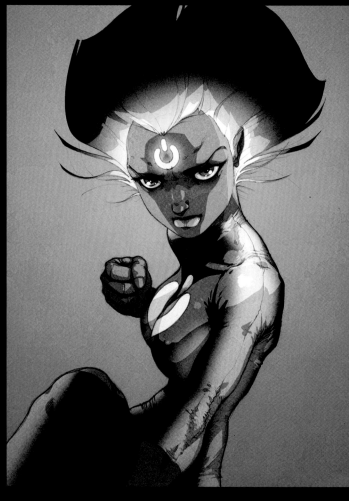

Kattokassitar Redux
Photoshop
Mikko Kautto, FINLAND

Something like an astronomer
PaintTool SAI, Photoshop
Viet-My Bui, AUSTRALIA

Wake
Photoshop
Sylvain Magne,

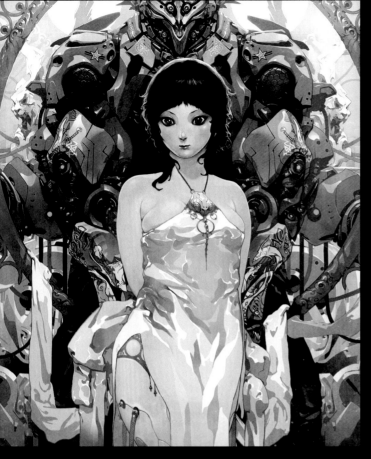

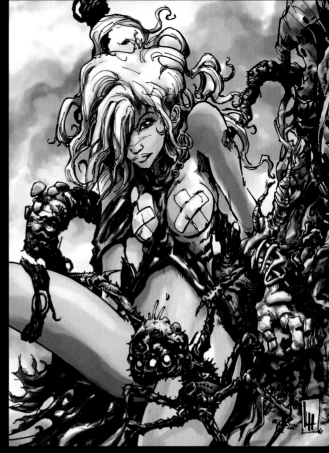

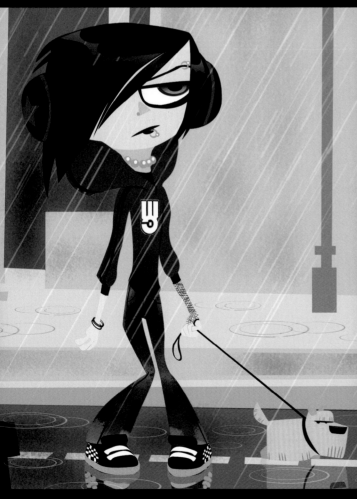

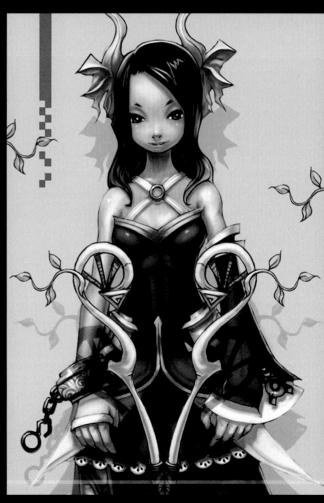

Beauty and the Beast
Photoshop
Reynan Sanchez,
THE PHILIPPINES *[top]*

Emo
Photoshop, Illustrator
Patri Balanovsky,
ISRAEL *[above]*

The Goblin
Painter, Photoshop
Luis Ho Tseng, SPAIN
[top]

Sifa
Photoshop
Zao Li, CHINA
[above]

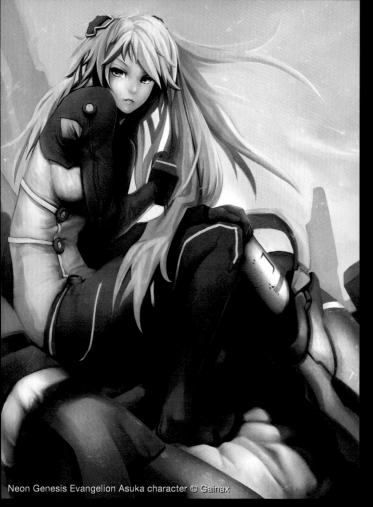

Neon Genesis Evangelion Asuka character © Gainax

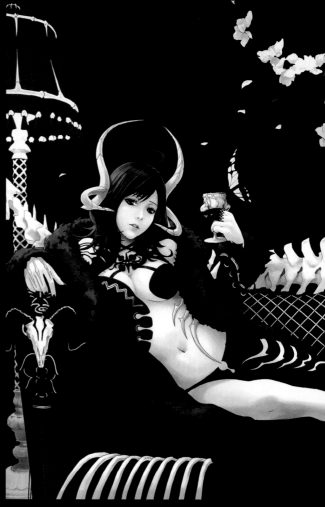

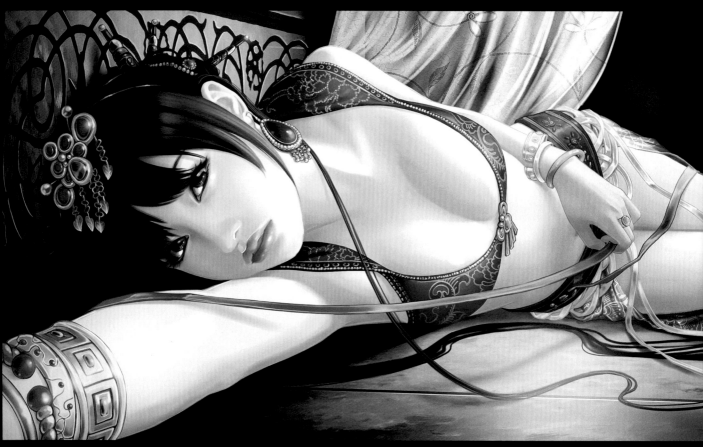

Asuka+Test Plugged Suit
Photoshop
Inspired by: Neon Genesis Evangelion

Diao Chan
Painter, Photoshop
Shawli Chen, TAIWAN

Dark Queen
Painter, Photoshop
I-Chen Lin, TAIWAN

Hunted
Photoshop, Illustrator
Steve Sampson,

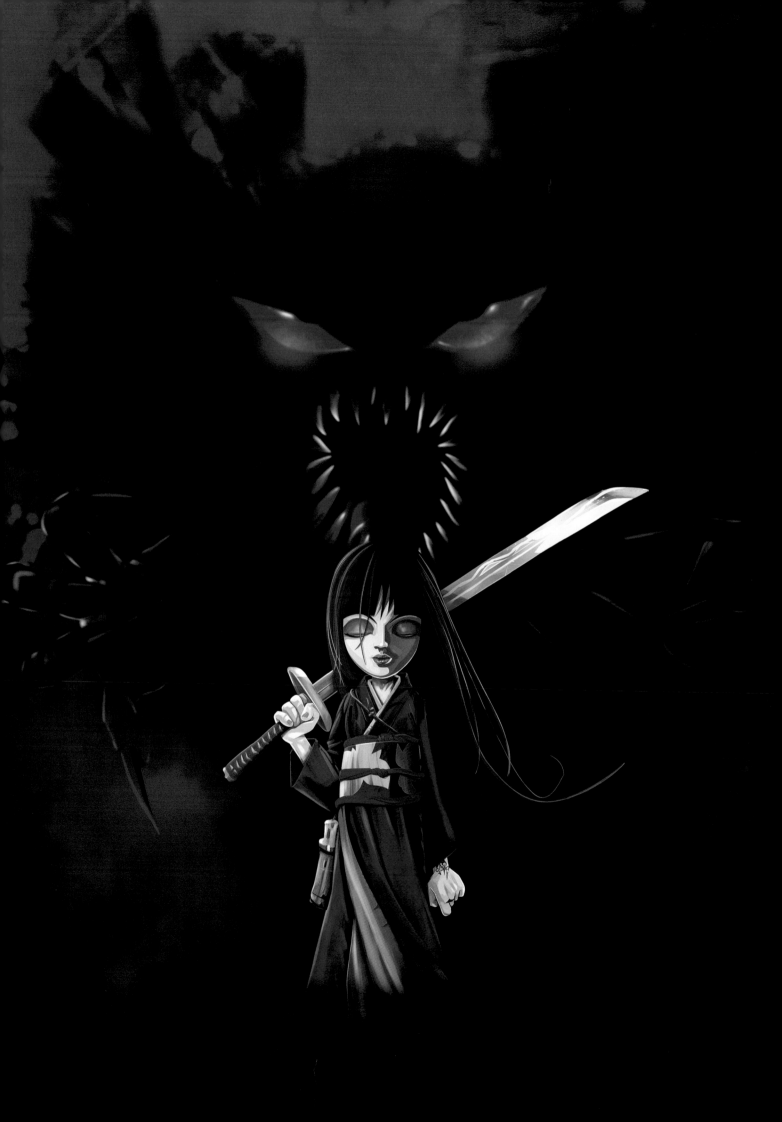

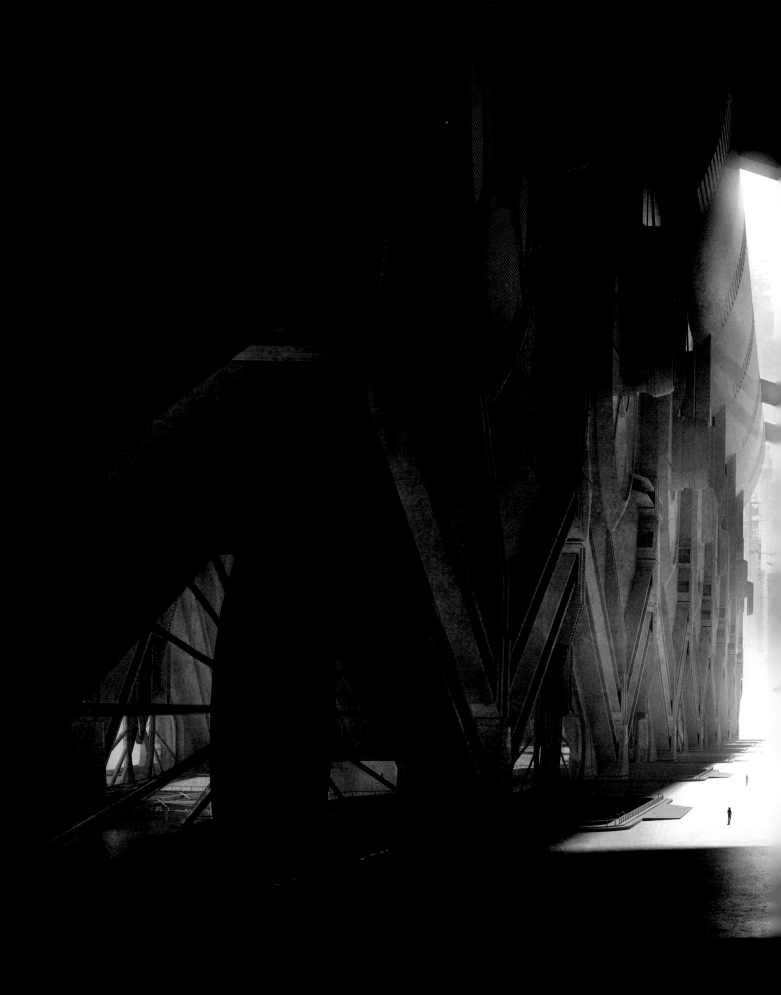

MASTER
Futurescapes

The Gateway
CINEMA 4D, Maxwell Render, Photoshop
Rudolf Herczog, SWEDEN

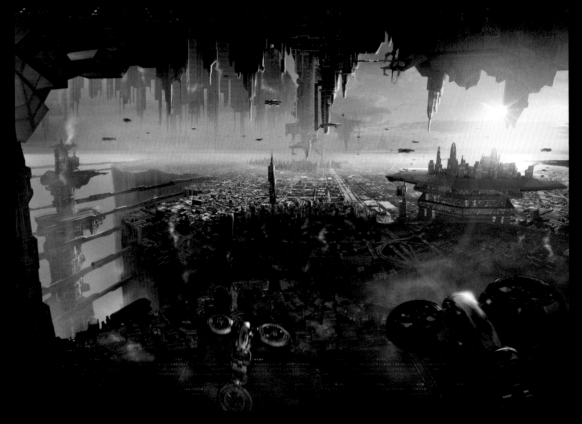

Techscape 2
Photoshop, Painter
Arthur Haas,
THE NETHERLANDS
[top]

Sunset City
Maya, Photoshop
Sujesh V Chitty,
CANADA
[center]

Fallen
Photoshop
Sandeep Karunakaran,
SANS Entertainment, INDIA
[above]

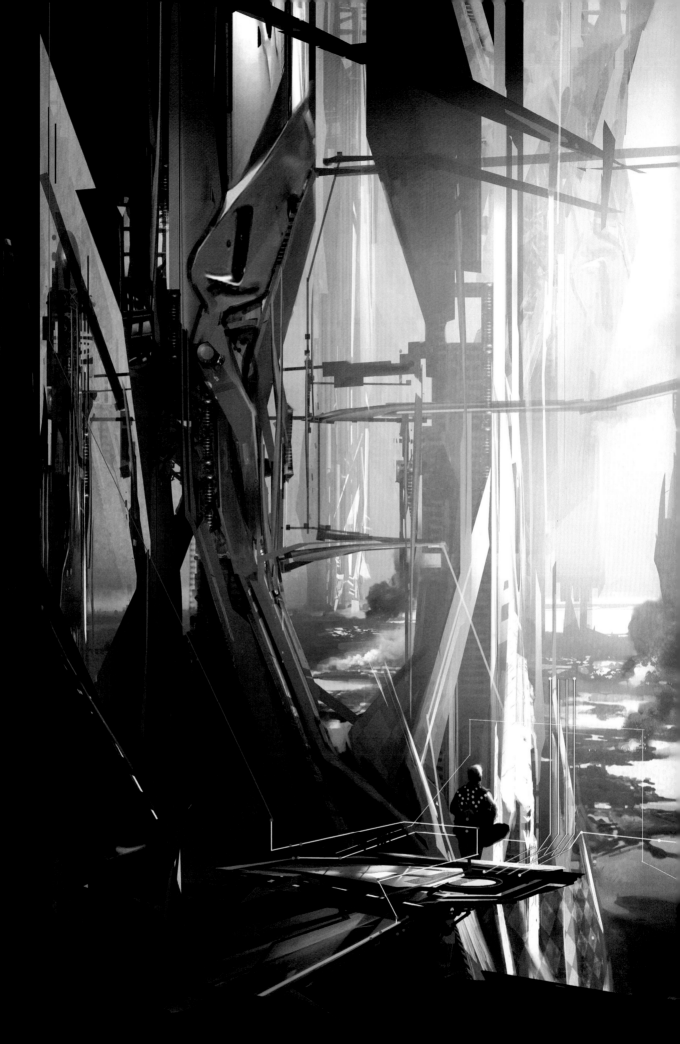

Geosynchron
Photoshop, Painter
Client: Pyr Books
Stephan Martiniere, USA

EXCELLENCE
Futurescapes

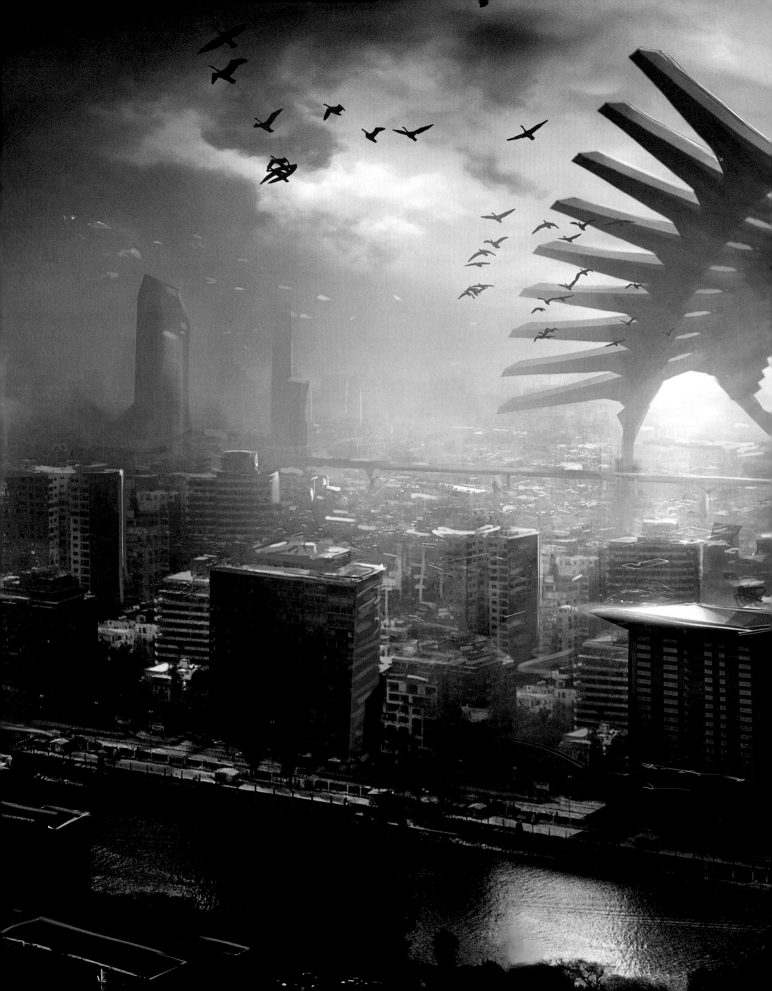

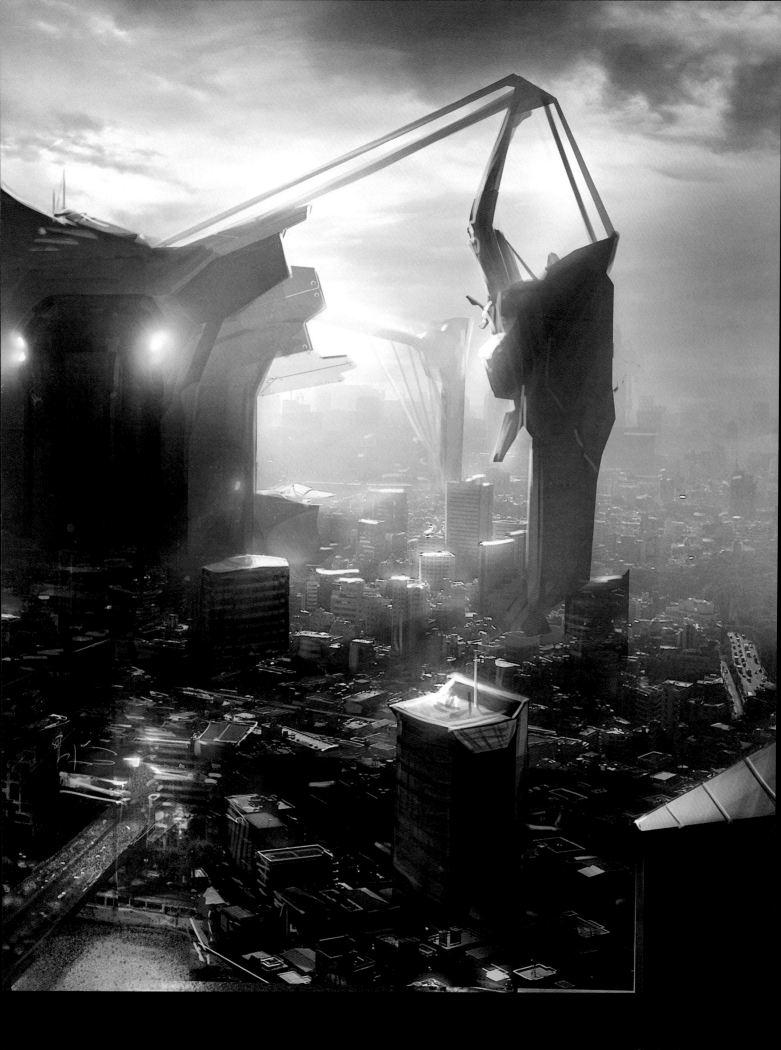

City Angels
Photoshop
Frank Hong. CANADA

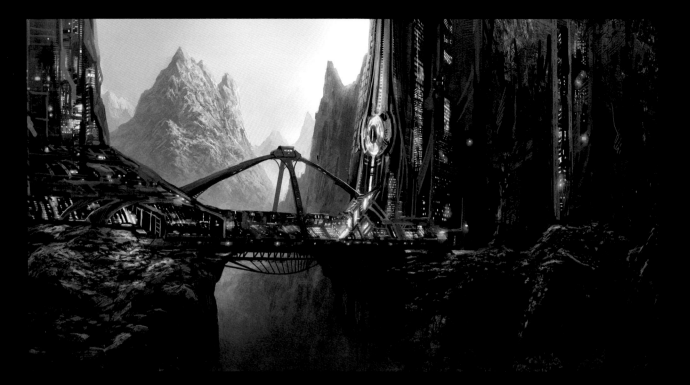

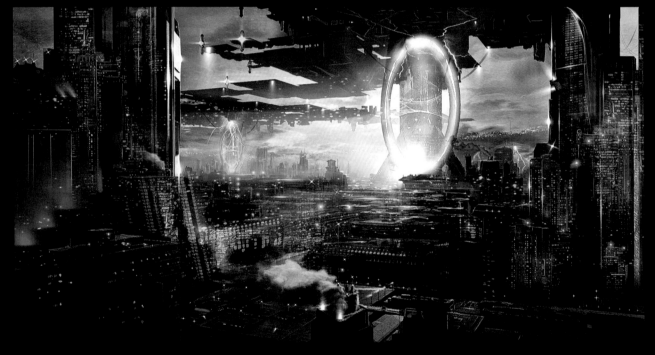

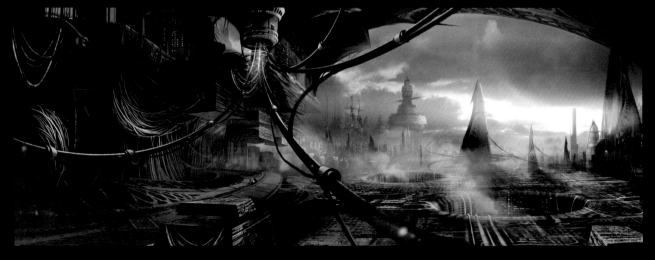

Connected Mountains
Photoshop
Bence Kresz,
HUNGARY
[top]

Hades: Valiant
Vue Esprit, Photoshop
Christian Hecker,
GERMANY
[center]

Heirs: Factory planet
PhotoPaint
Client: Jerzy Chodor
Tomasz Maronski, POLAND
[above]

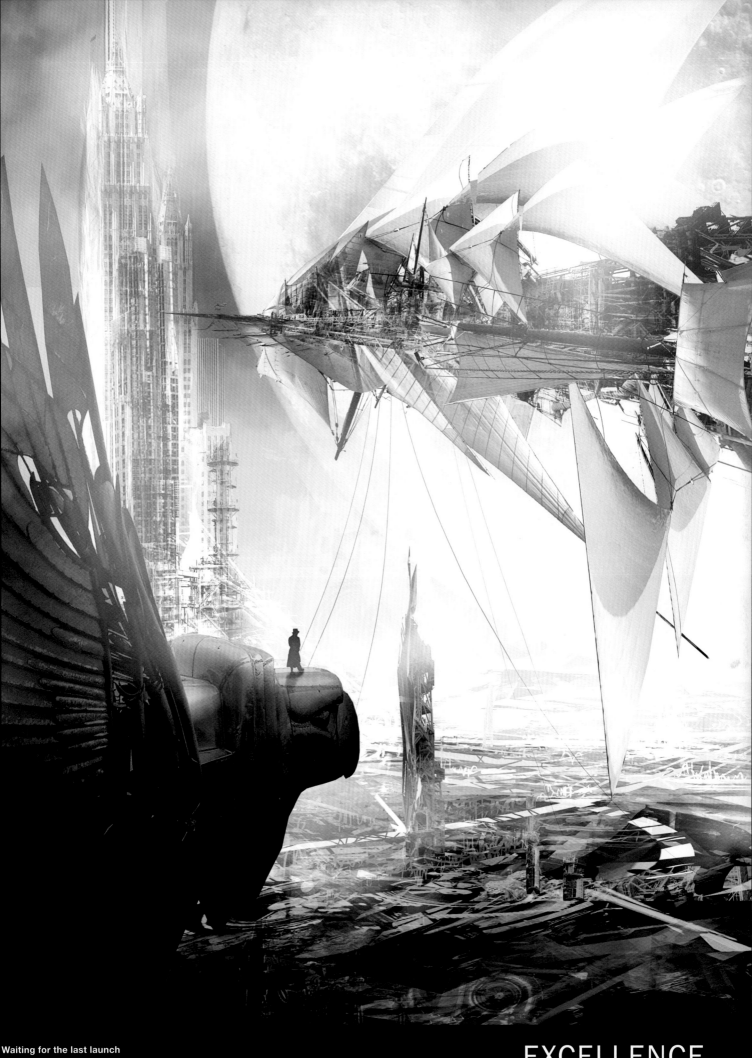

Waiting for the last launch
Photoshop
Inspired by: Stephan Martiniere and Daniel Dociu
Sorin Bechira, ROMANIA

EXCELLENCE
Futurescapes

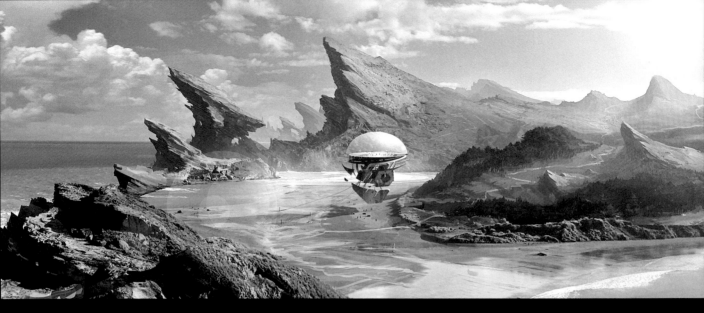

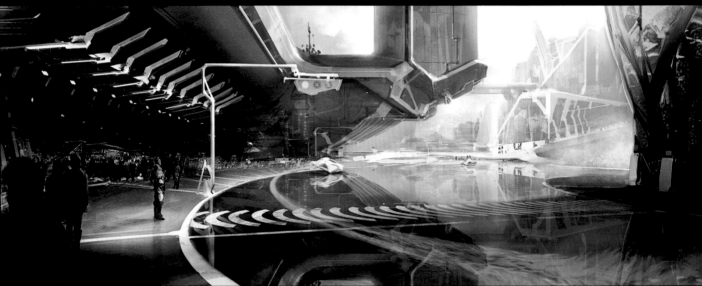

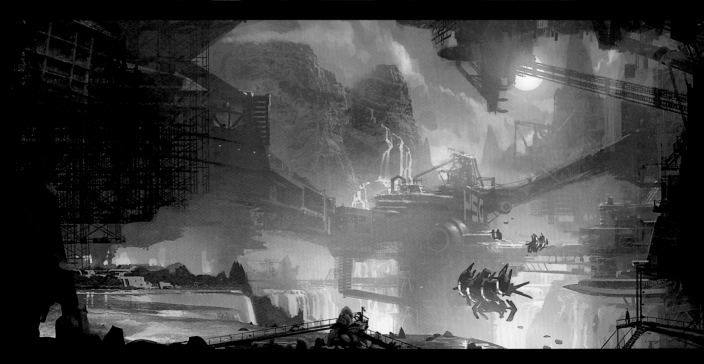

Explorer
Photoshop
Bastien Grivet, FRANCE
[top]

Procyon City Shopping District Plaza
Photoshop
Alex Chin Yu Chu, USA
[center]

Quarry
Photoshop
Patrick Faulwetter, USA
[above]

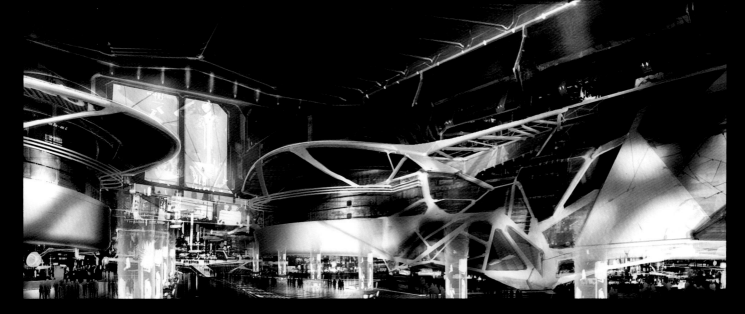

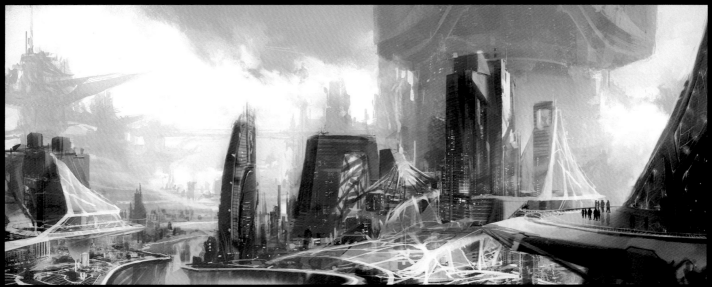

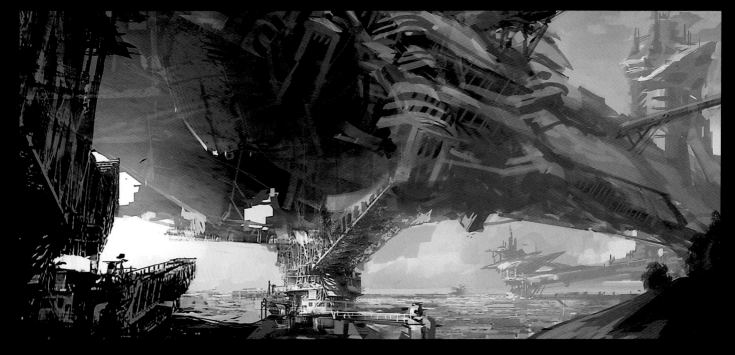

Procyon City Shopping District Detail Procyon City Mecha City

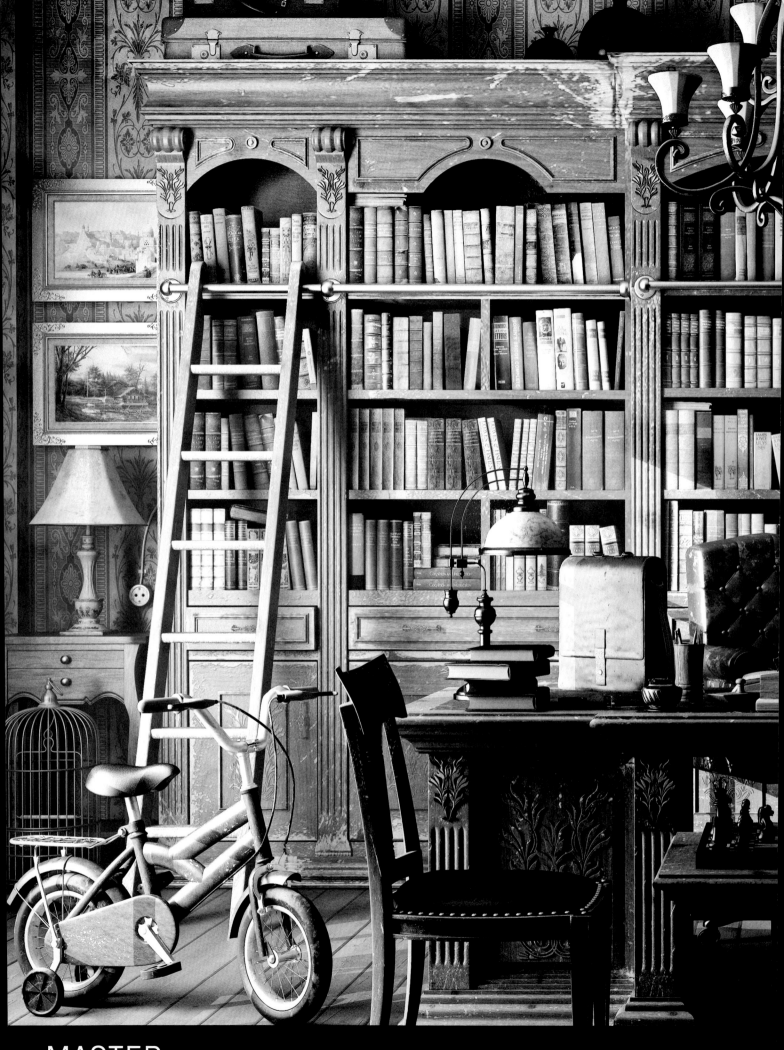

MASTER
Product Design & Still Life

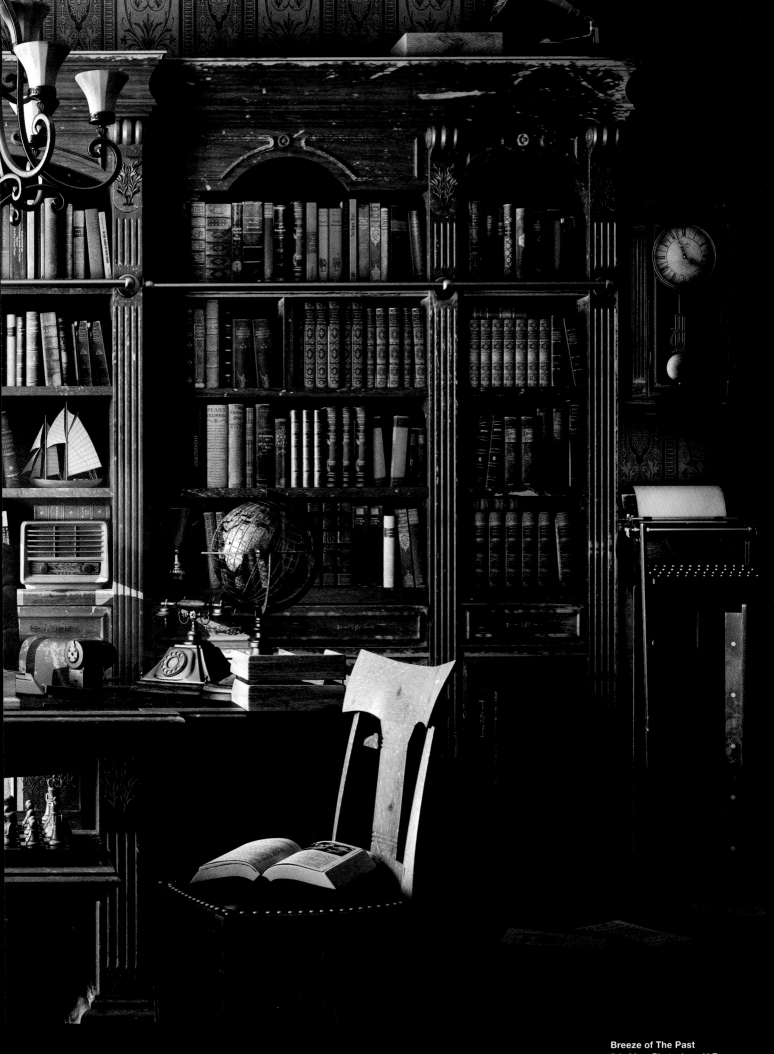

Breeze of The Past
3ds Max, Photoshop, V-Ray
Mohamed AbuYhia, EGYPT

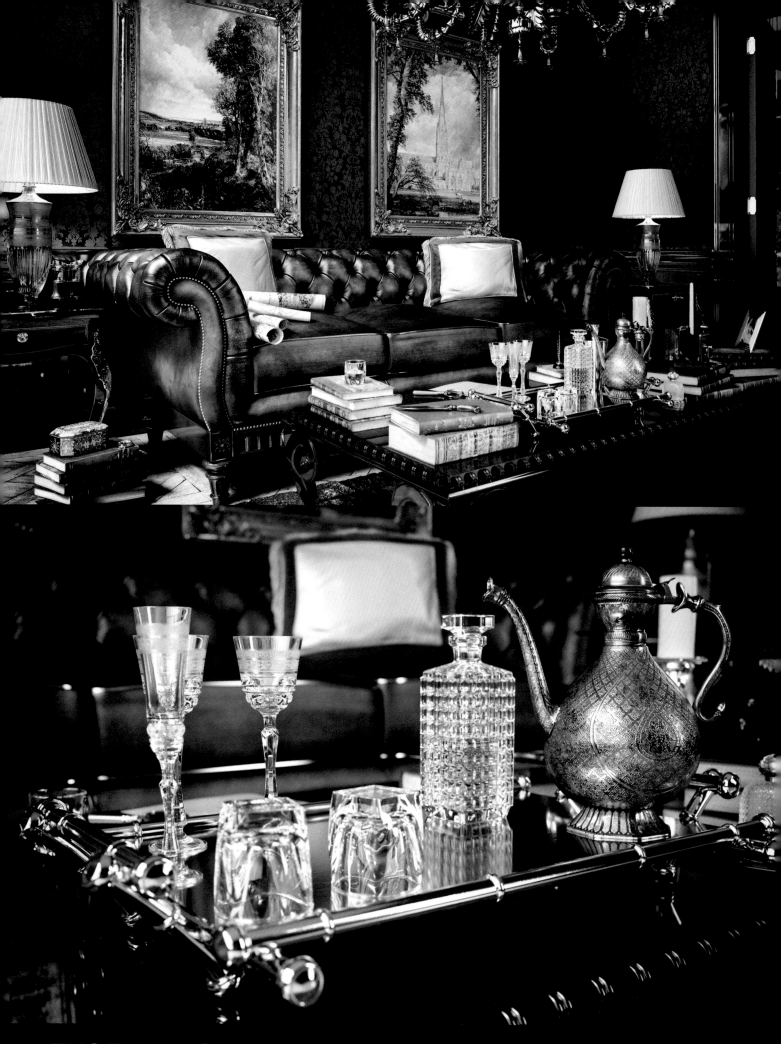

EXCELLENCE
Product Design & Still Life

Chesterfield project
3ds Max, Photoshop, Maxwell Render
Benjamin Brosdau. pure rendering GmbH. GERMANY

Barbershop Bear
3ds Max. V-Ray. Photoshop
Miguel Alba. SPAIN

EXCELLENCE
Product Design & Still Life

© Evermotion S.C.

Limited Edition
Photoshop
Models: Cake-Injection

Orient Gadgets
3ds Max, ZBrush, V-Ray, Photoshop
Client: Evermotion S.C.

Isabella
3ds Max, V-Ray, Photoshop
Gert Swolfs, G2 BVBA, BELGIUM

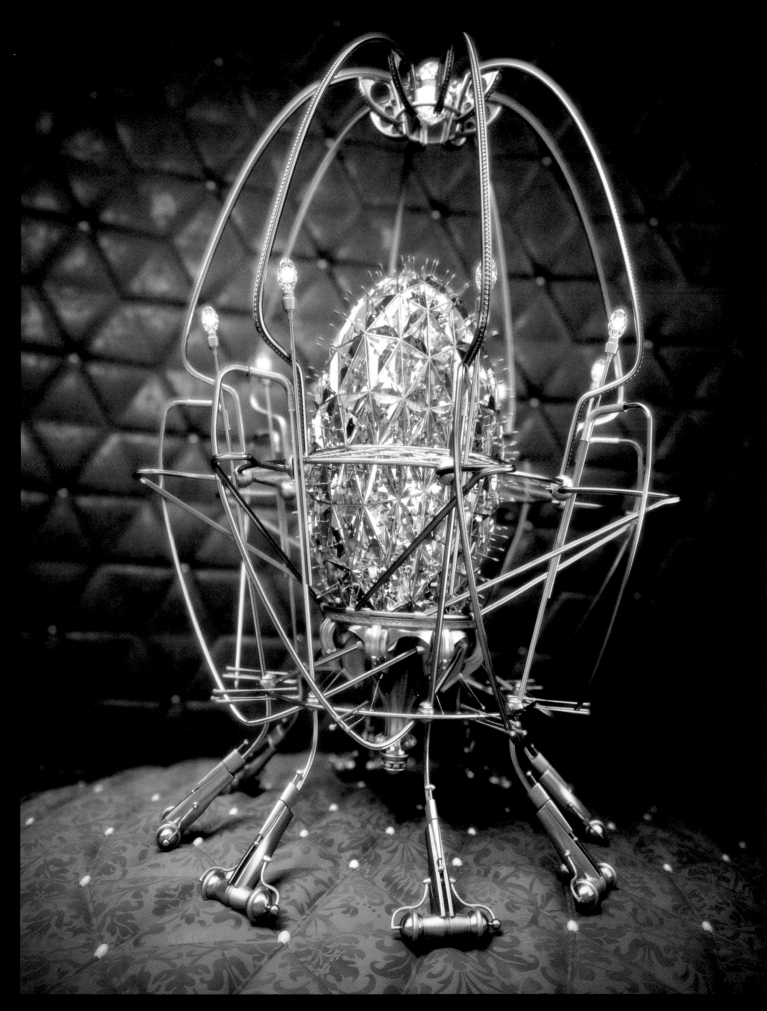

Fabergélvish
CINEMA 4D, V-Ray, Photoshop
Carlos Agell, Curare 3D Workshop,
VENEZUELA

EXCELLENCE
Product Design & Still Life

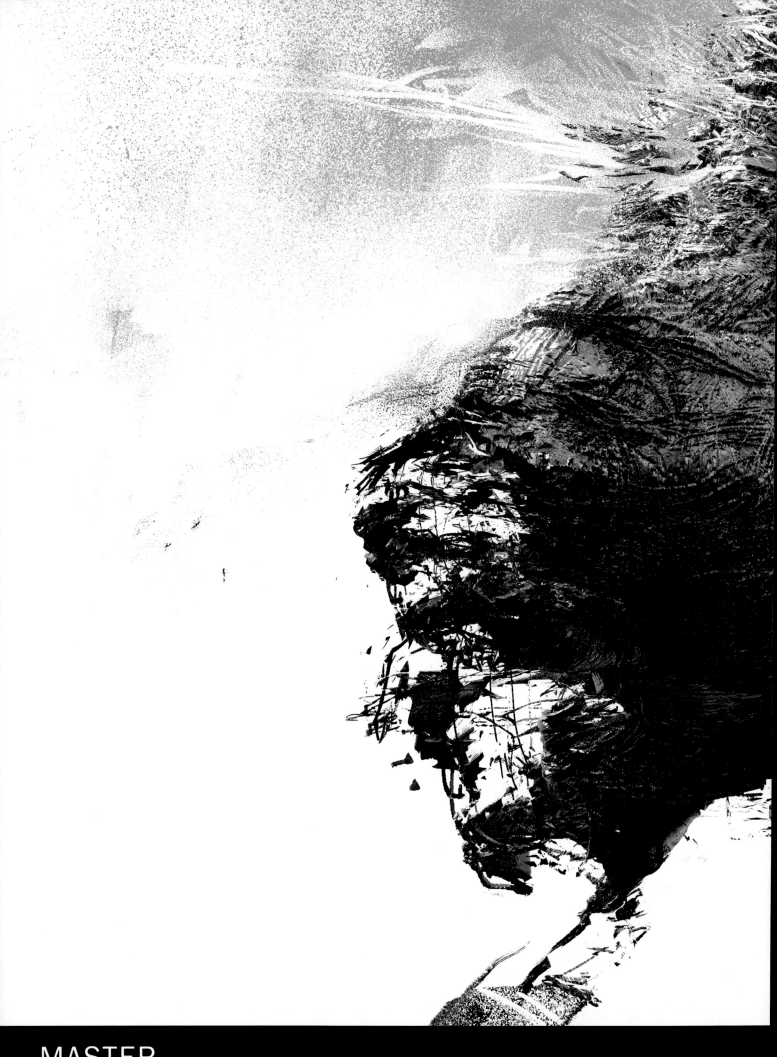

MASTER
Abstract & Design

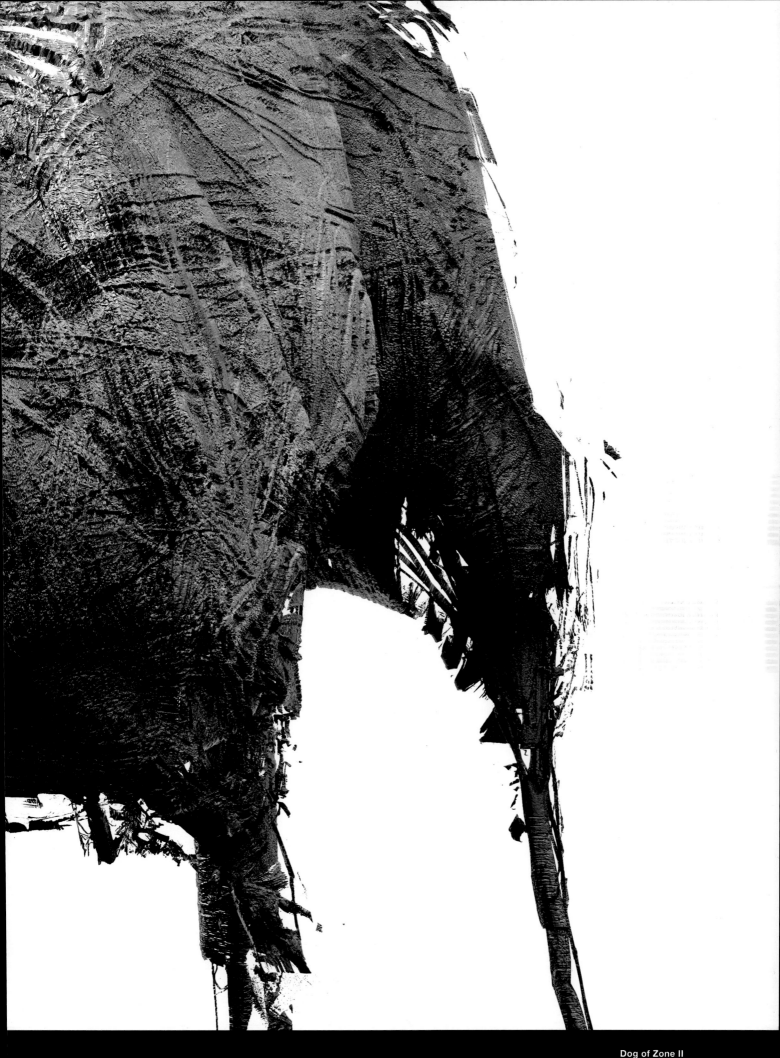

Dog of Zone II
modo, Painter, Photoshop
Lukasz Pazera, POLAND

MASTER
Surreal

Ladder
3ds Max, Photoshop, V-Ray
Jie Ma,
CHINA

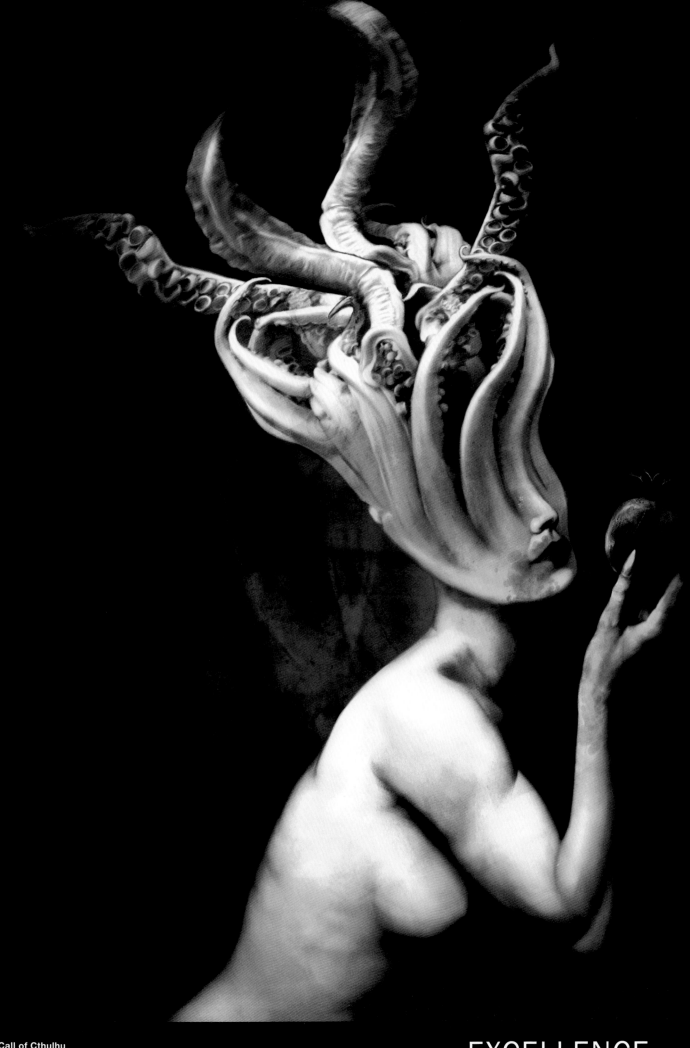

EXCELLENCE
Surreal

EXCELLENCE
Surreal

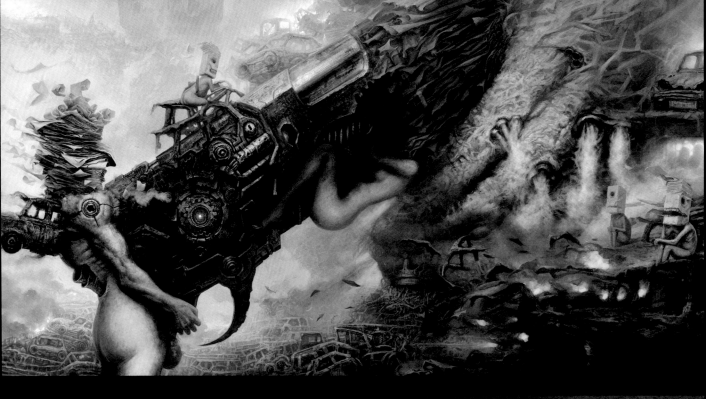

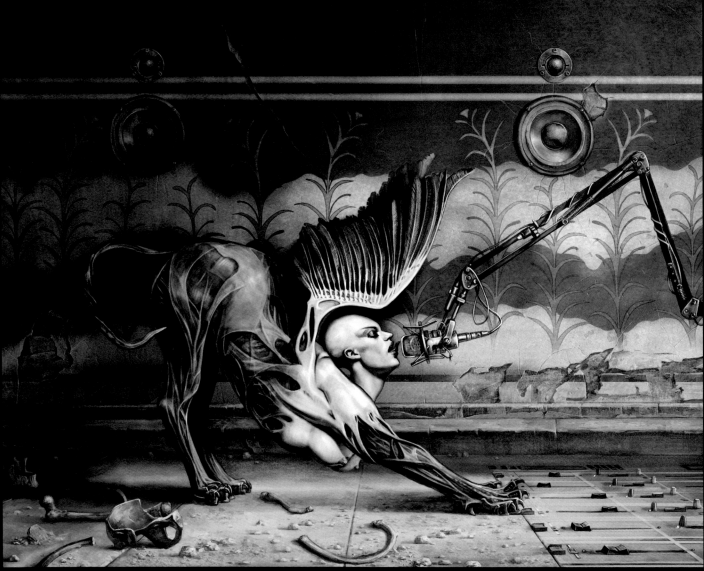

Concrete 0
Photoshop
Yang Xueguo, CHINA

Sphinx on-air
Painter, Photoshop
Yuriy Mazurkin, RUSSIA

'Scratches in the Dark' © Linee Infinite Edizioni

Scratches in the Dark
Painter
Client: Linee Infinite Edizioni
Corrado Vanelli. ITALY

EXCELLENCE
Surreal

MASTER
Storytelling

Mountain pass
Photoshop
Peter Popken, GERMANY

Storytelling

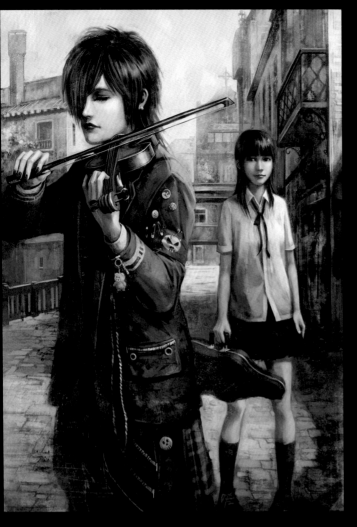 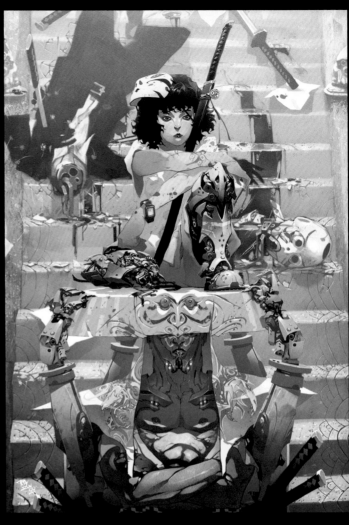

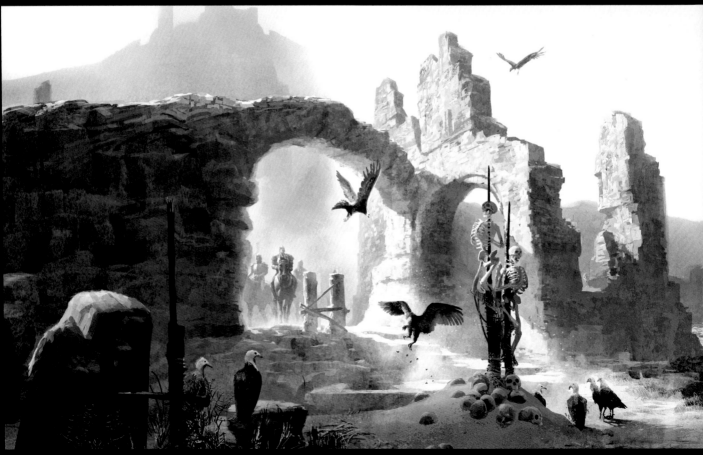

Violinist and schoolgirl
Photoshop, Painter
Chong Fei Giap, Sixth Creation,
MALAYSIA
[top]

Salt mine
Photoshop
Peter Popken,
GERMANY
[above]

Kabuki Slash
Photoshop
Reynan Sanchez
THE PHILIPPINES
[top]

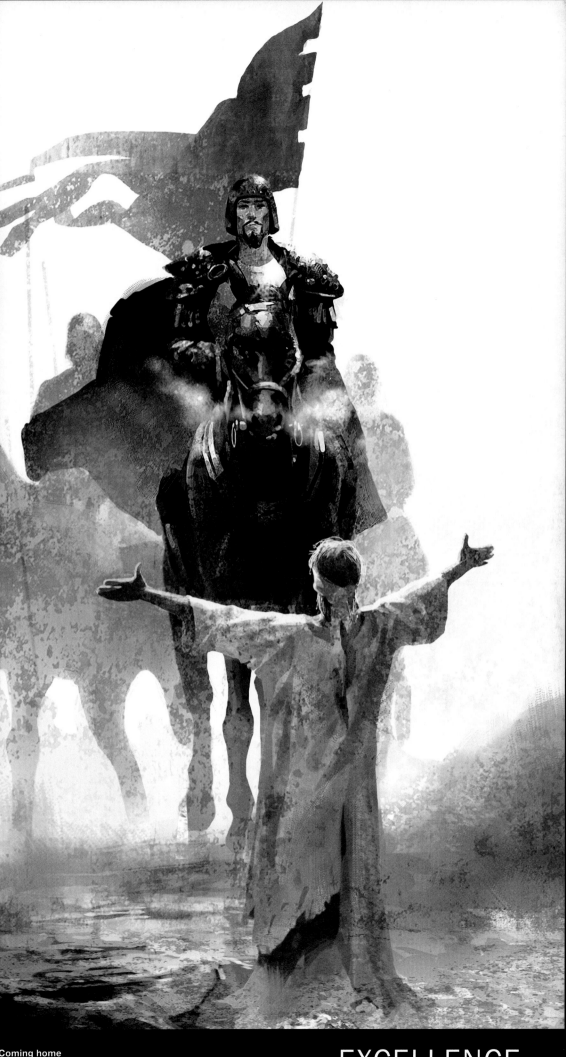

EXCELLENCE
Storytelling

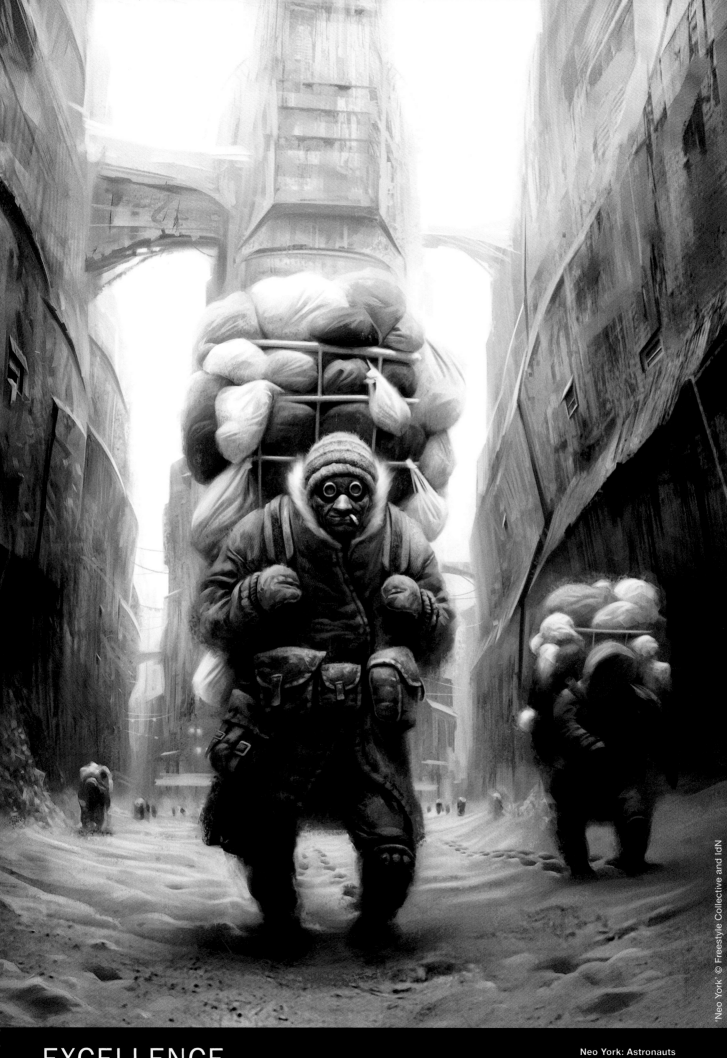

EXCELLENCE
Storytelling

Neo York: Astronauts
Painter, Photoshop
Client: Freestyle Collective and IdN
Michael Kutsche, USA

'Neo York' © Freestyle Collective and IdN

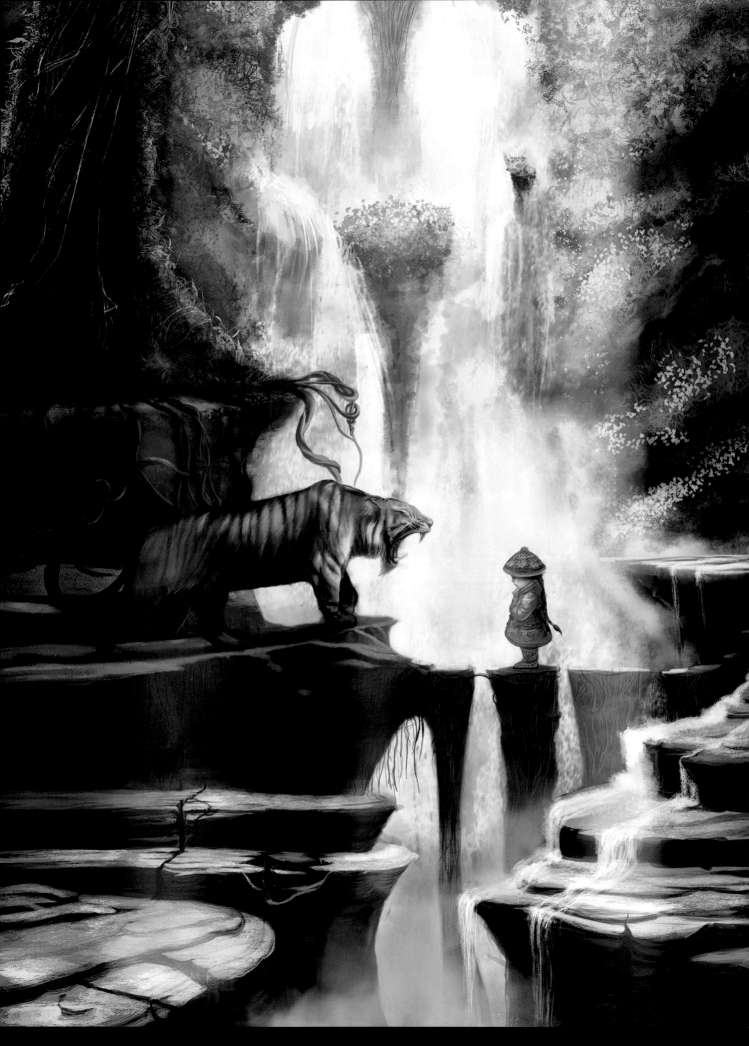

Little Blue and the Tiger King
Photoshop
Arijanit Roci, SWEDEN

EXCELLENCE
Storytelling

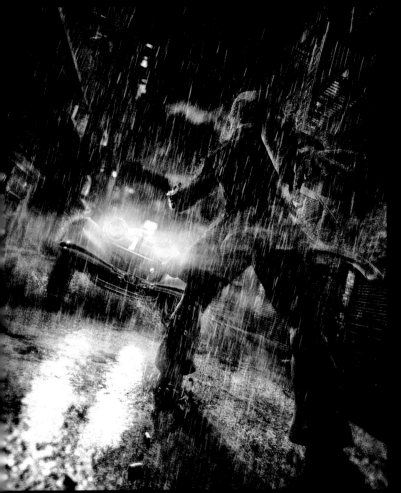

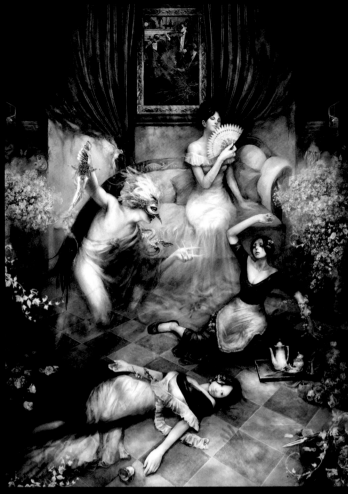

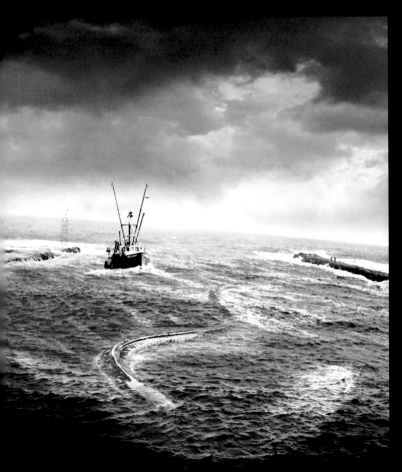

Showdown in Shady Alley
SoftimageIXSI, ZBrush, After Effects,
Photoshop
Ajit Menon, USA *[top]*

Sea Serpent
Painter, Photoshop
Ryan Doan, USA
[above]

Phantoms
Painter, Photoshop
Fangyu Zhang, Shanghai Film, Radio
& TV Production Ltd., CHINA *[top]*

Urban Angel: Suzume No Namida
Vue Esprit, Poser, Photoshop
Jacob Charles Dietz, USA
[above]

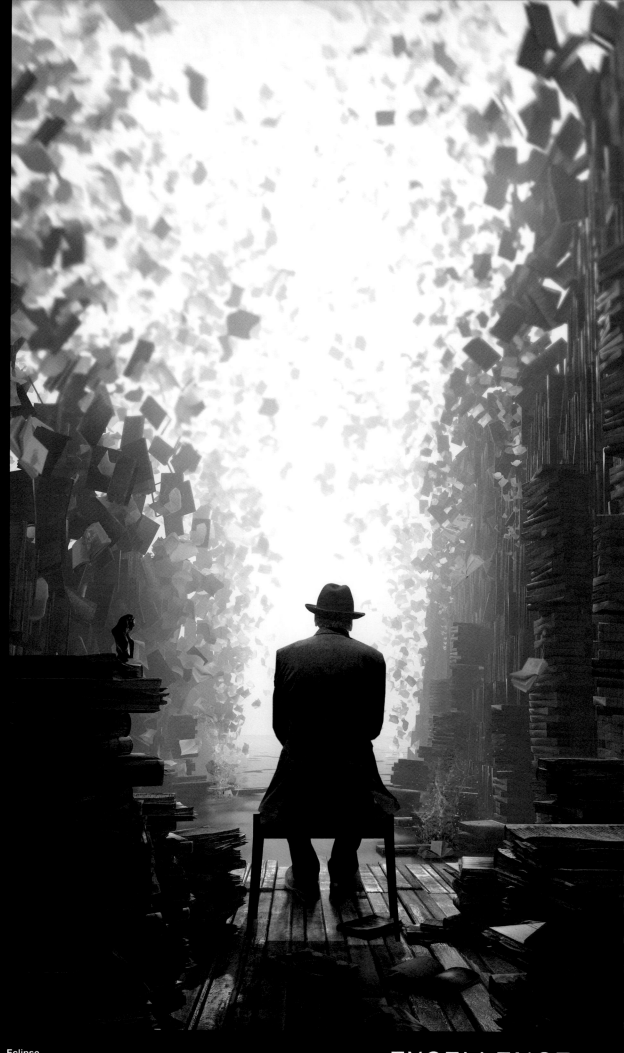

Eclipse
3ds Max, Photoshop, V-Ray
Jie Ma, CHINA

EXCELLENCE
Storytelling

Twisted: Journey to the West (Betrayer)
Photoshop
PhanVu Linh, VIETNAM
[top]

When she left
Photoshop
Pappy Onwuagbu, SOUTH AFRICA
[above]

Letter Unsent
Photoshop
Traci Cook, USA
[top]

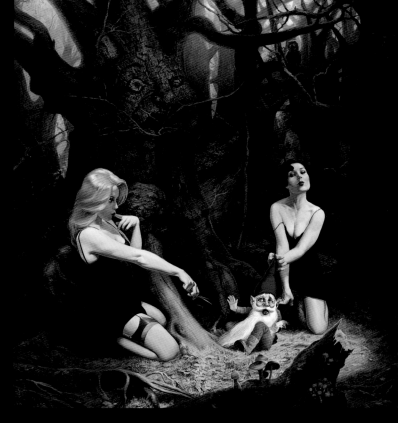

Farewell My Concubine **Holy Crap** **Dreaming The End** **Snow White and Rose Red**

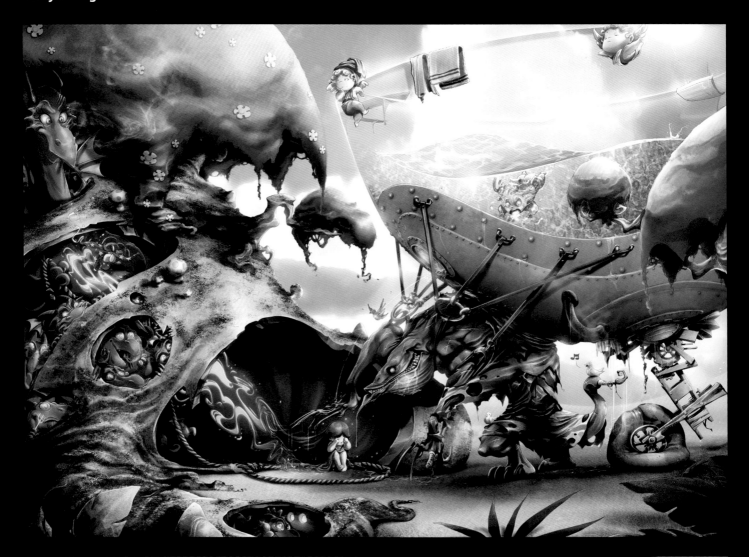

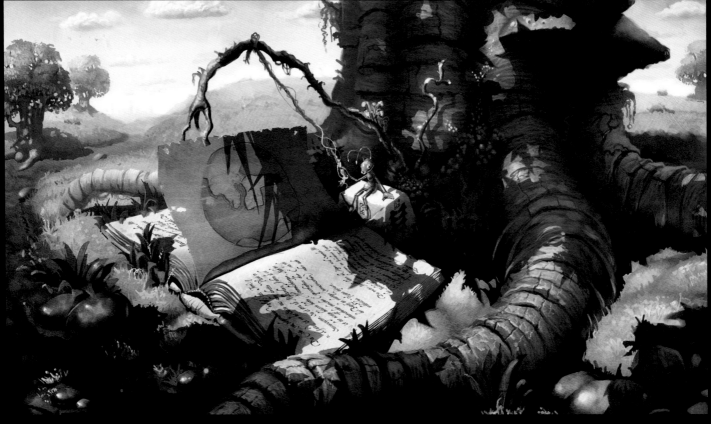

Good vs Evil?
Photoshop
Gleydson Caetano,
BRAZIL [top]

Bug's World
Photoshop
André Kieschnik,
GERMANY [above]

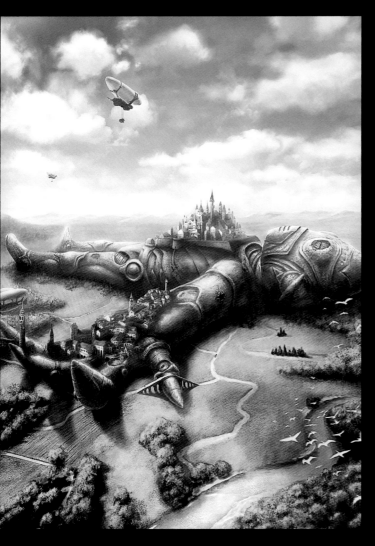

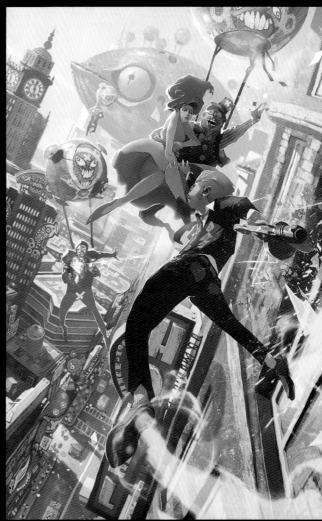

After the great giants war Blossom To the Rescue

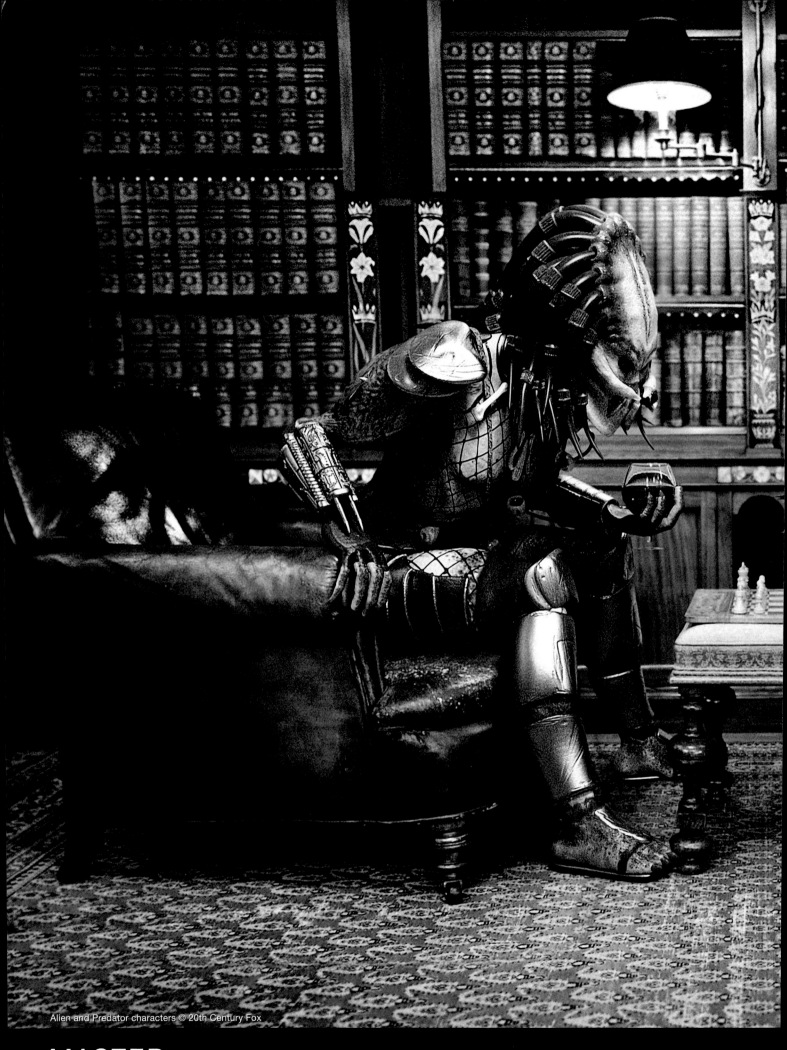

MASTER
Whimsical

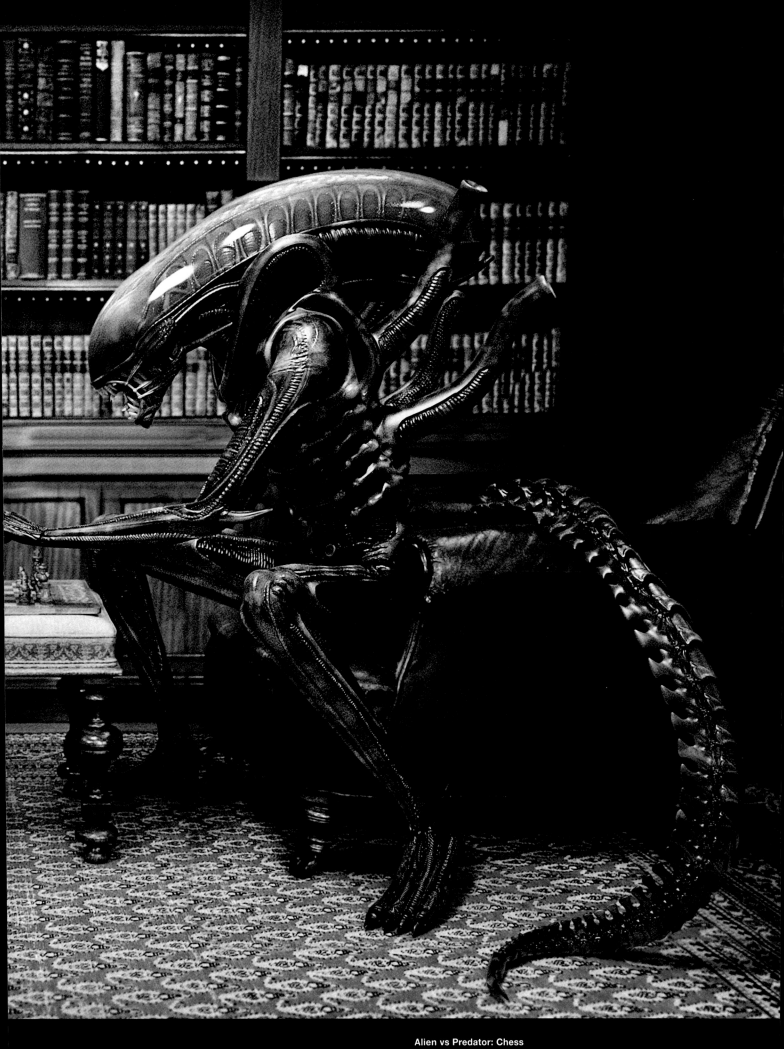

Alien vs Predator: Chess
modo, ZBrush, Photoshop
Inspired by: 20th Century Fox's Alien and Predator characters

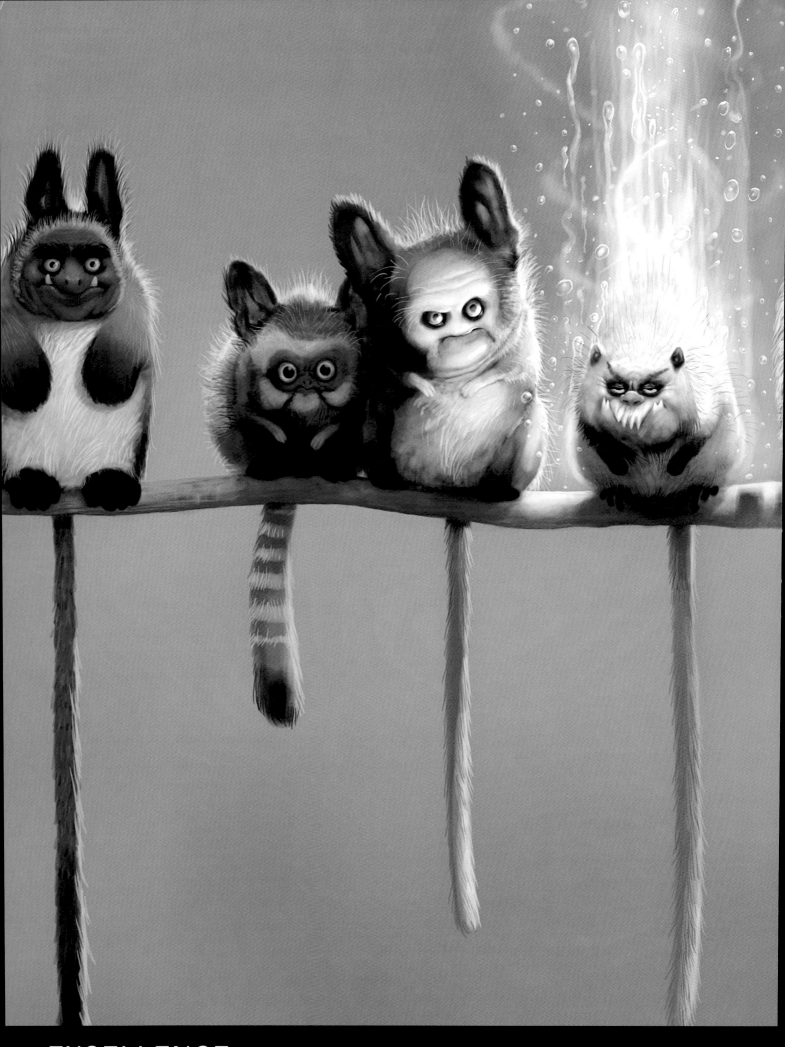

EXCELLENCE
Whimsical

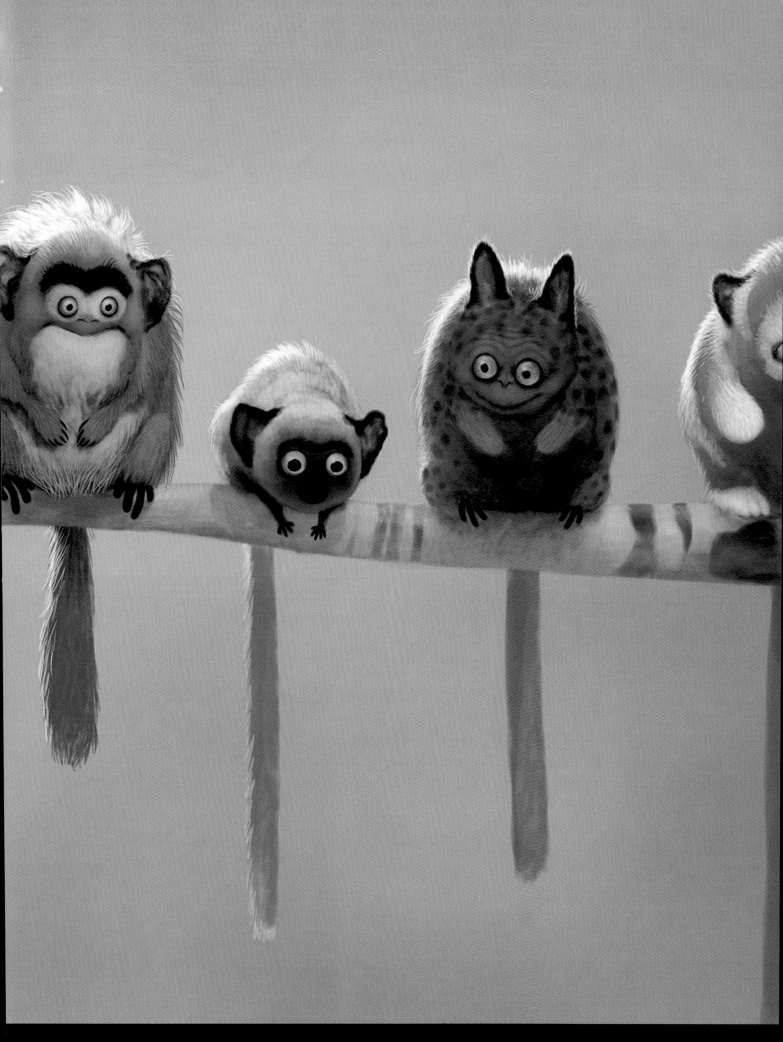

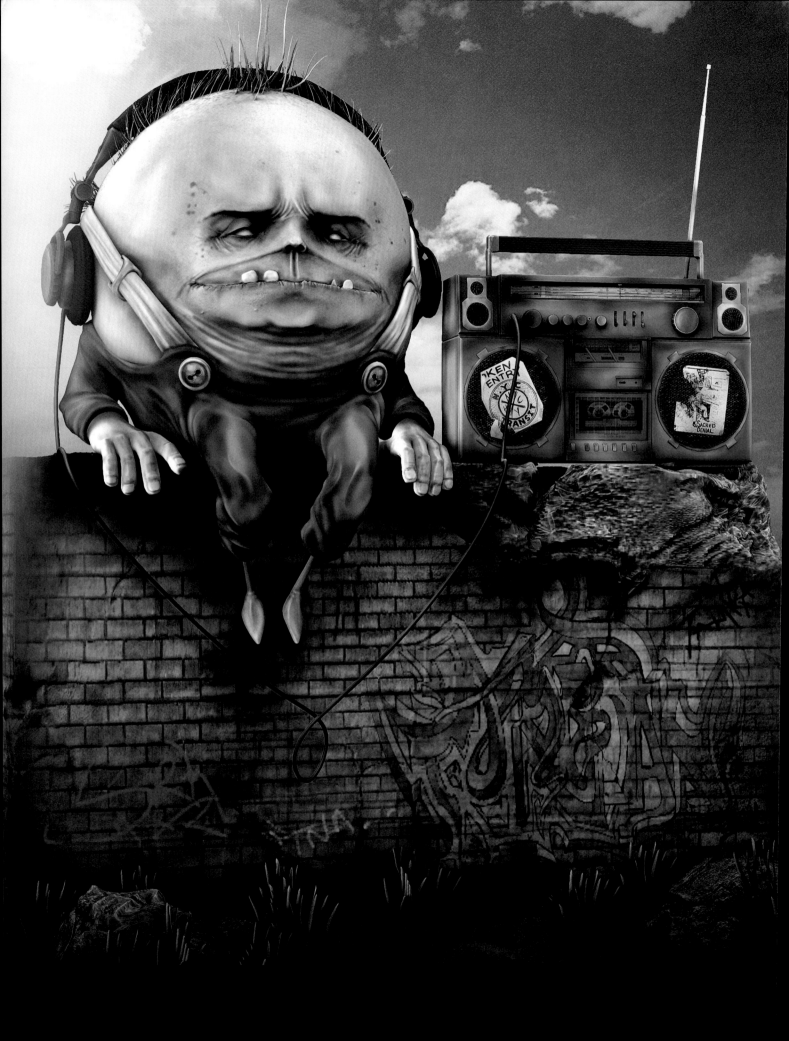

EXCELLENCE
Whimsical

Humpty Dumpty
Maya, ZBrush, Photoshop
Inspired by: Wesley Matthew Eggebrecht.
Aravindan Rajasingham, CANADA

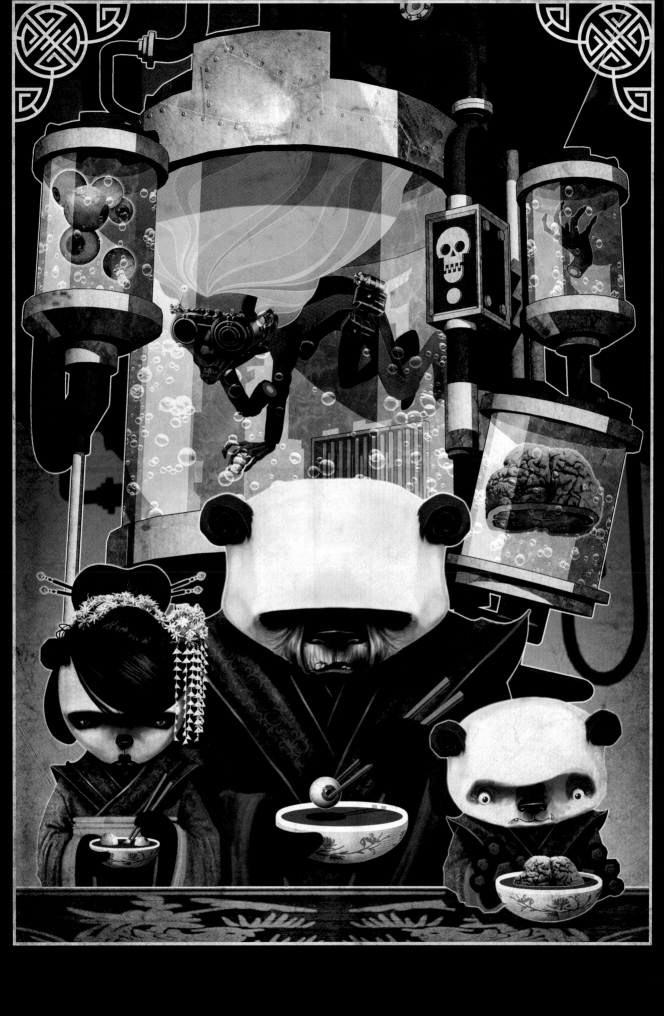

Goldie Locks and The Three Bears
Photoshop
Vanja Todoric, SERBIA

EXCELLENCE
Whimsical

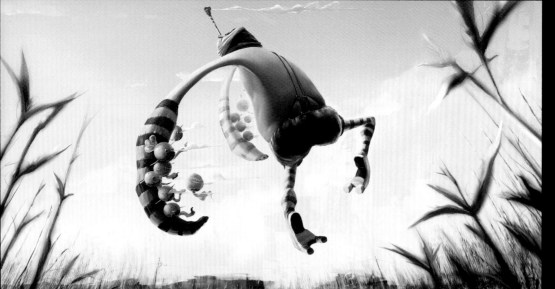

The Excitement
Photoshop
DingDing Chung, TAIWAN
[left]

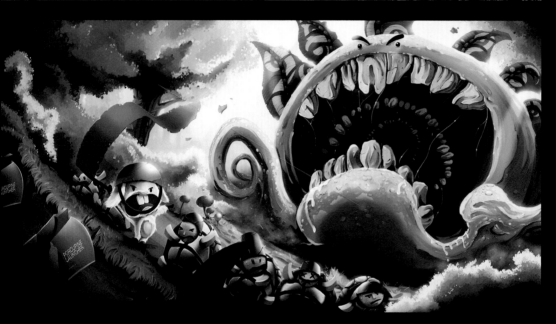

Forest Wars
Photoshop
Desmond Wong,
SINGAPORE
[left]

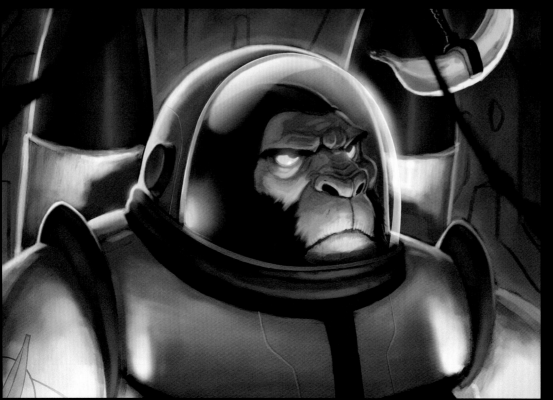

Yechi Monkey
Photoshop
Patri Balanovsky,
ISRAEL
[left]

The Safari on a Holiday Afternoon
Photoshop
DingDing Chung, TAIWAN
[right]

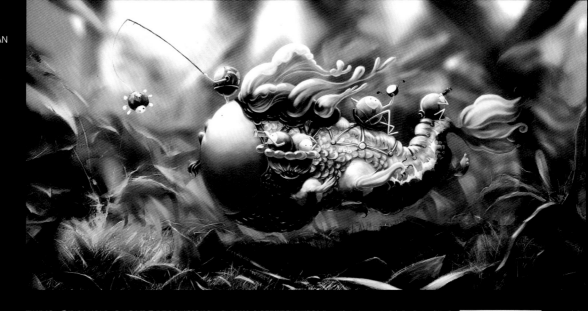

Brothers vs. Sisters
Painter
Szymon Biernacki,
POLAND
[right]

Deception is the key
Painter, Photoshop
Szymon Biernacki,
POLAND
[right]

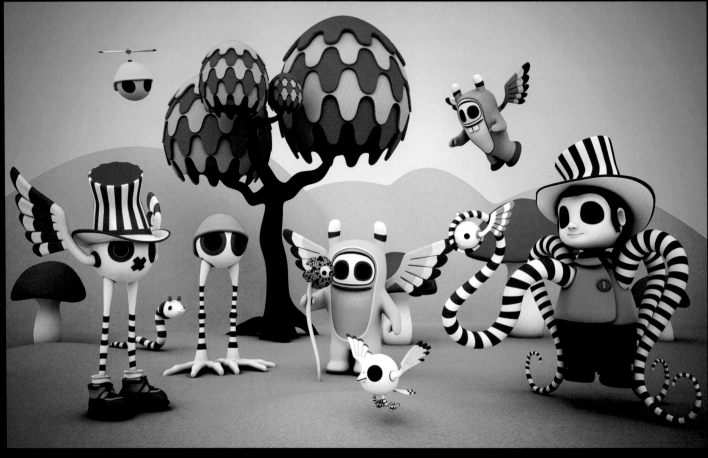

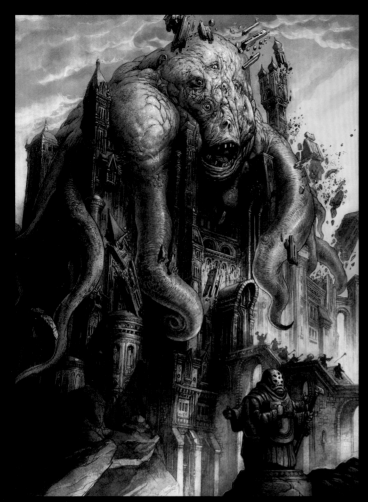

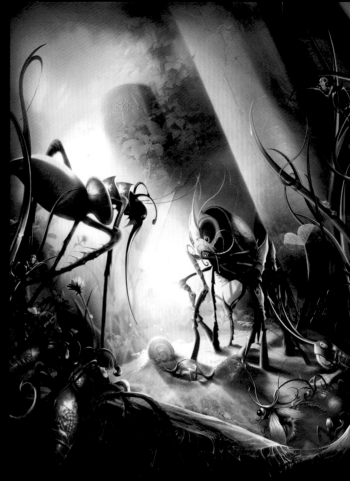

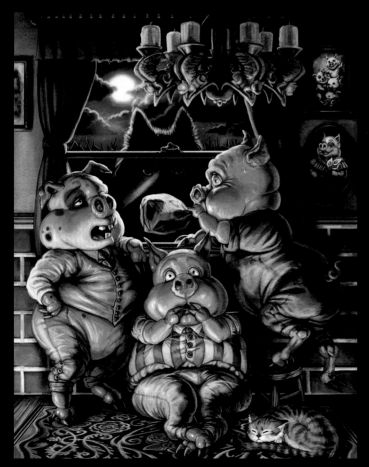

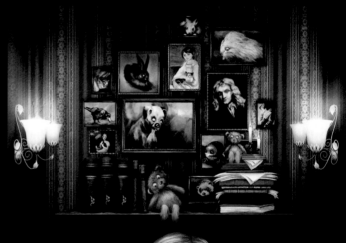

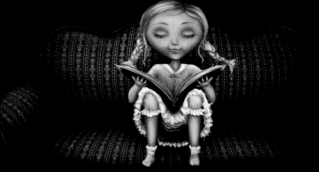

Oops
Photoshop
Sean 'Muttonhead' Murray, USA
[top]

Something Wicked This Way Comes
Photoshop
Felicia Cano, USA
[above]

Bugs' Tales
PhotoPaint
Tomasz Maronski, POLAND
[top]

Snoopy Pictures
Photoshop
Franziska Franke, GERMANY
[above]

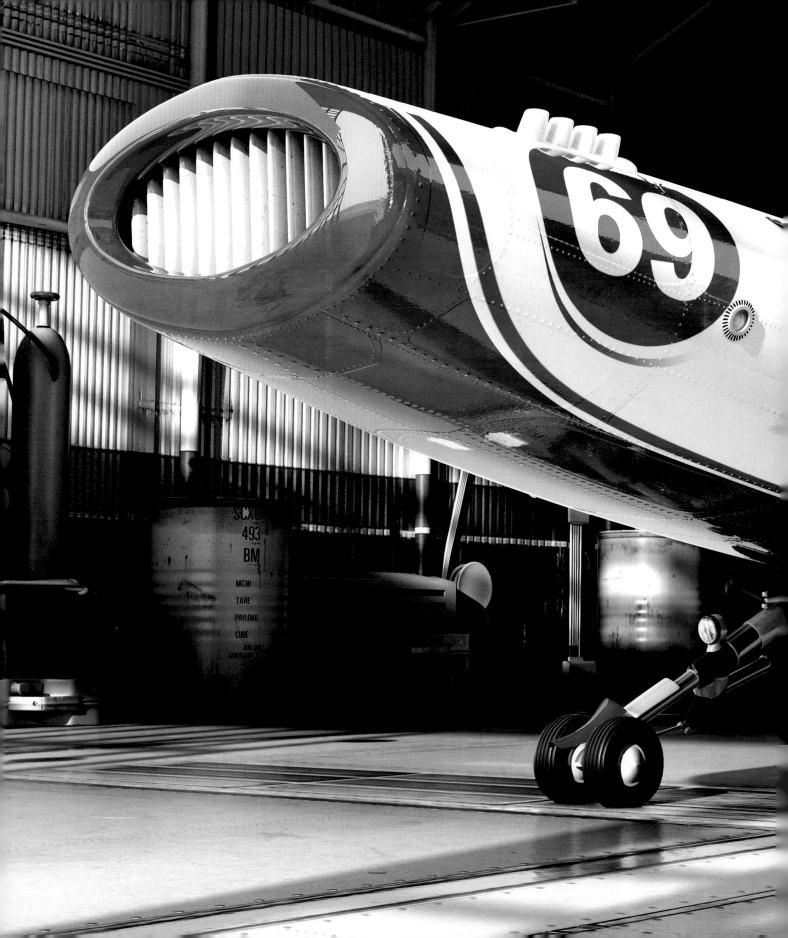

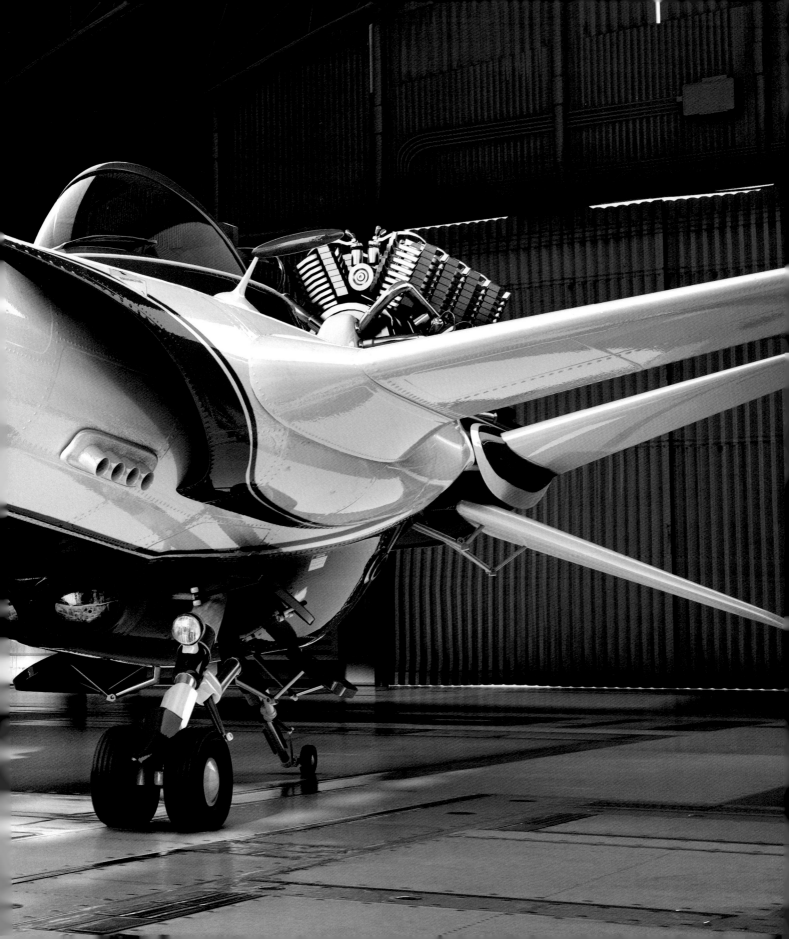

In the morning light
3ds Max, mental ray, Photoshop
Tristan Fricker, FRANCE
[top]

Infinitas
3ds Max, V-Ray, Photoshop
Client: Schöpfer Yachts and Sparkman Stephens Naval Architects
Tangram 3DS LLC, USA *[above]*

Armada Dorada
Photoshop
Sarel Theron,
SOUTH AFRICA *[top]*

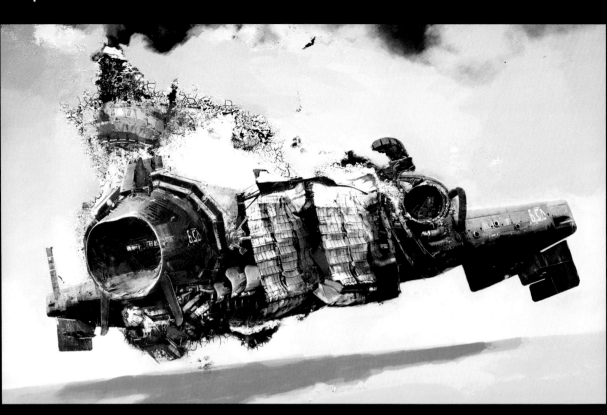

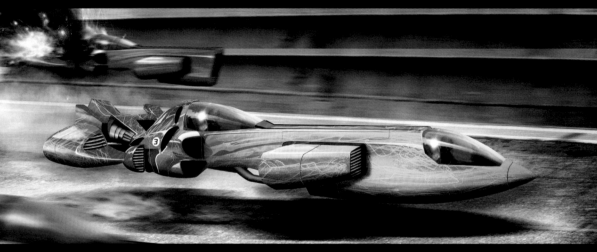

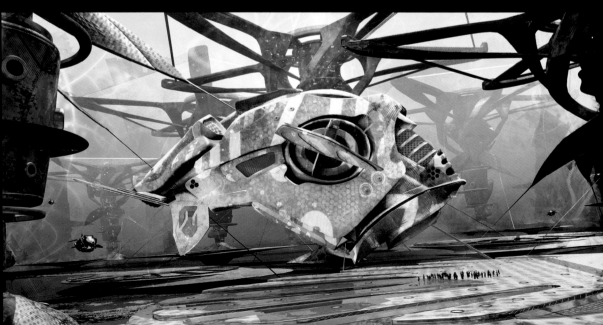

Air Ship
Photoshop
Hugh Sicotte, USA
[top]

Mac 3
Photoshop
Inspired by: Scott Robertson
Peter Ang, THE PHILIPPINES *[center]*

Landed
LightWave 3D, Photoshop
Neil Maccormack, bearfootfilms.
SWITZERLAND *[above]*

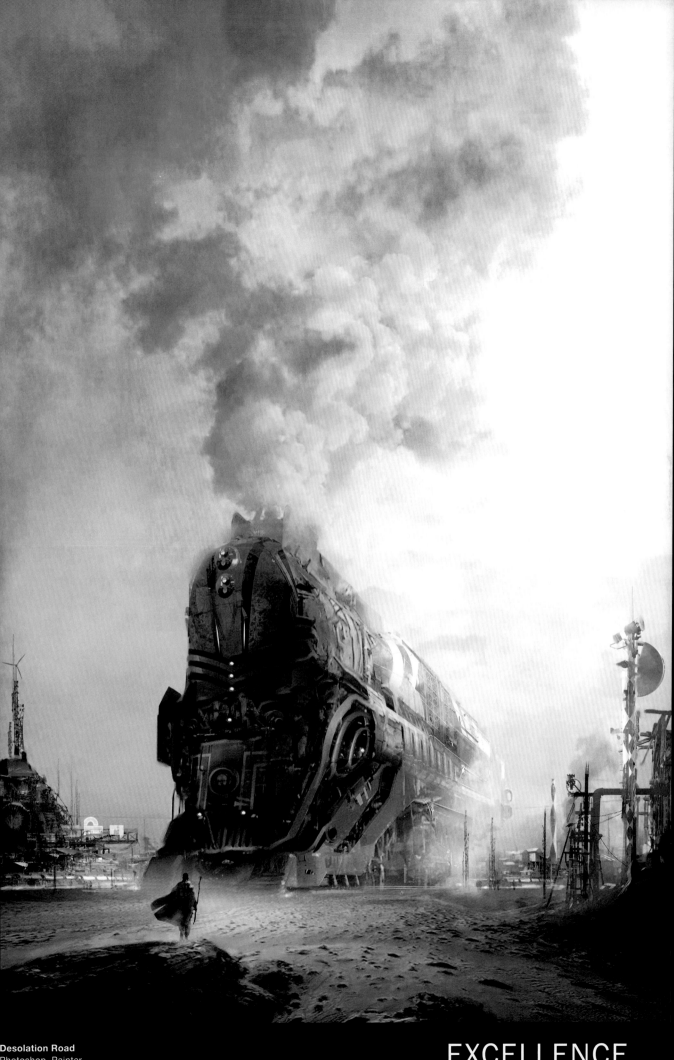

EXCELLENCE
Transport

The Retreat
Maya, mental ray, Photoshop, BodyPaint 3D
Rodrigo Lloret Crespo, SPAIN
[above]

Tempest
modo
Anders Lejczak,
SWEDEN
[left]

The Last Avia
VIZ, Brazil r/s, Photoshop
Pilot model: Anders Lejczak
Pavel Romsy, CZECH REPUBLIC
[left]

Farewell to Wings
modo
Anders Lejczak,
SWEDEN
[right]

Sukhoi
Maya, mental ray, Photoshop
Kiran Naidu, INDIA
[right]

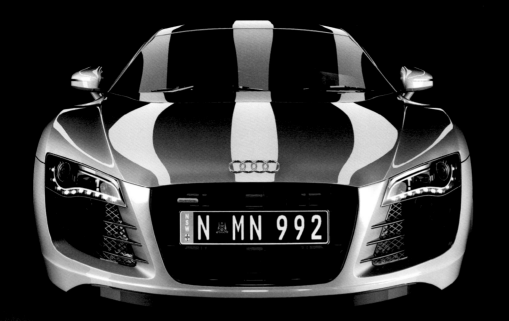

Audi R8
3ds Max, mental ray, Fusion
David Mackenzie, AUSTRALIA
[left]

City Escape
3ds Max
William Elliott, GREAT BRITAIN
[right]

TA Challenger
3ds Max, V-Ray, Photoshop
Vahid Mehri, IRAN
[left]

V Car
Painter, Photoshop
César Rizo, VENEZUELA
[left]

INDEX

EXPOSÉ 8 Limited Edition
The EXPOSÉ 8 Limited Edition features an extra section on the Master Award Winners. These pages can be found in the index with the following reference: [Limited Edition, i-xv]

INDEX

EXPOSÉ 8 Limited Edition
The EXPOSÉ 8 Limited Edition features an extra section on the Master Award Winners. These pages can be found in the index with the following reference: [Limited Edition, i-xv]

SOFTWARE INDEX

Products credited by popular name in this book are listed alphabetically here by company.

Company	Products	Website
Adobe	After Effects, Illustrator, Photoshop	www.adobe.com
Alchemy	Alchemy	www.alchemysoftware.ie
Ambient Design	ArtRage	www.ambientdesign.com
Autodesk	3ds Max, Maya, Mudbox, Softimage, VIZ	www.autodesk.com
auto-des-sys	formZ	www.formz.com
Blender	Blender 3D	www.blender.org
Cebas GmbH	finalRender	www.finalrender.com
Chaos Group	V-Ray	www.chaosgroup.com
Corel	Painter, PhotoPaint	www.corel.com
E-on Software	Vue Esprit	www.e-onsoftware.com
eyeone Software	Fusion	www.eyeonline.com
FeverSoft	fryrender	www.feversoft.com
GIMP	GIMP	www.gimp.org
Luxology	modo	www.luxology.com
MAXON	BodyPaint 3D, CINEMA 4D	www.maxoncomputer.com
McNeel	Rhino	en.na.mcneel.com
mental images	mental ray	www.mentalimages.com
Nemetschek	Vectorworks	www.nemetschek.net
NewTek	LightWave 3D	www.newtek.com
Next Limit Technologies	Maxwell Render	www.maxwellrender.com
Pixologic	ZBrush	www.pixologic.com
Smith Micro Software Inc.	Poser	www.smithmicro.com
Splutterfish	Brazil r/s	www.splutterfish.com
Systemax	PaintTool SAI	www.systemax.jp

THE ART OF
GOD OF WAR III

FLIP THROUGH EVERY PAGE OF
The Art of GOD OF WAR® III AT OUR WEBSITE!

We make the finest digital art books: Be inspired by the world's best digital art and learn how it is done! Ballistic Publishing is an award-winning publisher of high-quality digital art. Our books will inspire and educate you. For 'best of' digital art, take a look at the EXPOSÉ series. If you are interested in tutorial books, our d'artiste series contains master classes by the world's leading digital artists. To learn how the biggest games of the year are created from concept art to final playable product, take a look at our Art of the Game series. Visit: www.BallisticPublishing.com

/ B A L L I S T I C /
WWW.BALLISTICPUBLISHING.COM